INTERIOR PHOTOGRAPHY

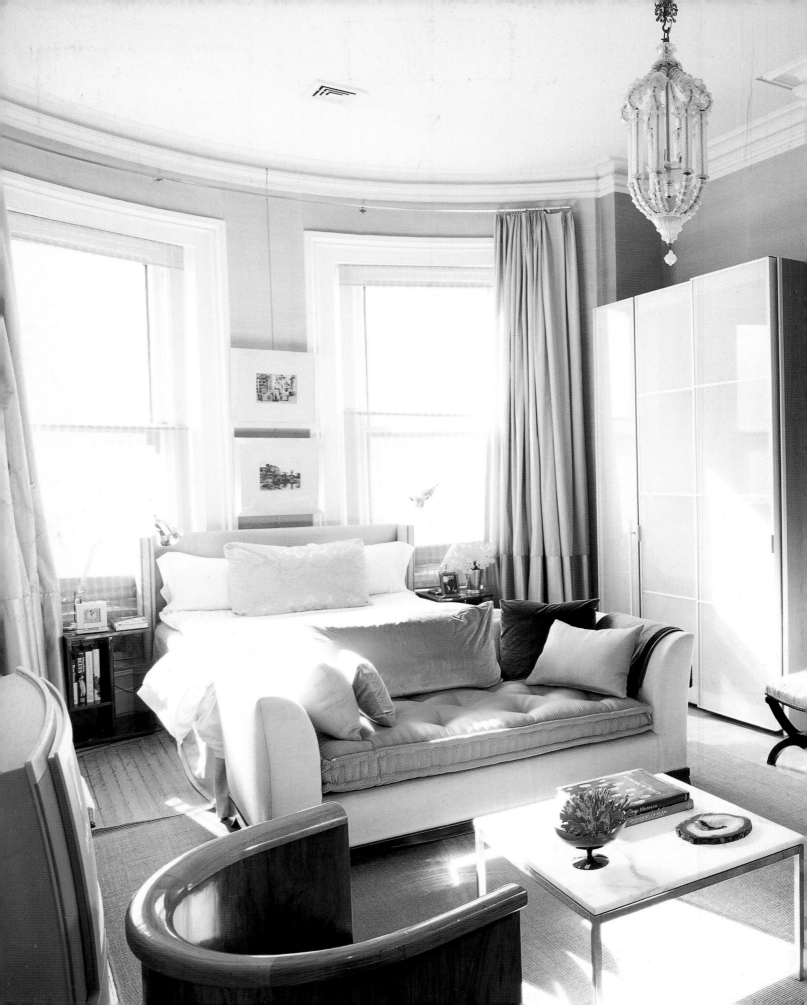

INTERIOR PHOTOGRAPHY

LIGHTING AND OTHER PROFESSIONAL TECHNIQUES WITH STYLE

ERIC ROTH

AMPHOTO BOOKS

an imprint of Watson-Guptill Publications / New York

I dedicate this book with
all my love to Becky,
Madeline, and Charlotte

Acknowledgements

Hard work would be unfulfilling without the
people with whom I share it and for whom I do
it. I am very grateful to the people who have
helped and inspired me, and I carry their spirit
with each new endeavor.

Thanks to Sabrina Murphy, Russ Mezikofsky,
Estelle Bond Guralnick, Gail Ravgiala, Susan
Sargent, Charles Spada, Leslie Wagner, Victoria
Craven, James Baker Hall, Brian Swift, Paul
Yandoli, Joe Picard, Frank Braman, Dan Cutrona,
Suzy Makepeace, Janet and Dave Henderson,
Ivan Orlicky, Ellen Rogers, Danine Warren, and
my loving parents, Bernie and Phyllis Roth.

I'm very thankful also for the care, dedication, and
pleasant manners of my editor, Stephen Brewer,
and creative designer, Alexandra Maldonado.

First published in 2005 by Amphoto Books
An imprint of Watson-Guptill Publications
A division of VNU Business Media, Inc.
770 Broadway
New York, NY 10003
www.wgpub.com
www.amphotobooks.com

Senior Acquisitions Editor: Victoria Craven
Senior Developmental Editor: Stephen Brewer
Designer: Alexandra Maldonado
Senior Production Manager: Ellen Greene

Text and illustrations copyright © 2005 Eric Roth

Library of Congress Control Number: 2004112177

ISBN 0-8174-4024-0

Printed in the Singapore

1 2 3 4 5 6 7 8 9 10 / 09 08 07 06 05

CONTENTS

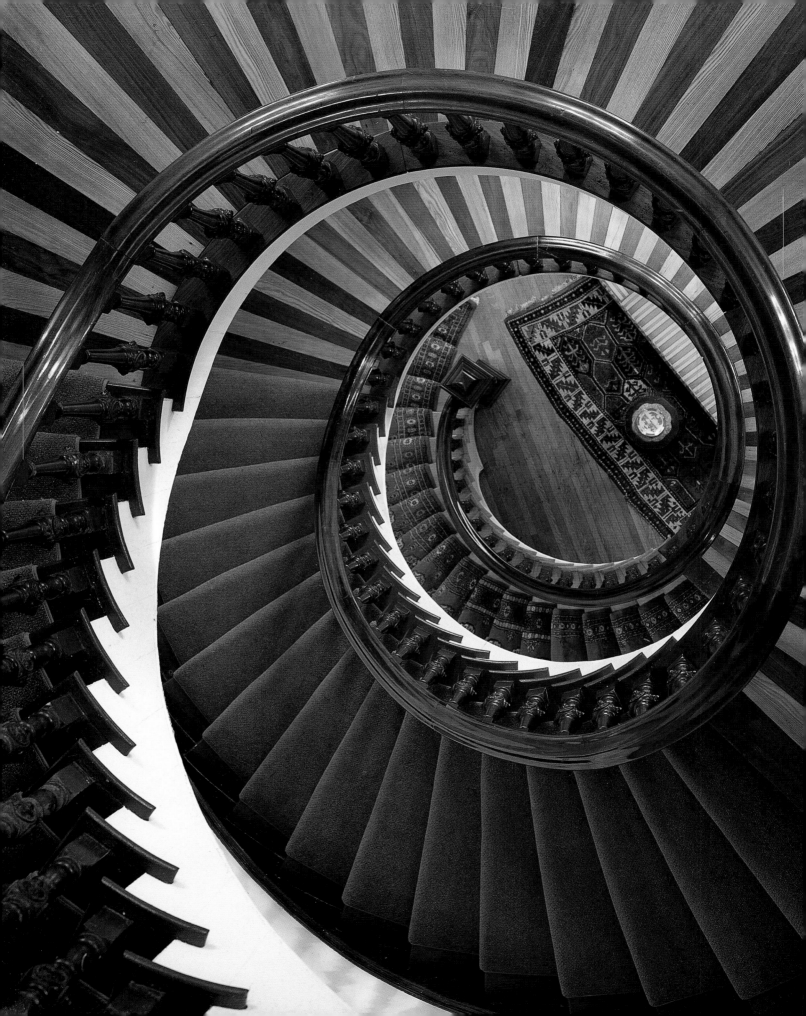

PREFACE

I love the magic of photography. It all started with a boat ride down the Charles River in Boston. It was my fourth-grade field trip, more than forty years ago. The equipment: my older sister's Girl Scout camera. The film: black and white. The lighting: natural. I remember the thrill of getting those pictures back from the drugstore two weeks later. They were uninteresting, blurry, and crooked, but to me, they were a miracle. That was it. I was hooked.

The funny thing is, I still marvel at what comes out of my cameras (and, thanks to eBay, I have hundreds of them). No matter what I shoot, or how I shoot it, there is always a surprise when reality is transformed into photograph. That feeling is still the same as it was the first time, or even better, and that's why I enjoy my work so much. I don't just love being a photographer, I am entranced by photographs. In a museum or bookstore, it is photography that holds my fascination.

Being a photographer seems to lend a sense of importance to everyday life. Many people travel through their day-to-day experiences without connecting with what they see, but this is the photographer's job. The photographer is a historian, gathering moments in a quickly changing world. We are the kids who loved "show and tell," science, magic tricks, and strange sights. Most of us have a bit of Peter Pan in us, refusing to grow up.

As a professional photographer for almost thirty years, I have worked on assignments covering most subjects. I've photographed people, places, and things. I've shot on large studio sets, small still-life and food sets, and in many kinds of location and travel environments. Without a doubt, I find the home-interior environment to be the most engaging and rewarding subject to photograph.

Interiors are fascinating because of the abundance of depth, detail, color, texture, composition, and natural and artificial light. These are all the material ingredients a photographer needs to create rich, beautiful images. A photograph of a home can be a kind of portrait of its people, often far more telling than an actual portrait. Through living, a dwelling evolves into a personal space. Physically, it's a three-dimensional work of art viewed from inside and out. The photographer can discover this expression, and with the right techniques, show it clearly in compelling photographs.

I hope this book pays fitting homage to the exciting art of photography. I have included tips and advice, and I discuss the photographic, social, and business practices that I believe in. I intend very little in this book as a strict rule. Art is about trying different things and breaking perceived rules. Innovation is more important than correctness.

Please let this book guide you to some point from which your uncharted voyage can begin. My goal is to impart some of the wisdom I have culled from a multitude of mistakes, wasted time and money, and eventual successes. I am telling you all that I know, and I believe that in an expensive undertaking like photography, if you pick up one solid tip from this book, you could save its cover price one hundred times over. And, if someone out there is inspired by my photographs and words, my mission is complete. I also hope you find my book entertaining.

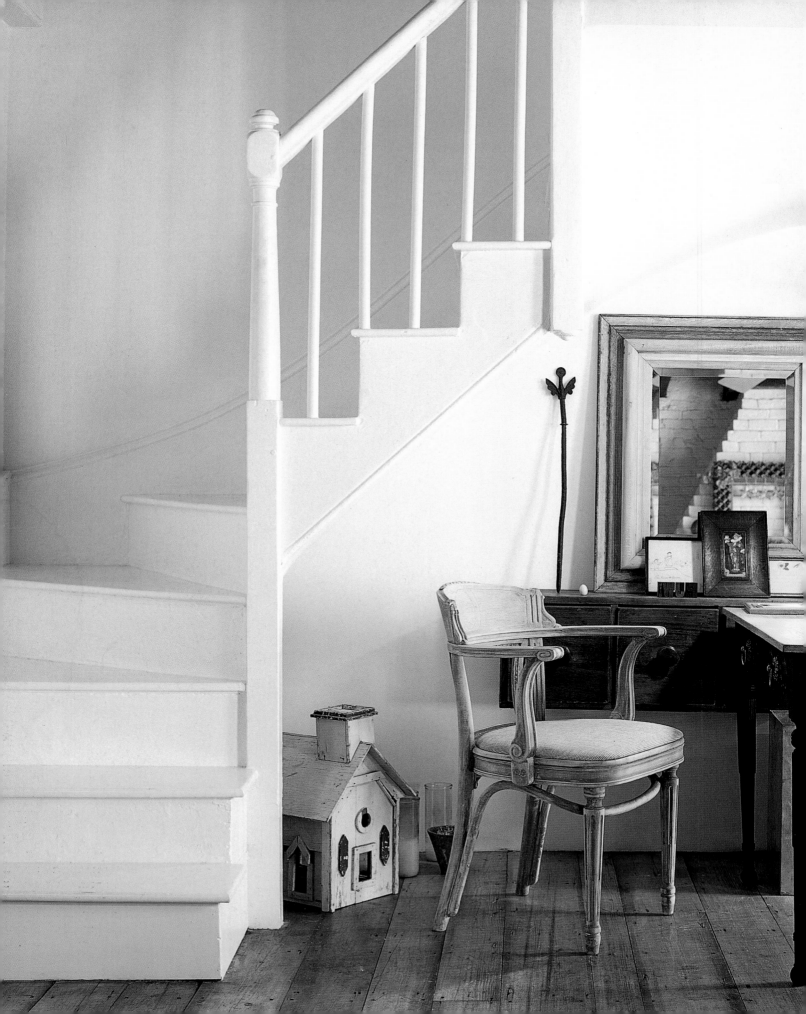

1
THE ART OF THE LOCATION

People love to look at photographs of homes. When we open a magazine to a beautiful photo spread of an interior, we leap through a photographic window into another reality. We enjoy an unhurried moment in which we can appreciate the beauty of a place. We imagine ourselves living in this space that someone has created to suit a life and personality, where the people who live in the house feel happy and can really be themselves.

CAPTURING THE ESSENCE

Home decorating is a form of artistic self-expression. In my view, the most beautiful houses are those in which the owners make statements about who they are. A photograph of the home becomes a portrait of the owner. Do they surround themselves with keepsakes and mementos? Are they adventurous with color and art? Do they like oddities that most people couldn't imagine having in their homes? Do they have an eye for balance and graphic clarity?

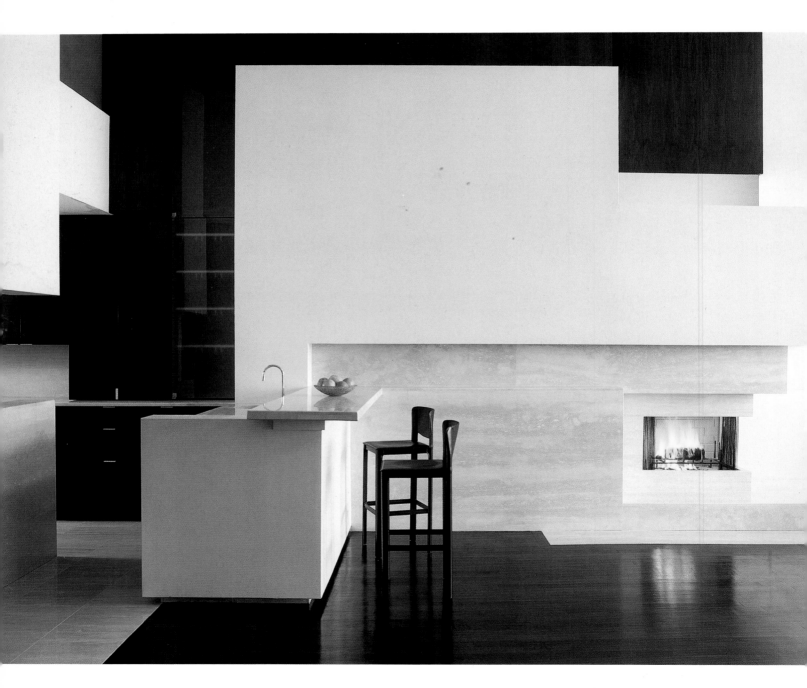

After photographing countless homes, I am more intrigued by each new discovery. I revel in the camera's ability, when used with spirit, to convey a place's personality. A photograph can often communicate more about a place than you would see by actually being there. I find it especially rewarding when the photograph creates interest in some ordinary objects by putting them together in a visual story. Then, with the right lighting and composition, they converge in creating a moment of beauty. This is what I would call "capturing the essence." These elements may be some furnishings, an architectural detail, a piece of art, flowers, a personal belonging, a bowl of fruit, books, some fabric, or any combination of all these pieces of the puzzle. Whatever it is, it tells the special story about the personality, style, and quality of this house.

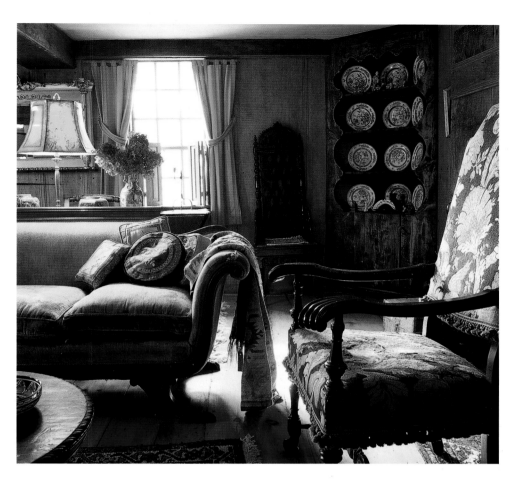

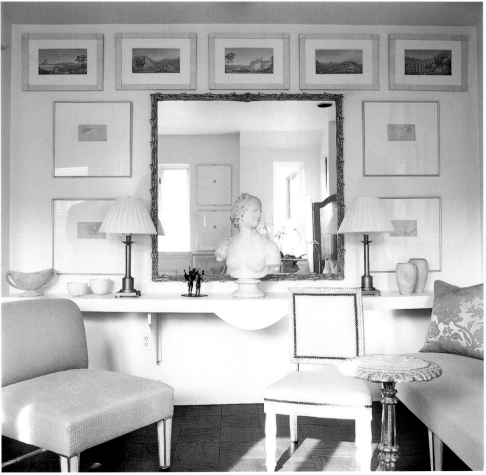

(Pages 8–9) Unused space beneath a staircase serves as a snug little study, creating a distinctive and inviting design element.

◀ Using strong lighting and sharp angles, I photographed this ultra-modern cubist space in the same graphic, architectural spirit the room conveys.

▲ These beautifully aged antiques don't feel like old relics. Artistically nestled in this home, they look comfortable in their space and alive with warmth. I made sure they were bathed in sunlight to enhance their charm.

▶ By emphasizing sunlight filling this richly decorated room, I was able to capture the sense that light is a dominant feature and lends the space an airy, uncluttered feel.

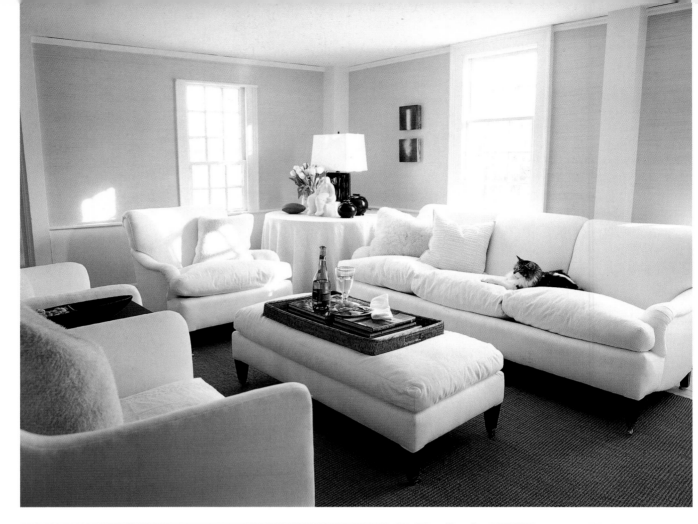

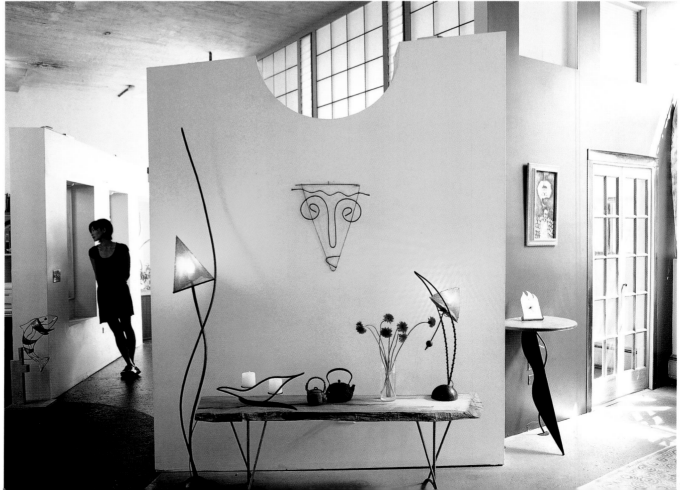

◀ Let the camera capture beauty in simplicity. This clean and tailored home is expressive in a quiet, soothing way.

◀ A colorful sculptor's loft presented me with an opportunity to make this bright, airy, and whimsical shot.

▲ The softness of this shot adds attitude to a curvy, funky pad.

◀ Sunlight creates a strong sense of place in this antiques-filled home, and the effect is to welcome the viewer to step in and admire its beauty.

CREATING A PERSONALITY

Your goal is not just to document what is in a room, but to create beautiful photographs—and some interiors just photograph much better than others do. When the decorator has used style, color, texture, scale, shape, space, and light creatively, the photographer will have obvious advantages. If the home is a cookie-cutter example of predictable, boring decorating and personality has not been allowed to flourish, you will have to manufacture excitement where none exists and poke and prod a room before it bends to your will.

Your success lies in your ability to create a personality, a quality those who look at your photographs crave and one that money can't buy. The photographer who recognizes the magic of finding a personality in any room holds the key to success and just needs to go capture it. Some spaces are fabulous, chic, and artistic and when shooting them you can't help but produce gorgeous photos that make you look brilliant. But here's another case of the spoils going to the victor, because the most successful photographers usually get these great assignments, along with a support staff, lavish fees, and a great public image that their clients love. How can they miss? Most photographers, though, are in the trenches, gutting it out, relying more on their wits than on what is handed to them. On most shoots, you will benefit greatly by having a stylist, or being a good stylist yourself. You and your assistant better have strong backs, because you will move furniture and accessories everywhere before you create a good composition. You will bring in things from shops and your own house, you will play with natural and manufactured light, and you will dig deep into your creative grab bag. These shoots are the most difficult. But if you've managed to infuse a room with some personality, you've done your job well.

▲ Small details become more expressive against a clean background.

◄▶ A remodeled Vermont schoolhouse was the subject of a funky magazine story I shot. The photos capture the owners' irreverent style, readily conveying a sense of place. Whether or not you'd like to live there is a question of taste. Edgy homes aren't every reader's cup of tea, but they're lots of fun to shoot.

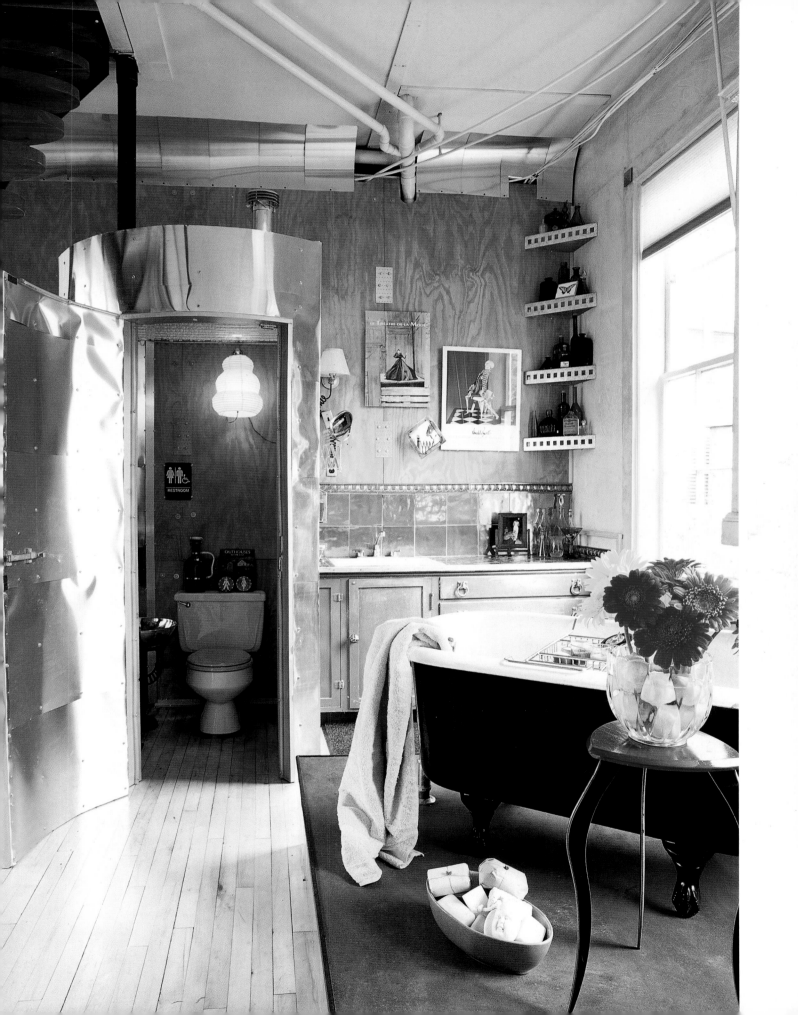

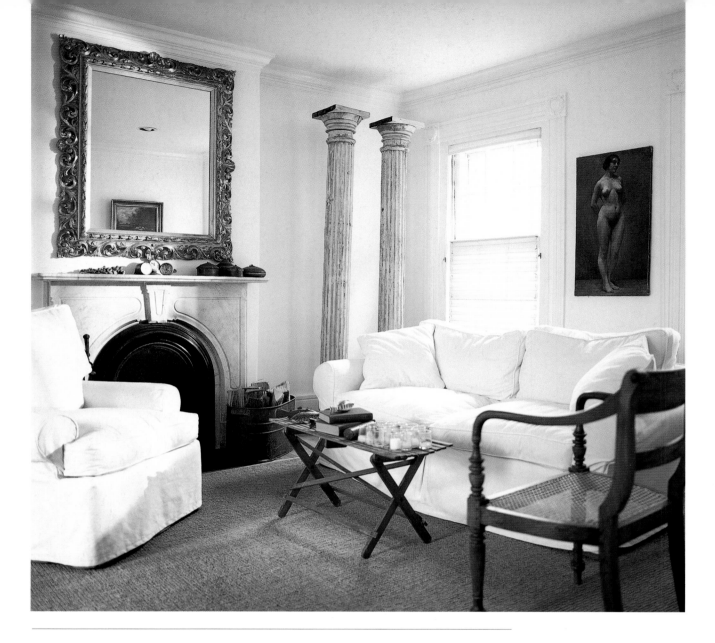

FINDING THE FEELING

How do we judge the effectiveness of a photograph in capturing the essence of a place? Most important, what is the feeling? By this, I mean the visual feeling. This is hard to define in words, because words just give a partial description. It is at once visual and visceral. It may be useful to compare the feeling of a room to the feeling evoked by music; at least, musical terms are very apt. When the content, composition, and lighting are in harmony, the work resonates. The photograph has rhythm and meaning. The sensitive photographer looks for visual harmony and will draw on it to strengthen the clarity and purpose of his or her imagery. A good interior photograph doesn't just show what the place looks like, it makes the viewer feel it, and understand what its beauty is about.

▲ Antique and classical touches make a strong statement when mixed with clean contemporary elements.

▸ The point of this photograph was to capture the look and feel of a bright, exuberant dining room.

▸ It's fairly easy to capture the charm of an urban garden, but I increased the appeal of this one by spraying the plantings to bring out their freshness and shooting it from above.

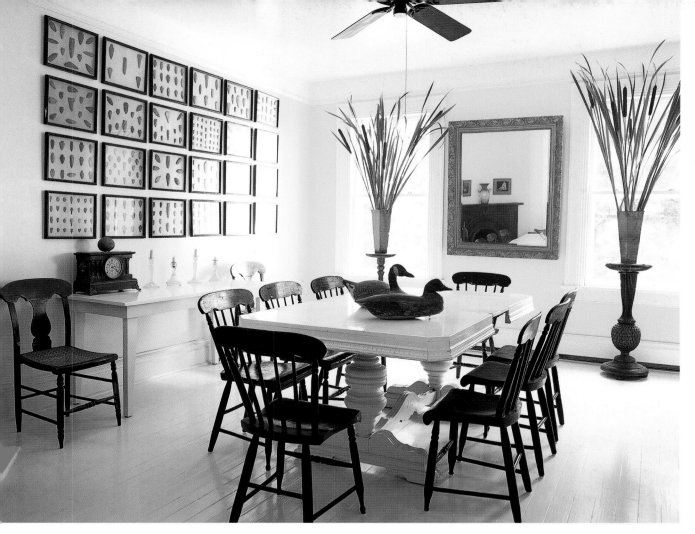

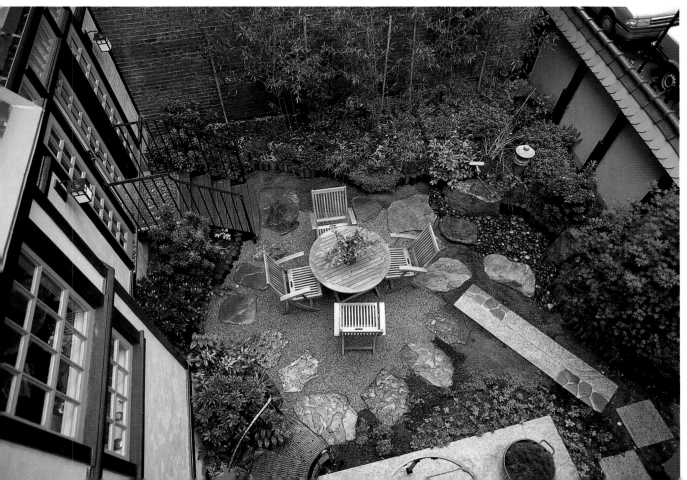

LOOK BEFORE YOU SHOOT

You make the best photographs in your mind, then in the camera. Accordingly, you must feed your mind's ability and desire to create images you will love. By looking at magazines and books about interior design you can improve your facility with this subject matter. I like looking at all sorts of home and garden magazines and books, and I learn something from every one; in fact, I learn from every photograph I see. Look at and think about two things: the quality and point of view of the photographs and the actual interior design. What do you like? What do you dislike? Though your personal taste is not really the main point of your work, you are still making constant judgments about what you want to include. You have to make quick, smart, confident decisions about what's hot and what's not. You have to have a vision and a point of view, so you have to know what you like and what you don't like.

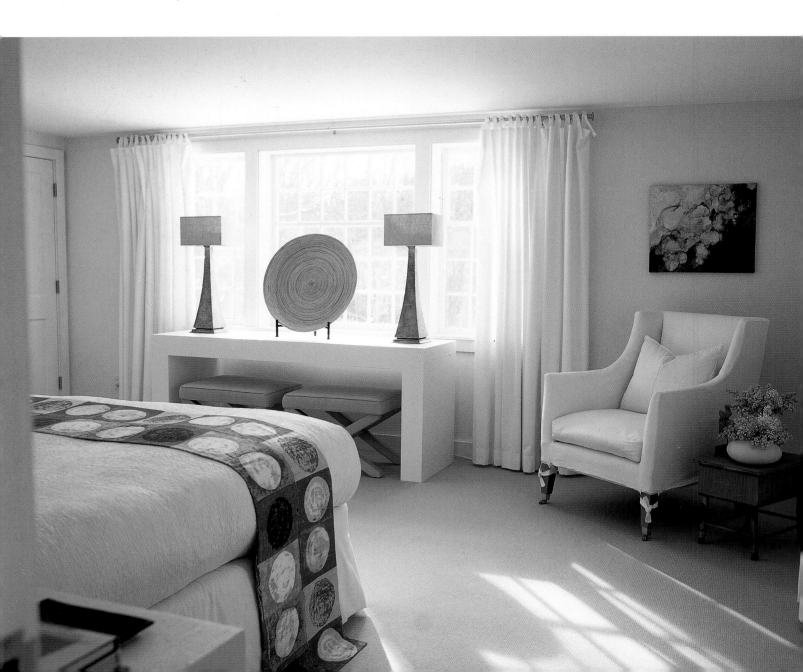

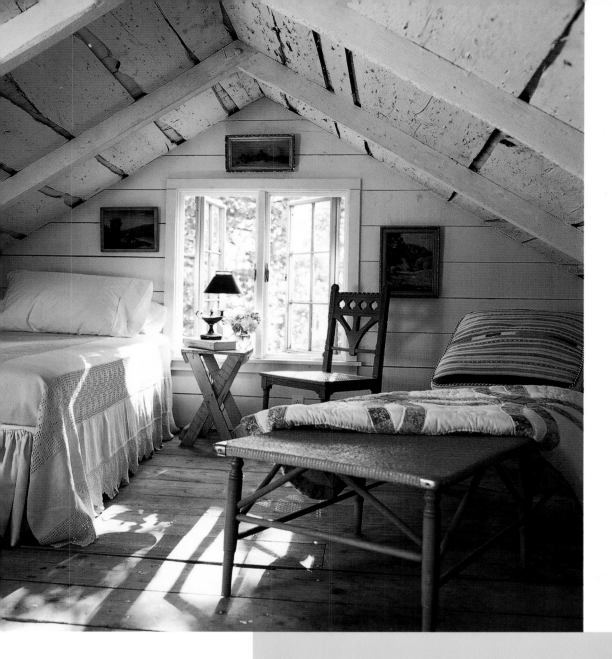

◀ It soon became apparent that the trick to photographing a room in this clean, tailored, soothing home was to let the camera capture beauty in simplicity.

▲ An attic bedroom immediately conveys a sense of cozy comfort.

Make the Most of a Location

Not every room is an automatic winner, but with the right mindset, you can extract a quality shoot from even the dog locations.

◎ **WHAT'S HOT:** Simplicity, yet fullness; natural beauty; a slightly rumpled lived-in look; an uplifting feeling; good scale, balance, design, and composition; furnishings that complement, rather than match or compete.

◎ **WHAT'S NOT:** Opulence and riches; furnishings that are matchy-matchy; sterility; square and symmetrical floor plans; too much memorabilia; unattractive personal effects; furniture-store predictability.

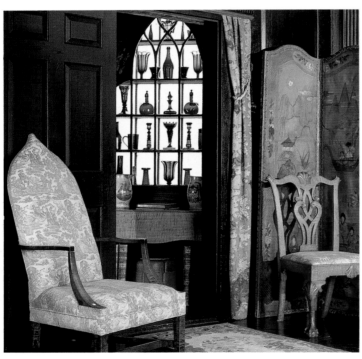

DEVELOPING AN EYE FOR DESIGN

As a photographer of interiors you will also heighten your appreciation of interior design. I have always admired art, furniture, fabrics, floors, and wall treatments and have a genuine interest in the pursuits of my clients who are interior designers and architects or are otherwise involved with decorative arts or simply interested in them. I enjoy speaking their language, and complimenting the "damask they used on the slipper chair, and how well it coordinates with the toile chaise." I enjoy knowing the names of many flowers, carpets, woods, finishes, and fabrics, and I wish I knew more about artists and period styles. Interior design is a full and interesting subject and any wisdom you gain will serve your photographic aspirations.

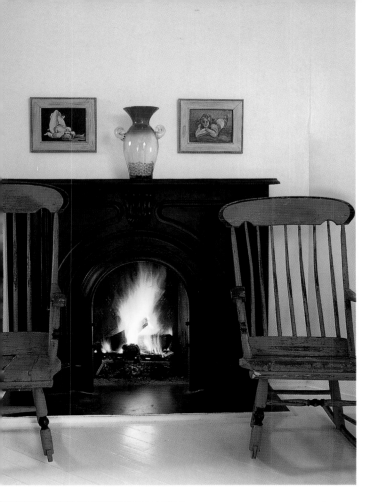

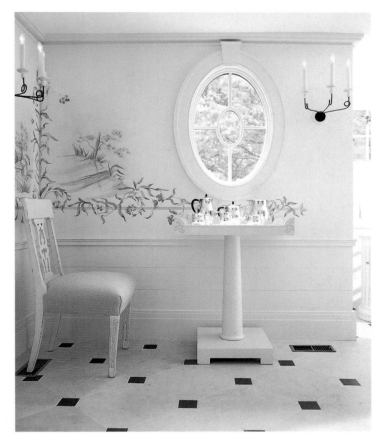

Beauty is in the details, and it's intriguing to look for small miracles through the lens of a camera, whether you focus on a treasured arrowhead collection, some architectural details, or something as simple as a bowl of fruit or a bouquet.

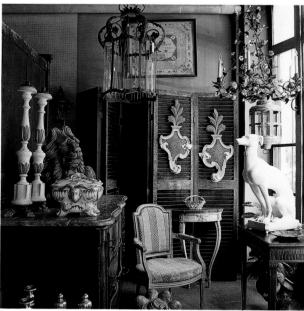

Antiques shops are among my favorite subjects. I love the sense of discovery I feel when browsing in one and capturing the art and beauty I find there with my camera.

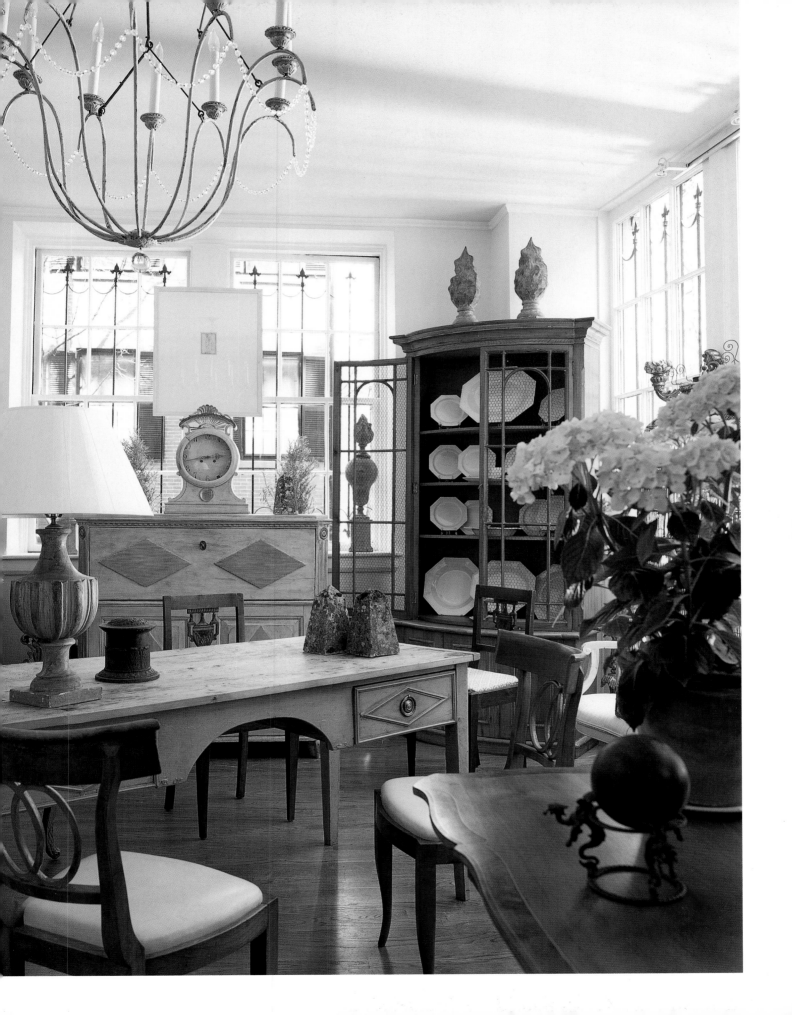

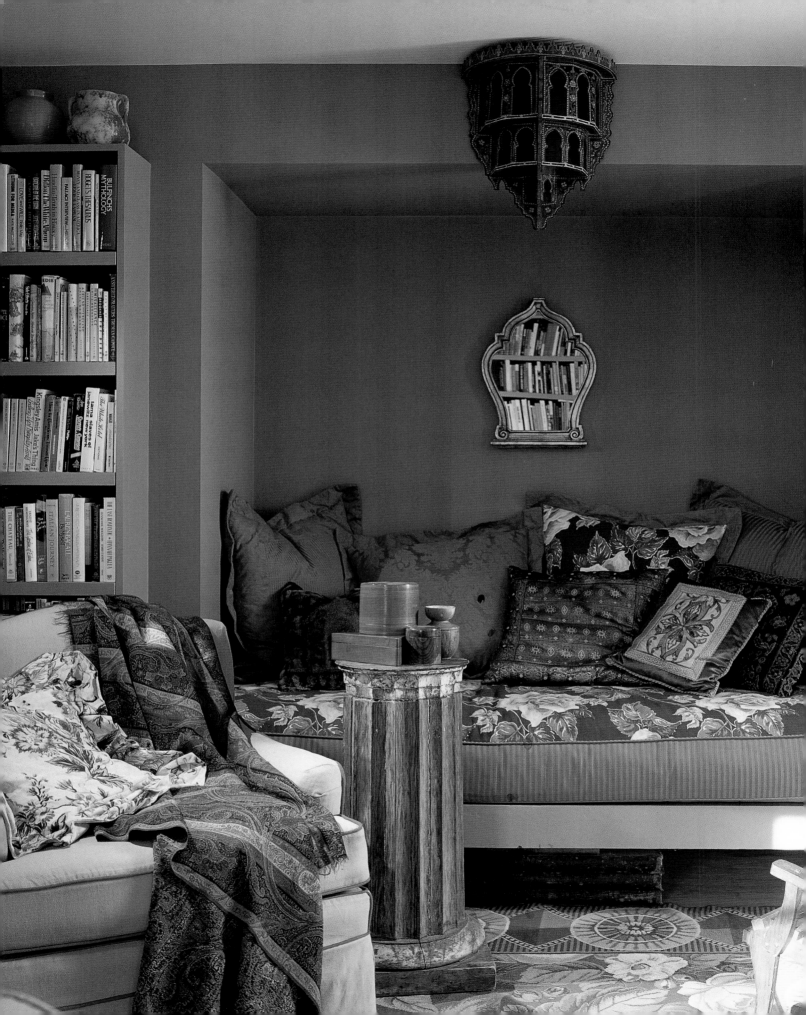

2 SCOUTING THE LOCATION

I've always liked the term "scouting" as it applies to photography. Scouting conjures images of an explorer discovering new territory, perhaps in search of treasure. The word also reminds me of my days as a boy scout when our motto "Be Prepared" was sage advice. Years later, as a photographer, there is no more sage advice I can give you than to follow that motto. I always try to prepare myself for a shoot by making a visit to a location beforehand. For me, scouting has become an important step in getting my best shots. Scouting can help you be objective about which views translate best into photographs, and will help you make better informed photographic decisions.

WHY SCOUT?

An hour of scouting and another hour of viewing the scouting shots will help you tremendously in formulating your own opinions about the best "look and feel" for the shoot. They will also help in planning the flowers, props, and accessories you may need to bring to the shoot. You might decide to hire a professional photo stylist if there is enough need and budget. Often, a combination of client, designer, talented homeowner, and photographer can handle the styling, but sometimes a professional stylist will be your best friend (see Chapter 5).

(Pages 24–25) It didn't take long to discover that this house has much to delight the eye, and everything builds on an exotic theme.

A fun location (below and right) reflects the tastes of owners who are creative and confident. These qualities, combined with good taste, always win my vote over a mere show of wealth.

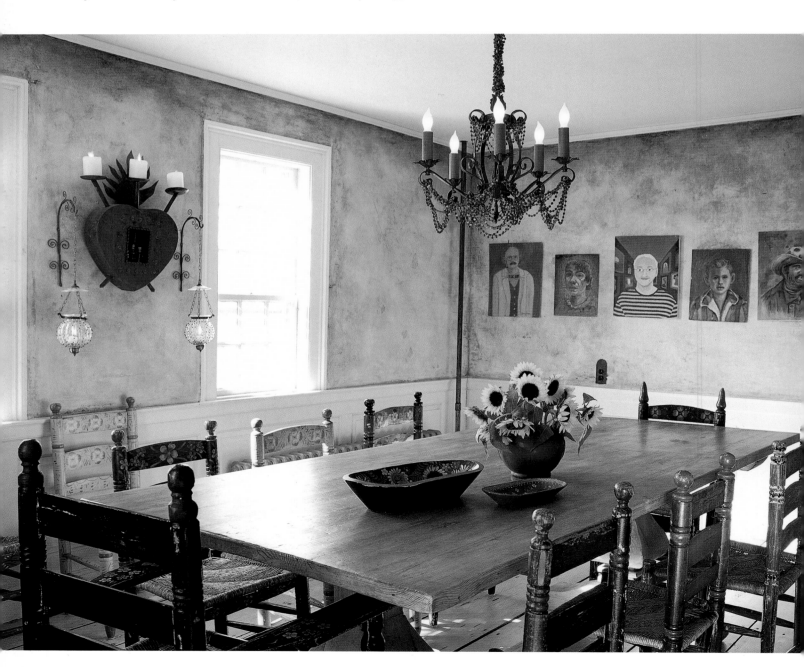

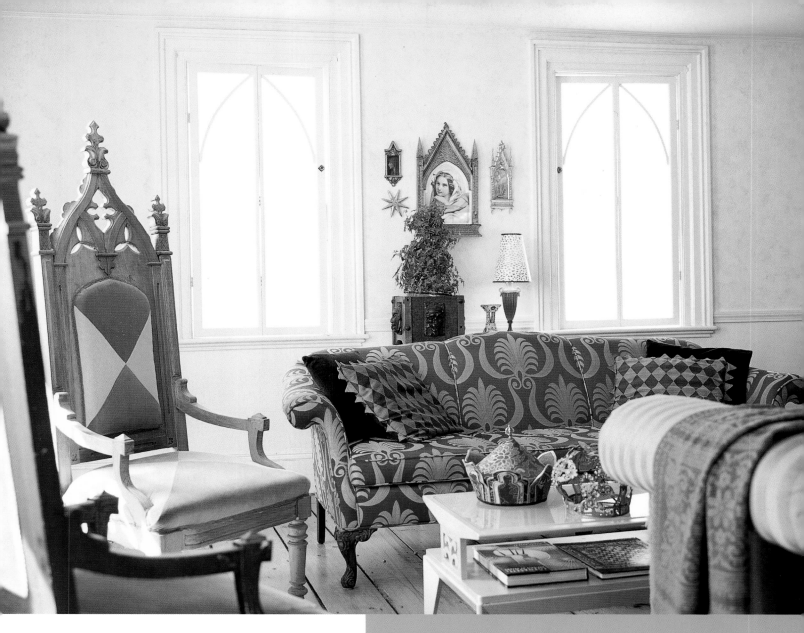

Even if you don't have an assignment, you should consider scouting locations that catch your eye. Your extensive knowledge of all the home magazines (often called "shelter magazines"), accumulated from hours of reading in the supermarket checkout lines, will come in handy here: You can send your scouting shots to a magazine that you think might be interested in the location. If you're really talented, lucky, or a little of both, you'll get a call from an editor offering a terrific assignment. But don't wait by the phone for too many hours—keep scouting for the next great shoot!

The Rewards of Scouting

◎ **Meeting with your client without time pressure and the urgency of a shoot allows for a relaxed exchange of ideas.**

◎ **Shooting some digital shots or 35mm slides with a handheld camera will provide excellent reference for shot selection and styling ideas.**

◎ **You can objectively identify which angles and compositions are strongest.**

◎ **You'll execute the shoot with more confidence and you'll conceive your ideas more fully.**

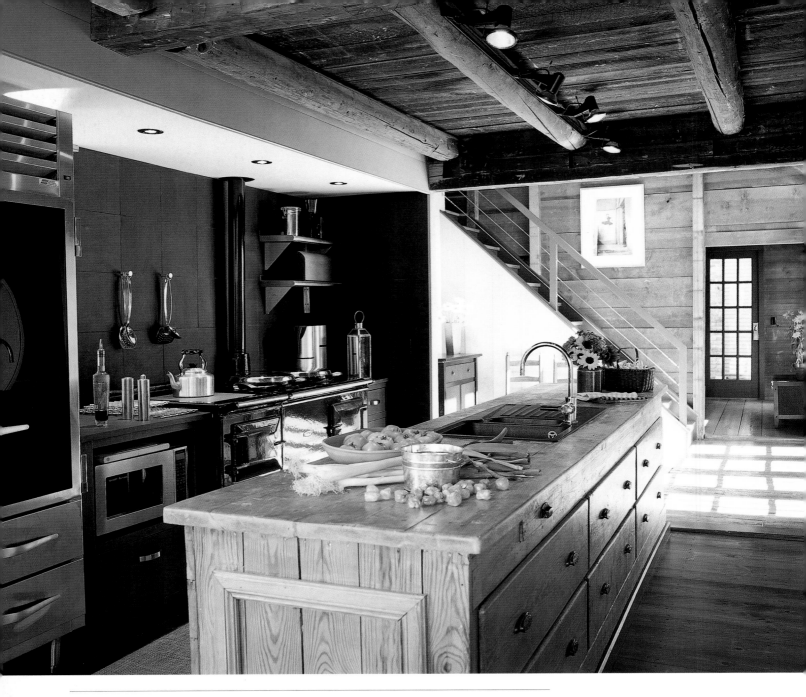

SAVOR THE FIRST IMPRESSION

When you walk into a photography location, your immediate reaction is key to the success of the shoot. First impressions, after all, are important, and this impression will probably set the tone for your shoot. Try to recognize how you feel when you look at different spaces. Listen to what your inner artistic voice tells you as you walk around. You may be attracted by the color and light in a corner. You may know instinctively that a very wide shot will be too busy, with the foreground piling up against the background.

▲ Ahhh, to walk into this . . . if only they all could be so good! This architect's home combines rustic, earthy charm with contemporary architectural details.

▶ It is immediately apparent that these homeowners appreciate both modern and antique influence, and what a nice discovery it was to walk into their sur- roundings.

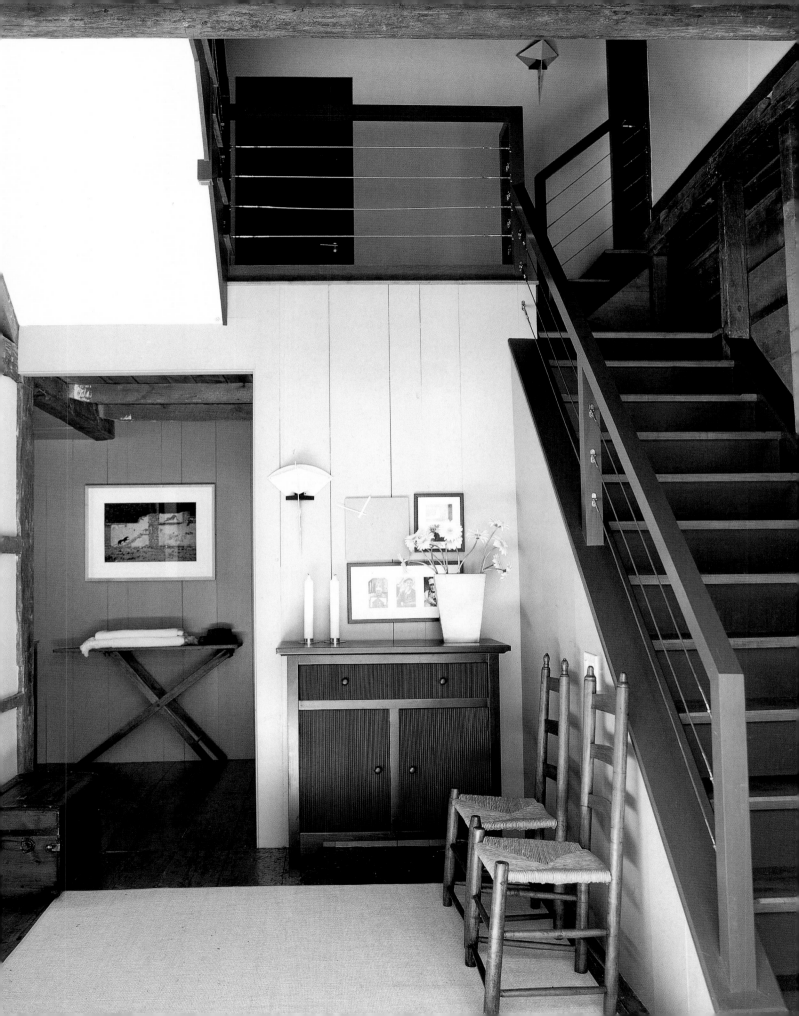

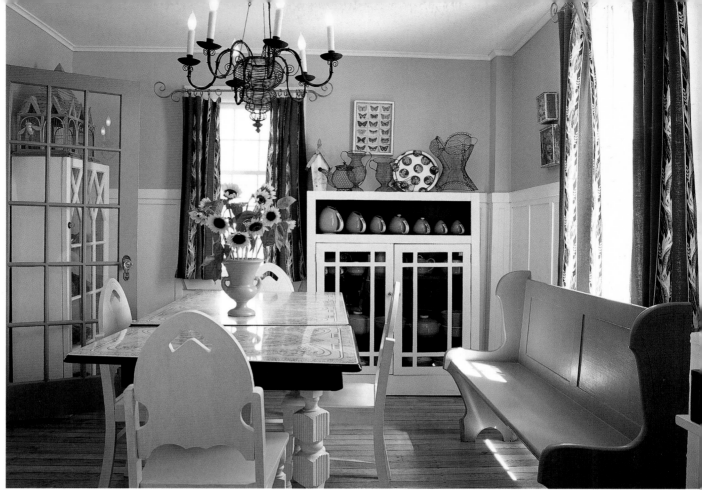

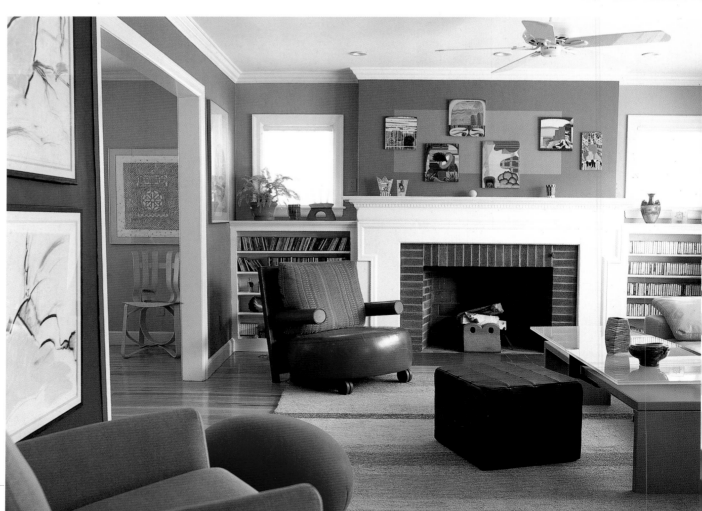

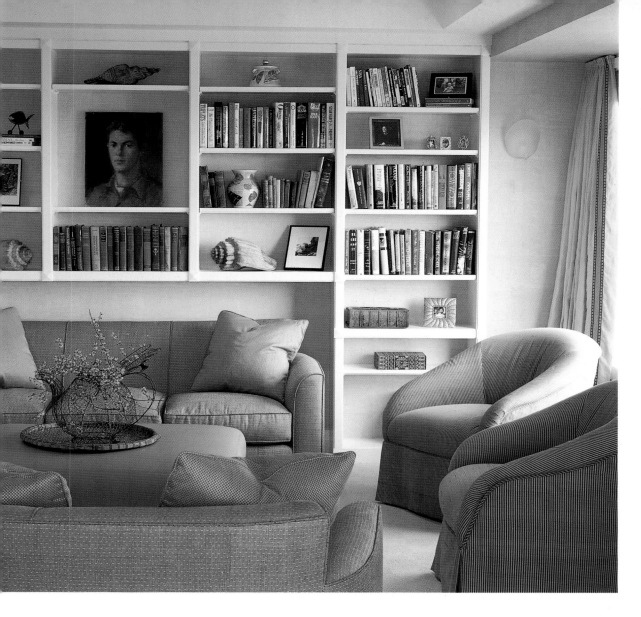

You will keep hearing your own thoughts and reactions, and you will see your future conquests. Try to make note of your first impressions as you walk around so you remember them, because they will be a valuable tool when you judge the quality of the photographs you will eventually shoot. The final photos will never be exactly what you expected, but you will know if they feel as good as you think they can be.

Keep Your Thoughts to Yourself

While you're listening so intently to your inner voice, be careful to control your "outer voice." You will insult the homeowner if you don't seem enthusiastic, and everyone, especially you, will regret your visit. Never tell homeowners that you don't like something; always compliment every facet of their tastes. Nor will your silence be well received; you absolutely must spew compliments, even if it hurts. You may hate the house, but just continue your scouting as if you like it, and even with no film in the camera, happily take a few shots of each room. This is a very charitable, honorable form of lying and true professionalism at its best.

◀ Stepping through a door can be like opening a treasure chest! This house belongs to a professional photostylist.

◀ This designer expresses her love of color and shape, the dominant themes of her living room.

▲ Comfort and warmth are key to this living room.

KEEP IT NATURAL

Scouting can be done quickly and easily in all natural, preferably sunny light. Turn off lamps and overhead lights whenever reasonable. Use a digital or a 35mm camera with a fairly wide-angle zoom lens (see pages 134–138 for camera suggestions). Most important, never, ever use the little on-camera flash for any photographic endeavor, except possibly forensics. This feature, the bane of a caring photographer's existence, has invaded the picture-taking world, robbing us of decent lighting. The on-camera flash kills all depth, texture, and mood. If your camera has it, turn it off or put tape over it; better yet, get a camera that doesn't have it.

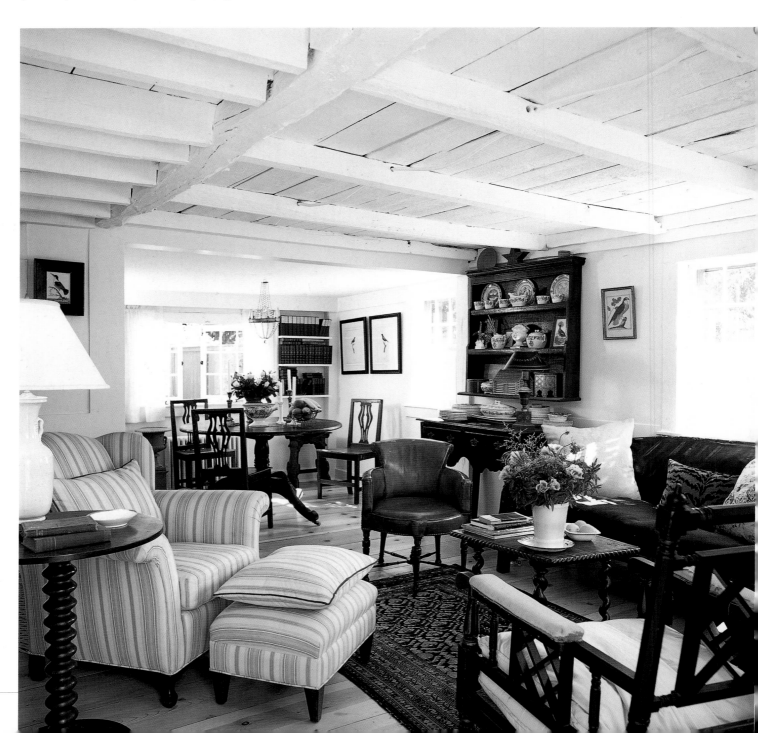

The solution to scouting in low-light situations is to use a longer shutter speed. If there is not enough light for a $\frac{1}{15}$ of a second or faster shutter speed, you should probably use a tripod, unless you are rock solid and/or can tolerate slight blurriness. I find a tripod too slow for scouting, so I brace myself against a wall or chair, hold my breath, and gently squeeze the shutter release for acceptably sharp results. Remember, this is just scouting. The shutter speed may be $\frac{1}{4}$, $\frac{1}{2}$, 1, or even an astoundingly long 2 seconds. Document a variety of overall views, medium-range vignettes, and close-up details using the zoom lens at many different focal lengths. Later, you and the client can assess each of these angles and compositions for strengths and weaknesses.

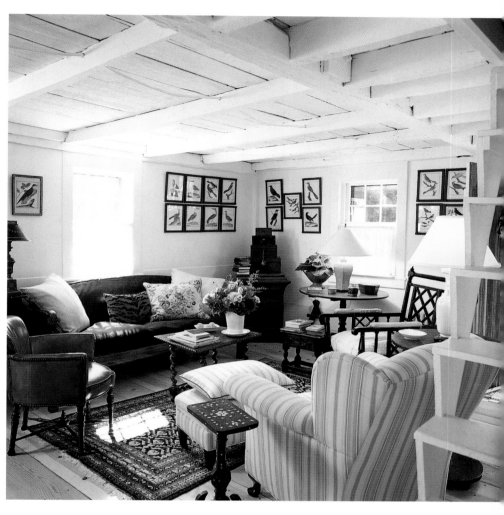

◀▶ **I jumped for joy at my first peek of this stylish location (left and above right). It's full of beauty and personality, two qualities sought by editors. Shots taken from two angles combine to show most of the room.**

▼ **Kitchens that are creative and functional are a rare find for the intrepid scout. The only issue here was finding the angles from which to show the room off to its best advantage.**

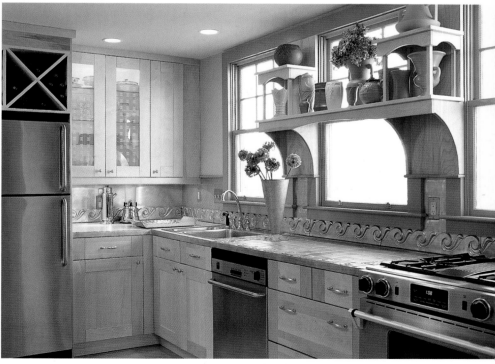

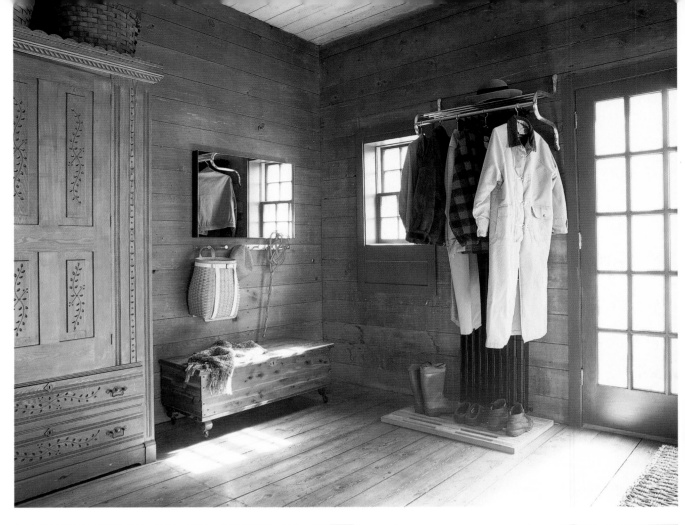

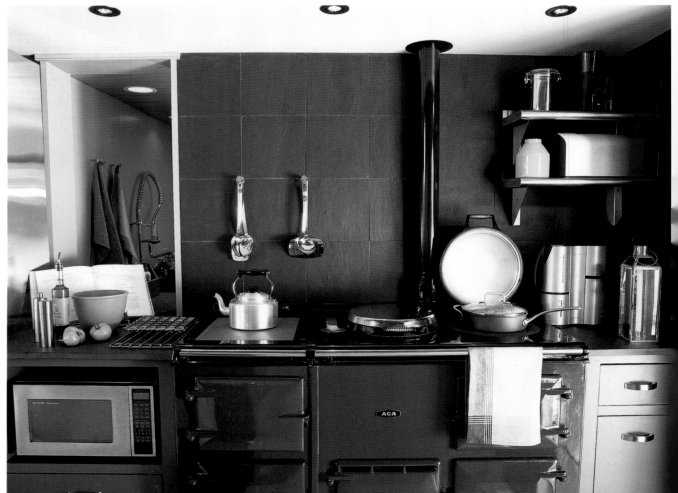

DISCOVER THE GEMS

Over the years, I've found that many of my best shots have been right under my nose. In other words, I discover them, as opposed to manufacturing them; they are found and not contrived. If these shots have lasting appeal, it's usually because they convey an air of truth.

The sensitive photographer will appreciate the subtleties, make a few improvements to clarify the message, and shoot. The essence evaporates, however, if you apply a heavy-handed approach and overwork the shot. Subjects as simple as a piece of fruit next to an armchair, or a gesture of the curtain over a sofa, can have a lot of feeling and power. Scouting will help you find the gems that are lurking about in a room. Without scouting, you might miss the subtleties and during the excitement and pressure of a shoot capture only the more obvious views.

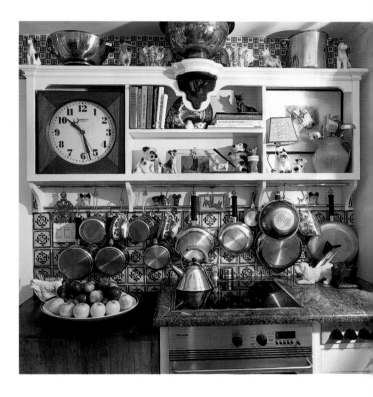

Photographs can capture the enjoyment of simple things, whether these are a functional entryway; a gorgeous, deep-gray English stove that conveys a quiet, solid elegance; a collection of unusual pottery; or organized kitchen clutter.

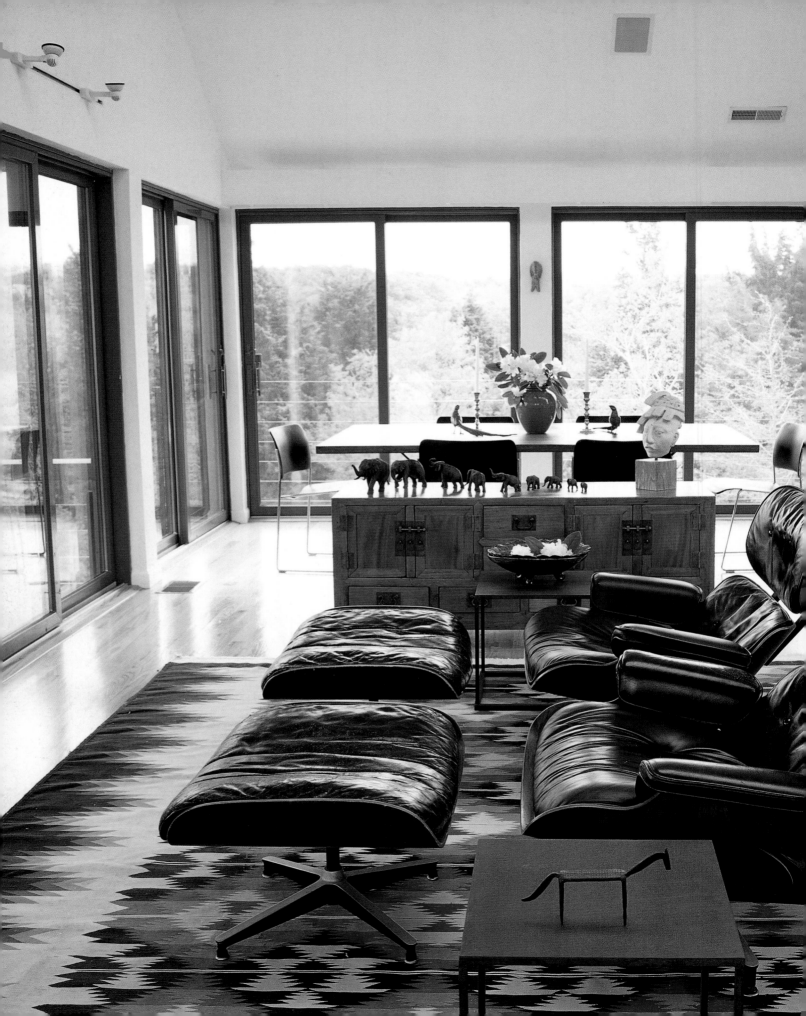

3 IT'S SHOOT TIME!

When I was in college during the 1970s, the hippie movement was big and we were much influenced by Eastern Zen philosophy. Our mantras were "Be here now" and "Become one with your surroundings." I'm glad I learned these concepts of cosmic awareness, because they apply very nicely to photography. As a photographer, you'll do your most powerful work when you become completely immersed in your environment, and when you do, you'll create photographs that have more feeling and personality.

START WITH THE FEELING

The very essence of photography is "seeing." I don't just mean looking carefully. I mean seeing all of something, what it means, and how it feels. As you work with what's in front of your camera, try to see different compositions and light and how various visual ideas make you "feel." Some images may be depressing, subdued, or dour. When an item with color is added and the light streams in, the scene is suddenly uplifting and spirited. Concentrating on this visual/emotional energy helps you see more deeply and create stronger photographs.

An important part of your job is to gather, sort, judge, and edit what is all around you. Try to relax and enjoy the visual puzzle you are solving. Nothing is ever perfect, so let spontaneity enter the picture. Too much control on your part will sap the life out of your photographs. With an overly controlling attitude, you'll be risking the worst thing that could happen, the thing I dread most: stiff, boring results.

It's important, too, to be attuned to the mood of a shoot. The atmosphere of every shoot will vary, and each can take on a different complexion. On a small editorial shoot, the photographer may be alone, mining the location, accompanied only by his or her own thoughts. On a big advertising, catalog, or magazine shoot, there may be a "cast of thousands." Present may be an editor, writer, art director, client(s), stylist, home owner(s), photo assistant(s), furniture mover(s), flower delivery person, curious neighborhood children. The point is to get in swing with the feeling of each shoot you do.

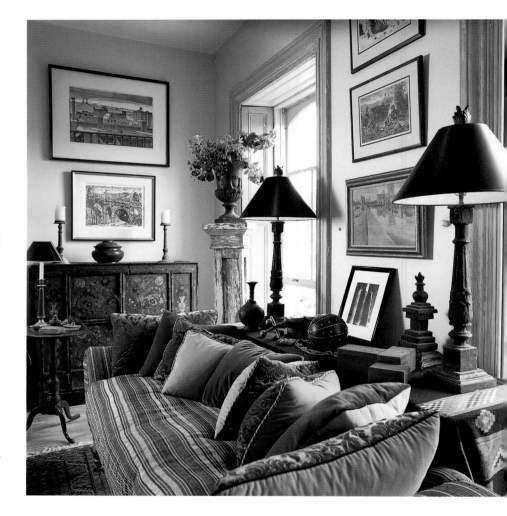

I enjoy doing a mixture of different-size shoots throughout the year. Working alone is a good time to hear your inner voice and develop your own ideas. But alone, you may have limited resources and financial rewards. In a shoot for an advertising agency or large magazine, you are likely to be part of a team and to fill a more specialized role. Often a client or art director rules, and expects you to obey; well . . . they are the ones signing your checks. If all you ever do is execute a client's requests, however, you'll be starving your personal thought process. You must adapt to every situation enthusiastically, and if you don't feel you can, don't take the job.

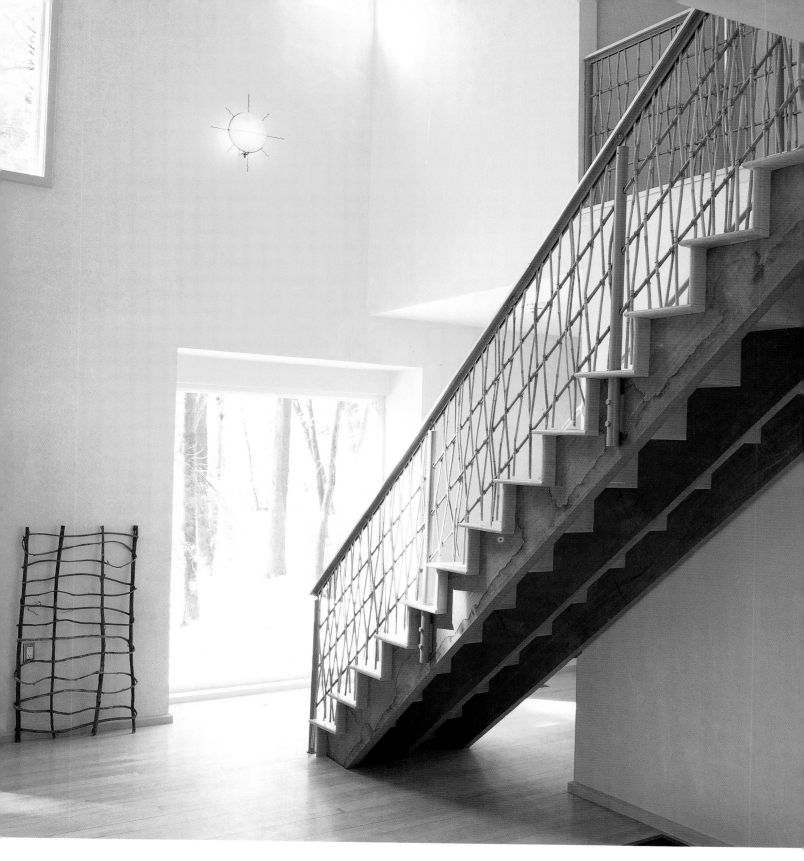

(Pages 36—37) An architect symmetrically displays classic Eames chairs in his home. This sense of symmetry sets the mood of the house, and I use a camera angle that best captures the effect.

◄ I use a camera angle to emphasize depth, inviting the viewer to sink into these colorful pillows that offer a counterpoint to the gray walls and engravings above.

▲ The strongest statements are often the simple ones: Here, a very graphic stairway leads to a poetically glowing window.

GET IN THE RIGHT MINDSET

Before you begin shooting, try to assume the best mindset. In show business they say, "You're only as good as your last performance." Well, in photography, you're only as good as your last shot. This is, of course, an exaggeration, but I am making an important point: A bad shot will come back to bite you. Leave your personal life and troubles behind and give each shot all you've got. In the end, this mentality will probably make you a more successful and happier person anyway.

If you know your clients are difficult, which most are, plan to kill them with kindness. The location may not be great, but just think of it as a puzzle you have to solve, and try to have fun with it.

Project confidence and happiness. People will think you're doing a better job if you're happy. They'll trust you and reward you with more freedom, and then you'll have a chance to actually do a

better job. Negativity is the enemy of creativity. If you allow negative thoughts to enter and control your mind, they will take hold and muffle your vision and voice.

As you shoot, envision the feeling and style of your final photographs and how they will look as a group. The spirit of your photography should echo the style and life of the environment. Enjoy being in the house and admiring it. Let the house speak to you and put you in its own special mood. Your approach to photographing a small intimate cottage might be relaxed and whimsical. A different attitude will be appropriate in conveying the personality of a large formal mansion, where you might want to project a stately, studied, and dramatic approach. Then again, abstract, graphic visual thinking will mesh well with a sleek modern environment.

A theatrical living room demands a dramatic shot to capture the spirit of the environs.

BE A GOOD GATEKEEPER

Whatever the nature of the shoot, as photographer and controller of the camera, you are, among other things, the gatekeeper, and this is a power that you should use for the good of all. A photo shoot can and should be a fun, expressive, and artistic experience; it's part of the photographer's job to keep it that way. I recommend diplomacy and humor as a guide in dealing with various artistic opinions. Say "The sun is fading; let's work quickly to get the beautiful light," rather than "Hey you! dahhh! Hurry up!" If the homeowner seems offended that her grandmother's vase isn't in the dining room shot, just say something technical like, "It doesn't read against that light background." When you enlist people's help, not only do you save your own energy for visual creativity, but everyone feels included in a rewarding endeavor. You are in charge of bringing home the great shots, and regardless of who contributes, you get the photo credit. We all have egos, and your fellow workers will be more helpful in achieving the best results if you convey confidence, politeness, and, in controlled amounts, inclusiveness. Of course, when a participant is overbearing, you must stand your ground and make your own final decisions.

When a photographer appears to be open to suggestions, he or she is fostering an active flow of ideas and projecting confidence. And hey, you never know when the homeowner, who is so familiar with the house, might have an interesting point of view. Maybe even the flower delivery person is a latent artist with a great visual idea. You can't know everything!

If you disagree with the client or editor about a certain prop, angle, composition, or whatever, you can pull out the "shoot it both ways" trump card. This is often the perfect photographer compromise that only costs a roll of film and can buy you a much better client relationship and possible future employment. When the light is changing, the dog is in a perfect spot, and the flowers just can't be touched one more time, but the client is still fussing with everything and you're afraid of losing the shot, why not say, "I'm just going to put this shot onto a roll of film in case we lose the light, then we can keep working on it." Nobody can argue with this perfect photographer's compromise.

As you mastermind the shoot, sometimes you just have to stop and photograph the flowers!

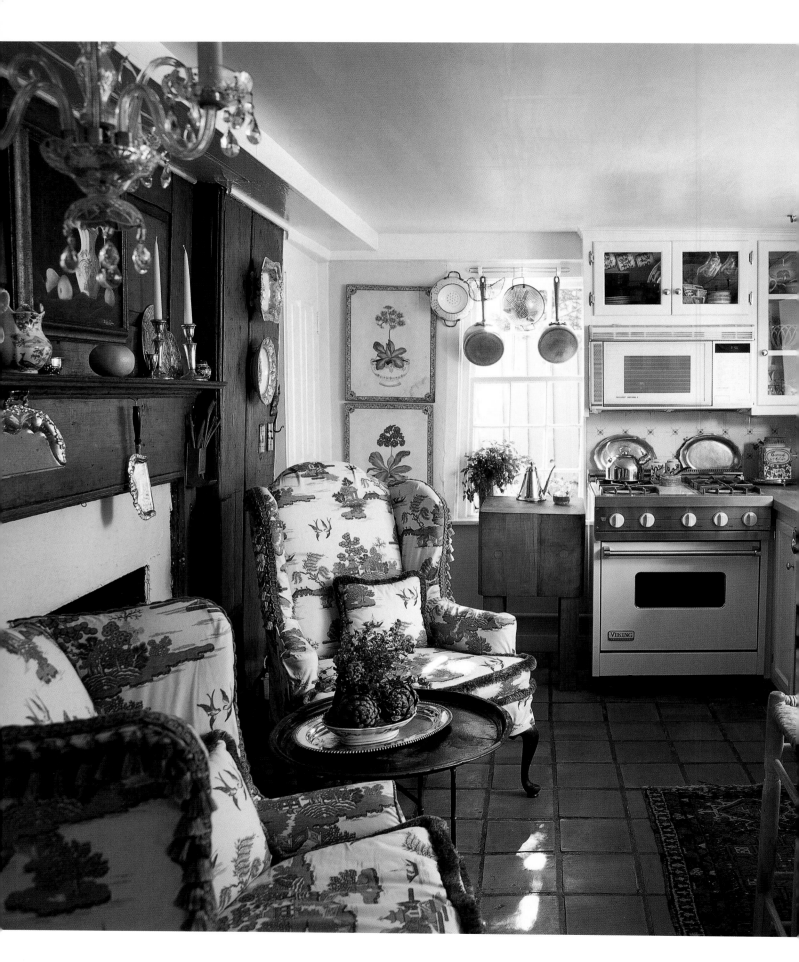

CHOOSE YOUR SHOTS AND ANGLES

You may notice that I have yet to mention the task of setting up equipment. That's because your ideas are more important than your equipment; nice equipment sure can help, but without ideas, equipment is meaningless. Before a tripod is placed or a light stand unfolded, you should have a visual and emotional feeling about your location. As I've been discussing, take a few minutes to become aware of an interior's personality and style, its strengths and weaknesses, and what is special about the place.

Now you are ready for the "photographer's dance" of finding, clarifying, and composing each shot. You must carefully edit what is included and what is left out of your camera's frame. Each shot should make a simple and strong visual statement. You want just enough, but not too much. You are trying to harness the right feeling that comes from where you are standing, how high you are, how much you see, and how you see it. Then, put yourself in the shoes of a magazine editor or art director. How would this place look in a ten-page layout? You will want to establish the story with some strong overall views, medium vignettes, and occasional details for texture, beauty, and intimacy. The group of pictures will become stronger if each shot has a supportive relationship with the others. Include a variety of horizontal and vertical images. Keep an eye out for a great cover shot or a double-page spread.

Wide-angle room shots benefit from a strong foreground, which enhances the feeling of depth. The foreground may or may not be in focus, the middle ground usually is, and the background is also usually sharp. You can create a feeling of expansiveness if you can successfully capture a pleasing view from one room to another. Low angles can create drama and intimacy, as long as your eye can travel past the foreground and see a beautiful destination beyond. The added depth enhances the feeling of "being there." Wide shots are great when they work, but be mindful that it's easy to end up with a busy mess. When this happens, just move or zoom in a little closer and simplify.

The wide-angle lens can really give a feeling of depth and "being there," allowing you to capture a strong foreground while letting the viewer's eye travel through the room.

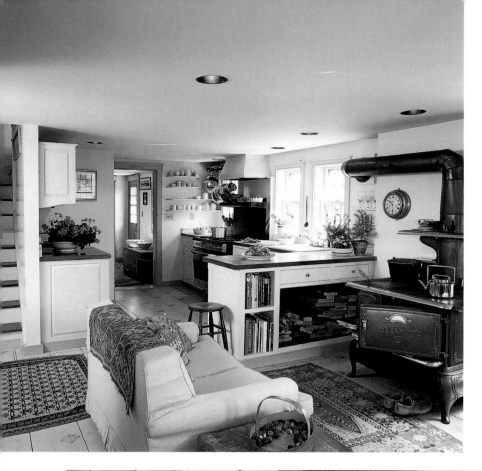

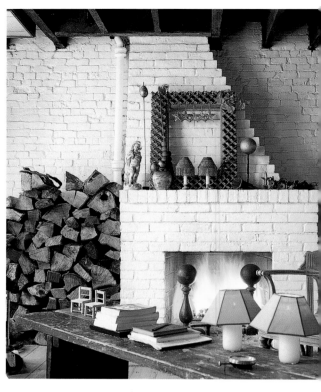

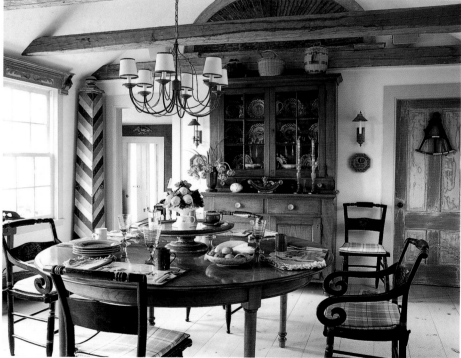

▲ The openness of this comfortable cottage allows a wide and deep view that tells a lot about it.

▲ By carefully choosing my angle, I was able to capture the essence of this lovely eclectic room, full of personality and bathed in clean soft light.

▲ Fire adds warmth and glow to this basement apartment, and the direction of light clarifies the fireplace and the interesting shape of the chimney.

Courtesy Counts!

Ask if your car is in the way, take your shoes off if that seems appropriate, be complimentary of the homeowner's taste. Don't ever be critical, don't leave tripping hazards lying around, don't drag furniture across the floor, don't put a camera down on an antique table. Ask about using the bathroom, opening the refrigerator, getting a drink of water, letting the cat out. You get the idea. A little common courtesy will inject professionalism into your presentation and affect the quality of your work, too.

KNOW WHEN TO SAY "ENOUGH"

One of the most important gifts with which any artist can be blessed is knowing when to stop. When do you say that an interior photograph is "done"? My theory is that you are just hit with a good feeling and you say something like, "Wow!" or "Ooh," and then it's done. You're ready for the next shot.

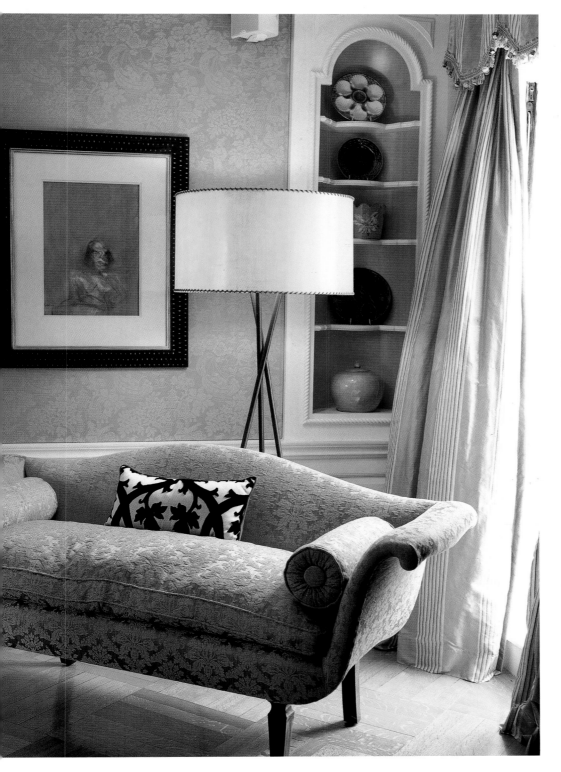

Sometimes, you've spent more than an hour on a shot, and it isn't the gorgeous shot you envisioned. In fact, the Polaroids look bad, and you can feel the frustration level simmering. At this point, you risk the loss of your objectivity, and your eyes and brain just need to look at something else. Instead of overworking it, why not have lunch, a cup of coffee, or go on to another shot? You'll probably think up a solution to the dilemma if you let it go for a short while, and you can go back to the shot with new energy.

Shape, color, pattern, and light are major ingredients for photographic entertainment and beauty. Once I saw these elements come together in this frame, I knew it was time to stop.

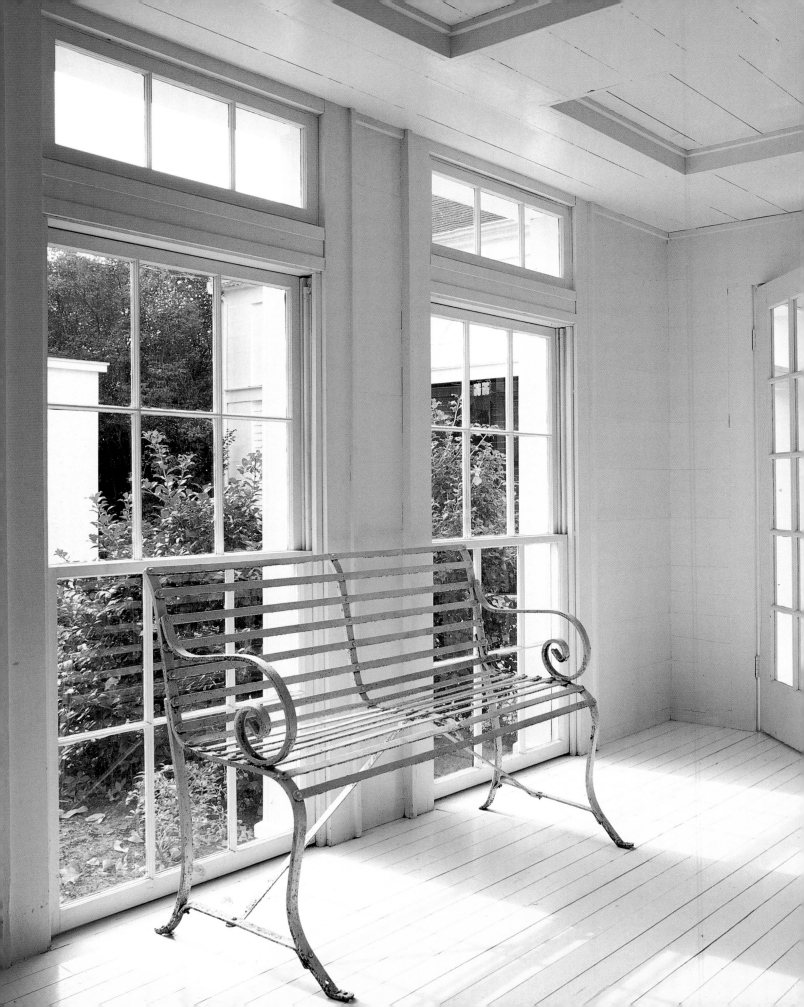

4 LIGHTING, THE MAGIC INGREDIENT

Interior photographs combine natural window light, artificial room lights, and photographer-added or modified natural and artificial light. What's fun, if you like surprises, is that you will encounter different, often complex, lighting conditions with each space you photograph. I would like you to think of each interior lighting situation as a wonderful and sometimes difficult puzzle to solve. You will consider the quality, direction, intensity, and color of the light as it interacts with the space and its contents. I hope you will enjoy working with the interplay of highlights, shadows, reflections, color, and contrast. With a little experience, you will become more sensitive to the quality and feeling of the light. In your quest for a beautiful photograph, you will factor the weather conditions, time of day, and even the season into your lighting decisions

THE PRECEPTS OF GOOD LIGHTING

As with any artistic endeavor, there are many styles of lighting. The only rule is: Don't look for rules to follow because there are none! In fact, someone who thinks there are steadfast rules is probably too limited in his or her approach and will do boring work. A dynamic practitioner will vary his or her techniques and continually evolve different ways of achieving optimal results. I have some basic precepts I usually try to follow, but my actual execution changes daily.

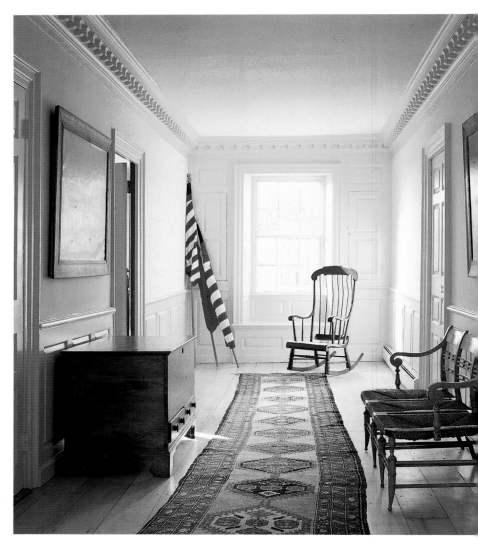

- **Start with the feeling, let everything else follow.** Through beautiful lighting, photography can actually convey how a room feels, often more profoundly than if the viewer were really there. This is because a photograph can accentuate the mood of a room, and the mood is chiefly dependent on lighting. When the mood of the lighting works in harmony with the feeling of the room, it's right!

- **Make it natural or at least make it look natural.** Good lighting doesn't call attention to itself; it just contributes to a beautiful photograph. Though a shot may be lit artificially, try to make it look natural, as if the light is coming from the room's windows, lamps, and other lighting the residents would normally use. Work with and enhance the room's natural light and avoid opposing and working against the natural light with artificial sources. If you counteract the beauty of the natural light the results will be flat and boring. By the way, you may notice I never use the popular photographer's term "available light." Saying the light is merely available makes our job sound too easy; "natural light" is a much more artistic term.

- **Don't be afraid of highlights and shadows, when they are appropriate.** Without some rich dark areas, the light areas will have less impact. Use the drama of deep tones as they contrast with glowing, streaming brightness.

- **Backlight is beautiful.** Whether it is from the windows or your photographic lights positioned just out of frame, backlight is the key to depth, shape, texture, and a feeling of reality. Conversely, front light is usually flat and ugly and wipes out all the desirable qualities that back light brings out.

Pages 46–47) Simple, clean, natural
unlight—and nothing else.

◀ This gracious hallway is lit only by
one window that stands, surrounded
by stately beauty, beckoning the
viewer. The flags, leaning casually,
add authenticity and impact.

▲ Creamy tones take on a soft, natural
glow from a splash of sunlight
spilling through shuttered windows.

LET THE SUN SHINE IN

Sunny weather usually provides the best light with which to work. Most houses will pick up a satisfying glow when the sun shines. If possible, plan the shoot accordingly. You are likely to follow the sun from room to room as it travels around the house. You can then augment, modify, and enhance it in various ways. If your schedule does not permit weather postponements, don't worry! When weather conditions cannot be accommodated, there are many exciting lighting options you can use to adjust to any type of weather short of a hurricane.

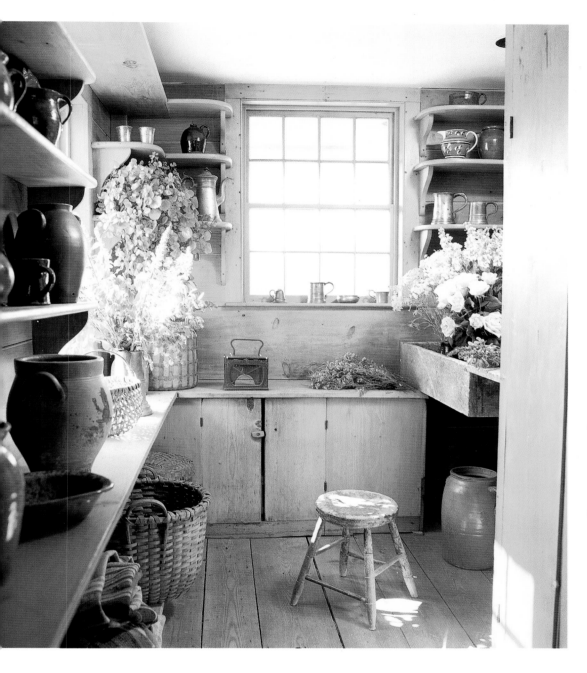

◀ The low-angle winter sun creates beautiful light when it streams far into a room. The warmth of a fire adds to the sensation of comfort.

◀ A rustic pantry is awash in buttery sunshine. Lighting doesn't get much better than this.

Many clients prefer to book shoots in the summer, because they assume the light will be best and will last the longest. Besides, since the world is in bloom, many people consider summer to be the prettiest time of year. It's true the days are longer, and there is more greenery outside. But, oh! What you are missing if you don't consider the beauty of other seasons! Late fall, winter, and early spring offer us the beauty of long streams of sunlight reaching through the windows, far across our rooms. And the trees have fewer leaves to block those golden rays. Northern winters may also provide a special outdoor reflective white coating on the ground, bouncing soft, clean light up through every window; a phenomenon I call "snowglow." After years of scheduling shoots, I encourage clients to book shoots any time of the year, not just in the summer.

THE POLAROID TEST

One of the most interesting aspects of photography is the visual translation that happens from real-world image to photographic image. We've all experienced the excitement of seeing newly developed images for the first time. After more than thirty years and thousands of pictures, I still find this transformation to be a boundless source of surprise and fascination.

When a photograph is made for enjoyment or fine art purposes, it's great to relax and let the process take its course. Free shooting gives unexpected, spontaneous qualities, which often heighten the photograph's artistic appeal. In the commercial environment, however, unexpected results are usually not welcome. Your client, art director, editor, stylist, assistant, curious bystander, and of course, you, want to know exactly what the final picture is going to look like.

This is when Polaroid film is worth its weight in gold. Most professional cameras can be adapted to shoot Polaroids. Because you shoot these Polaroids through the same camera and lens, they will closely replicate your upcoming results on film. Your Polaroid test exposures of each shot will help you fine-tune your lighting, composition, and styling.

- You can best judge the quality of the lighting with a Polaroid because it closely simulates the contrast range of film, which has a much smaller range than that of the human eye.

- The Polaroid can tell you what is good about the light and what needs improvement. It will help you tailor the mood of the light to help convey the style and feeling of the space you are shooting.

- The Polaroid shows the effects of electronic flash as it complements other light sources, an impossible feat for the human eye.

- With Polaroids, your clients and helpers can see the photograph and participate in the shooting process. Hopefully, you'll gain their confidence and valuable assistance by proofing with Polaroids.

I have found that my clients are invariably pleased with the final film from a shoot in which they approved the Polaroids. The film is everything the Polaroids were, but better. As with any technical advance, however, something precious can be lost.

Reliance on the instant print is no replacement for good visual and photographic skills. There are times when you might overuse the Polaroid and overwork a shot. If you look at the Polaroid too long, and shoot too many Polaroids, you'll lose you're objectivity. You may forget what attracted you to the shot to begin with and the life will evaporate from it. Like any tool, a Polaroid is only as good as the person using it.

Safety First

Before discussing the artistic effects of lighting, we must face the physical realities. You are entrusted with the privilege of entering someone's property with large equipment. There are many ways you could cause damage and even injury, so you can't be clumsy, messy, or unsafe. Your eye for safety is a mandatory requirement, and careful consideration follows.

I avoid equipment that creates excessive heat or electrical draw. I prefer light, compact gear that doesn't create an obstacle course, won't fall over onto priceless objects, and is unlikely to explode, leak, or otherwise misbehave. Don't leave dangling cords, tripods with extended legs, or other tripping hazards in walkthrough areas. Always sandbag the base of tipsy, top-heavy light stands or lights you have placed outside. Some locations are especially delicate; you don't want to rest a camera on that silk couch or leave a gooey, caustic Polaroid on the antique table. Your impact will be noticeable enough while you are shooting; don't let it be felt after you are gone.

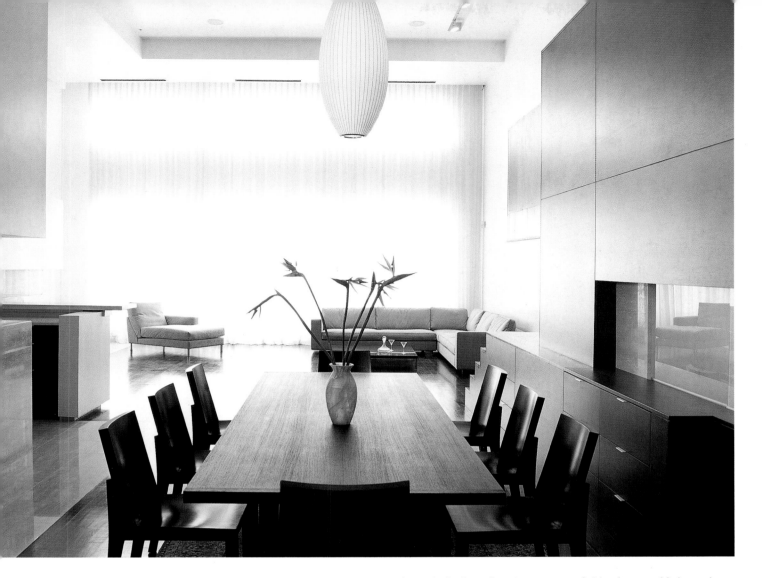

Proofs made it clear that the success of this shot would depend on capturing the geometric lines of the space.

Digital Monitor Viewing and Proofing

As of this writing, in my experience, film is still the preferred medium for many clients of interior photographers. We are unquestionably witnessing, however, a daily rise in the acceptance of digital photography, and we can now welcome a new method for instant proofing. Some high-end digital cameras include imaging software and can be controlled by a laptop computer. This fabulous tool can provide you with a quality instant image, and eliminate the need for Polaroids. A digital camera can be nothing short of a "magic picture viewer" for previewing shots as you work. The advantages are many: You save the processing time and the cost and pollution associated with Polaroid materials; you have a sharper, bigger image to look at; and you can keep the high-quality digital files. Then, if you still want film, you can just switch to a film camera. If the client wants a proof print, as are available when you use Polaroids, you can connect a small proof printer to your laptop.

But don't throw away your Polaroid yet! You may not want to drag your computer around on every shoot, especially outdoors. I recently tried to use my laptop while shooting in a garden. To see the screen, I needed to drape the dark-cloth from my old view camera over the computer monitor. Now, that's using the old and the new! Keep in mind, too, that with Polaroids you can use the same camera and lens you will use for the actual shot, so you might get a truer representation of what you will get with final film.

"BLOWN-OUT" WINDOWS

I love the uplifting feeling of bright light pouring through windows into a room, washing over the furniture and spreading across the floor. The sun's glow can make ordinary objects come alive. But in your zeal to capture the lovely effects of natural light, you may discover that the low tolerance of film or digital recording for indoor-to-outdoor contrast ratios causes windows to appear overly bright, or "blown-out." I've found that many clients don't want to show blown-out windows, in spite of my many attempts to wax poetic in praise of their beauty. (One effective argument is for the merits of using a photograph with blown-out windows on a magazine or book cover, because the light window areas provide a great background for all those sell lines and other copy.)

It is fine to allow a window to be bright, but not so bright as to lose all detail and tonality. The solution is to brighten the inside by adding artificial light; in this way you lessen natural daylight just enough to darken the windows so they show some detail and tonality. Keep in mind, though, that the more artificial light you add to counteract window blow out, the uglier and less natural looking your lighting will be. Window reflections of your lights also become more of a problem as you try to raise the interior light level. A polarizing filter can help darken the sky somewhat, but the most effective solution is to use Photoshop to cut and paste a darker window view exposure into a shot with a good interior exposure. This allows full use of the natural light to grace the interior, and is especially useful when you want to show an ocean or city view that is very difficult to capture, no matter how you light the room.

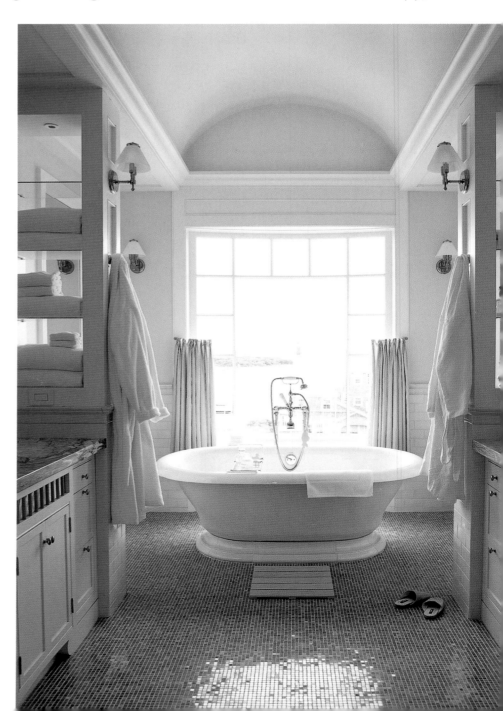

Clean, natural light is the perfect backdrop for a luxurious bath. In this case, the blown-out window works to my advantage, because a view of the neighborhood beyond would be distracting and ruin the mood.

COLOR SHIFTS AND CORRECTIONS

In our quest for beautiful lighting, we soon realize that natural light comes in many colors. Likewise, there are many possible causes for the existing light to have an unwanted color cast. If you are shooting digital, you will have a great chance after the shoot to make easy color fixes in Photoshop. Transparency film, however, is completely unforgiving, and requires precise color control as you shoot. When the light is not neutral, as is sunlight for daylight film or studio lights for tungsten film, the color rendering will be off. Our task is to correct any unwanted color cast, and there are many tools and methods for achieving neutral light and good color.

- **Discover the color cast.** You may see it with the naked eye, in a Polaroid, or on the screen in which you view a digital image. Or, you may simply suspect that a color cast will be present because of the different lighting sources you are using.

- **Identify the source of the color cast.** The source may be inside the room (light bouncing off a colored carpet) or outside (sunlight reflecting off a lawn).

- **Specify and quantify the color cast.** You can do so with guesswork, or after making color-meter readings for accuracy.

- **Employ color correction procedures.** These include using a filter or filters on your lens, adding artificial light that is color-correct, reducing unwanted, colored light, correcting color bounces with white reflectors, or using various combinations of these tactics.

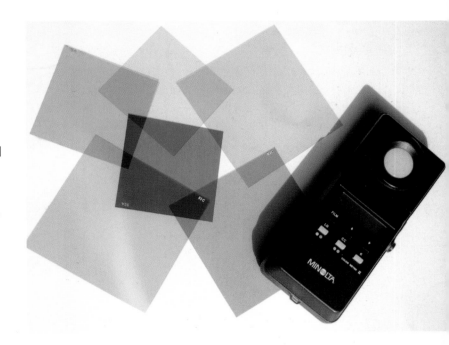

Warming gels, cooling gels, and a good light meter are essential tools for correcting unwanted color casts.

Color Correction Filters

I carry a complete kit of gelatin filters to correct color casts. Most situations call for either warming gels in the amber range or cooling gels in the blue range. Unfortunately, whoever created the system for categorizing these filters was devious, drunk, or not very clever, and has left a legacy of confusion. To me, the following list of light-balancing filters highlights the irrational nature of this system: It just doesn't make sense. Like many things in life, however, we're stuck with it, so study the system. It's not so intimidating once you have it all memorized.

- Amber filters for correcting too much blue light (in order from pale to strong): 81, 81A, 81B, 81C, 81D, 81EF, 85, 85C, 85B (the 85B is so strongly orange that it converts daylight to tungsten incandescent light).

- Blue filters for correcting too much amber light (also from pale to strong): 82, 82A, 82B, 82C, 80C, 80, 80A (the 80A is so strongly blue it does the opposite of the 85B and converts tungsten incandescent light to daylight).

BALANCING SCIENCE AND ART

As is the case with any and all aspects of photography, lighting is not an exact science. Rather, lighting is a synthesis of creative and technical elements. There is certainly no one solution to any lighting problem. The task at hand is solving whatever problems you face. This is your personal approach, and you will continually improve upon the way you handle lighting over time and with experience. Lighting will become a very important part of your artistic stamp.

The simplest rooms to light are, not surprisingly, those that have great light to begin with. This usually means many windows that admit sunlight. Don't give up if the sun isn't shining; cloudy conditions will often produce lovely soft light, which renders clean, neutral color and pleasing contrast. If you suspect the existing sunny or cloudy light to be perfect as it is, and your Polaroids confirm that feeling, go ahead and shoot a 100-percent natural-light photograph. The use of natural light, however, should not be seen as a badge of honor; it is only the means to an end, the end being a beautiful photograph. Usually, a reflector here or there will lighten a dark dead spot and improve the overall feel of the shot, and you'll still have a 90-percent natural-light photograph.

Subtracting Light

There are many techniques, both simple and complicated, for adding natural-looking light to produce gorgeous images. Often, however, you can also achieve great results by subtracting natural light. Sometimes, it's really as simple as pulling a window shade down. Suppose, for instance, that a bright window right behind the camera is projecting flat front light onto your foreground. You can close the shade, maybe all the way or just halfway, to make a dramatic improvement. If there is no window shade, try blocking or reducing unwanted light from the window with a few cards or possibly a translucent panel. To achieve the desirable amount of natural light, sometimes the easiest method is the best method.

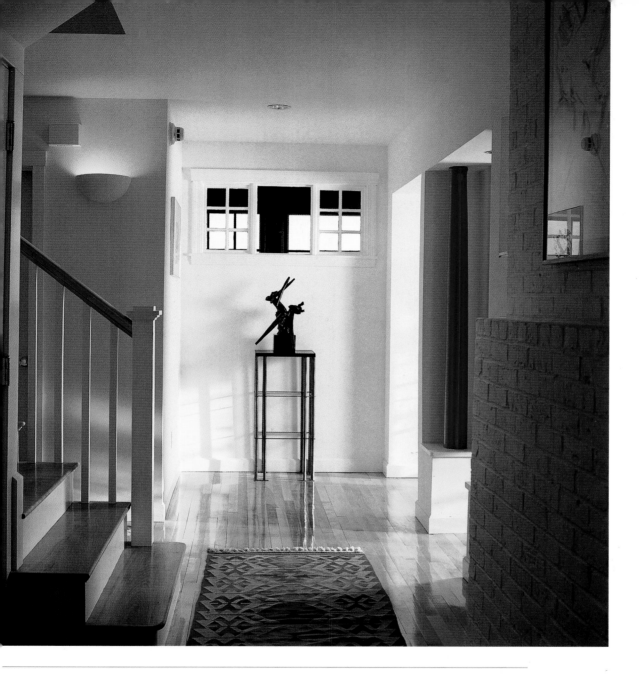

SOME COMMON LIGHTING SCHEMES

As you've probably already discovered, most rooms have good natural light in some areas and not in others. In these cases, the Polaroids will show you that there is too much contrast. The windows and nearby areas are too light, and the foreground or areas farthest from the windows are too dark. The most common solution here is to add interior light, especially in the darker areas. This must be done artistically and subtly, in ways that complement the natural light and never work against it. Your goal is to achieve a look that seems natural. On the following pages are some schemes to help you overcome common lighting problems to get the results you want.

Sometimes the best way to set up a lighting scheme is simply to take advantage of a good situation. A spot of sun brought this scene alive, and sunlight was the only light I needed—a good thing, too, because I wouldn't have had time to set up lights, reflectors, and other equipment and snap Polaroids before the sun moved on.

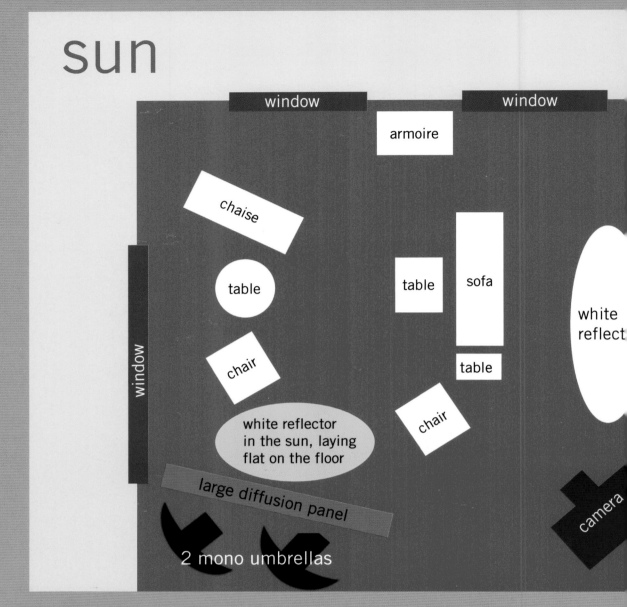

Overpowering Red Bounce

It's a sunny autumn day and you are shooting a chic apartment with white walls, white furniture, and a red carpet. The sun is streaming through the windows and across the red carpet, bouncing hideous red light all over the white walls and furniture.

Well, unless you want the "pink look," you must take some action. One option is to shoot another room first and come back when the sun moves off the rug. If you really love the sunny look, however, you must add clean white light to overpower the red bounce.

The first step is to minimize the red bounce; if there is sun on any out-of-frame areas of the rug, cover those areas with white reflectors. Then, for a beautifully soft, natural effect, place two side-by-side backlighting umbrellas on the sunny side of the room to enhance the natural light. Use white reflectors to gently fill in the light on the opposite side of the room and a silver reflector to lighten a dark chair in the foreground.

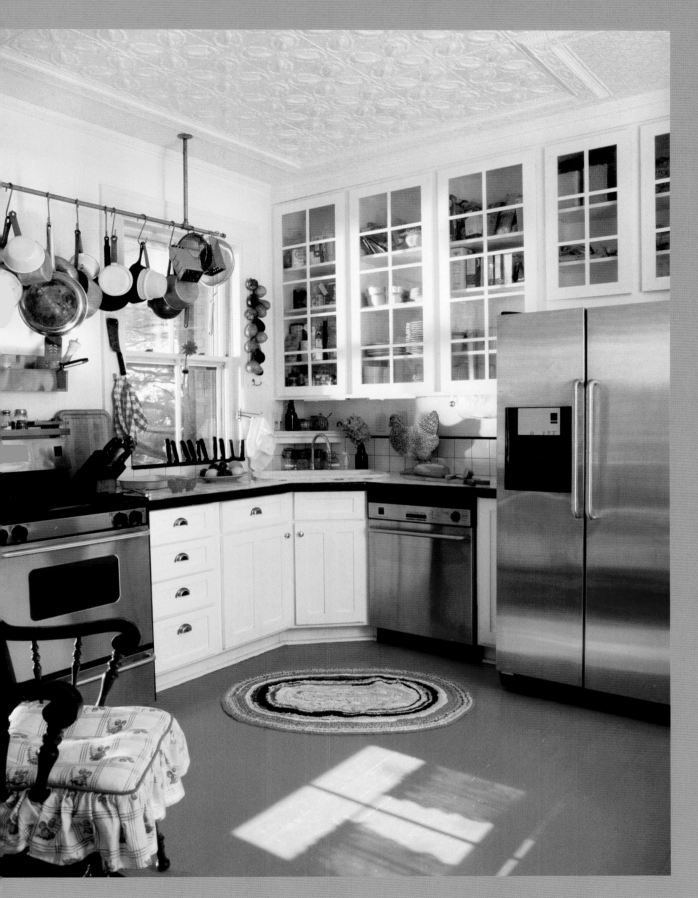

By enhancing natural light in this kitchen, I was able to reduce red bounce off the shiny kitchen surfaces. I kept some faint reflections, though, to add interest to the shot.

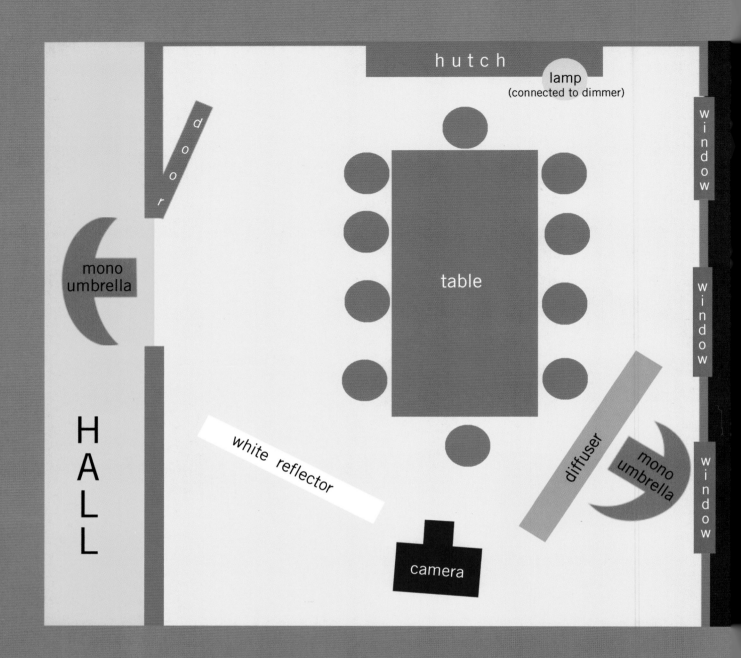

hutch

lamp
(connected to dimmer)

window

window

window

door

mono
umbrella

table

H
A
L
L

white reflector

diffuser

mono
umbrella

camera

Making the Most of Natural Light

A lightly cloudy spring day greets you at the quaint farmhouse. You admire the soft window light, which, though pretty, is not enough to light the whole dining room. There are only three small windows on one side. You resist the inclination to "balance" the light by adding light directly from the opposite side of the windows. This approach would flatten the natural light and result in a boring shot. Instead, you place a strobe umbrella light coming in from the same side as the windows. This light works with the window light to fill in shadows in a natural way. On the dark side of the room is a doorway to the kitchen. You place another strobe umbrella coming in from the kitchen to fill shadows on the dark side of the room—the effect is convincingly natural, since the light is coming in through a doorway. Then all you need is a few white reflectors to help the foreground.

Strobe Power

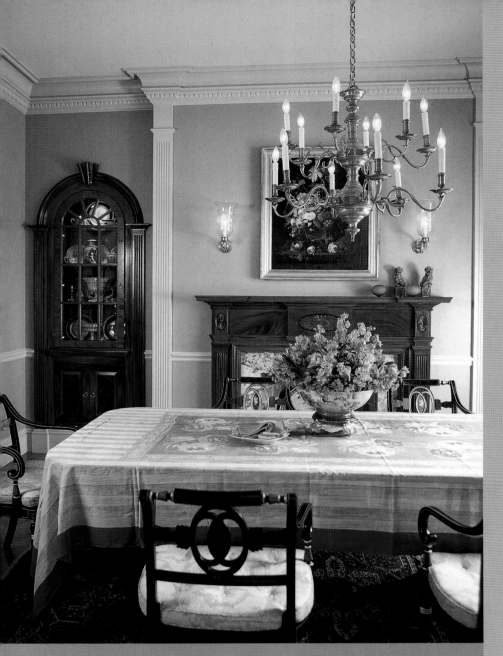

The challenge here was to get the full effect of sunlight reflecting off the pastel walls and bring out the pleasingly soft hues.

I recommend the use of strobe, or electronic flash, for lighting interior photographs. Strobe lighting offers a convincing array of advantages: strobe lights are light and compact, they run cool, they use far less electricity than hot lights, they are relatively inexpensive, they are powerful, and their power is easily adjustable.

There are two more features about strobes that I find invaluable for interior work: They are color balanced for daylight, so they are easily blended with natural sunny or cloudy window light, and they emit a burst of light that is instantaneous, allowing the photographer to easily vary the artificial-to-natural-light ratio. In fact, you can do it by simply turning the shutter speed and aperture dials on the camera. When you adjust the aperture, you will vary both the amount of natural light and strobe light exposing the film, but when you adjust the shutter speed, you vary only the amount of natural light exposing the film.

You can let the beauty of natural window light shine through by letting the shutter stay open for an extended time; possibly ¼, ½, 1 second, or even more. By bracketing shutter speed and aperture, the different combinations of natural and artificial light will provide a wide choice of different contrast ratios, thereby creating different moods. You will see these effects on the Polaroids and can bracket your exposures on film accordingly.

One last detail . . . there is a table lamp on the sideboard in the background. When the lamp is off, it looks dead; but when turned on, the Polaroids show it to be too bright or "hot." An easy solution is to attach a plug-in dimmer unit you can purchase at hardware stores and adjust the light so the lamp casts a pretty warm glow.

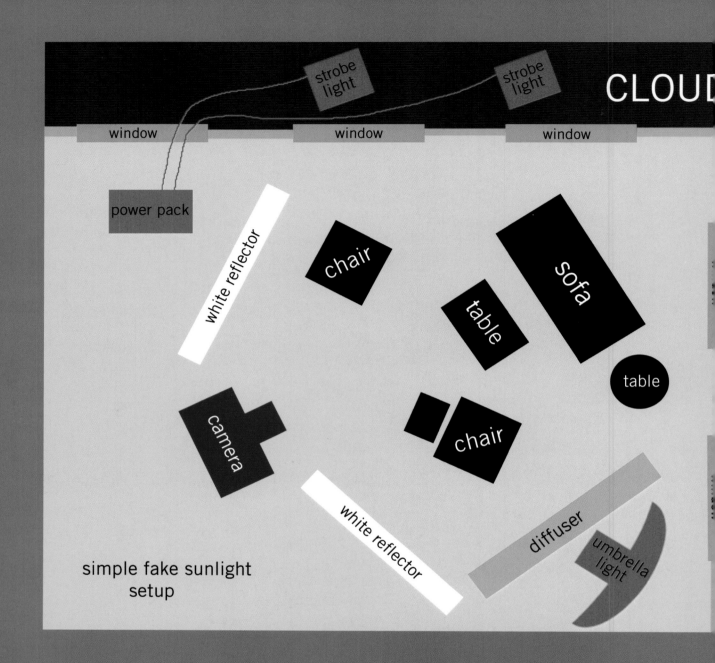

simple fake sunlight setup

Bringing Sunshine into a Gray Day

You are assigned the task of creating beautiful, sunny looking pictures of a cozy cottage. The location is beautiful, but the weather, yuck! Dark gray skies and drizzle have moved in on the only day you could schedule. Here's a case for using fake natural light. Be prepared to invest more time, as much as 100 percent more time, in each shot than you would with sunny weather, but you and your client will be amazed at the beautiful results.

You can cover two strobe heads with big, clear plastic bags and place them outside two windows at identical angles. The plastic bags will keep the heads dry, and you can run the cords through a door or window and plug them into one or two power packs (which should always remain dry). Don't use monolights, which essentially have a built-in power pack, outside in the rain, and don't turn on the modeling lights, which are hot and will

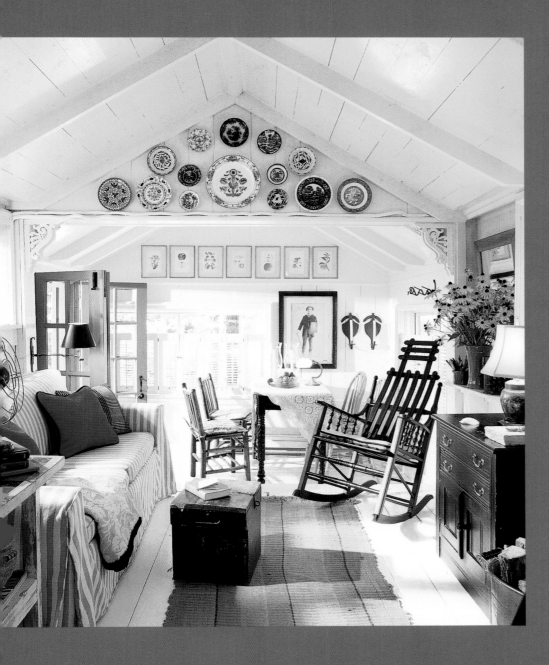

Sunrise? No, I shot this cottage on a rainy day, and placed two tungsten lights outside the windows. The warm glow doesn't look quite natural, but I don't really care—I think the effect is lively and beautiful.

melt the plastic bags. The strobe tubes, by themselves, don't get hot and will not melt the bags. You must place sandbags on the bases of your sturdiest light stands to prevent the wind from blowing the lights over.

I recommend the use of a radio synchronization system instead of sync chords under any weather conditions. Sync cords are cumbersome, create a tripping hazard, and are too short for distant light placement. You can live without a radio synchronization system, but you'll be glad to have it.

Your two powerful outdoor lights are now blasting through the windows. This will look exciting, but a bit harsh and shadowy. To soften and blend the fake sunlight, add a strobe and umbrella (which I nickname a "strobrella") with a large diffuser in front of them. Then, add some large white reflectors in the foreground, and that should do it—you'll have a room that looks like it's flooded with natural sunlight!

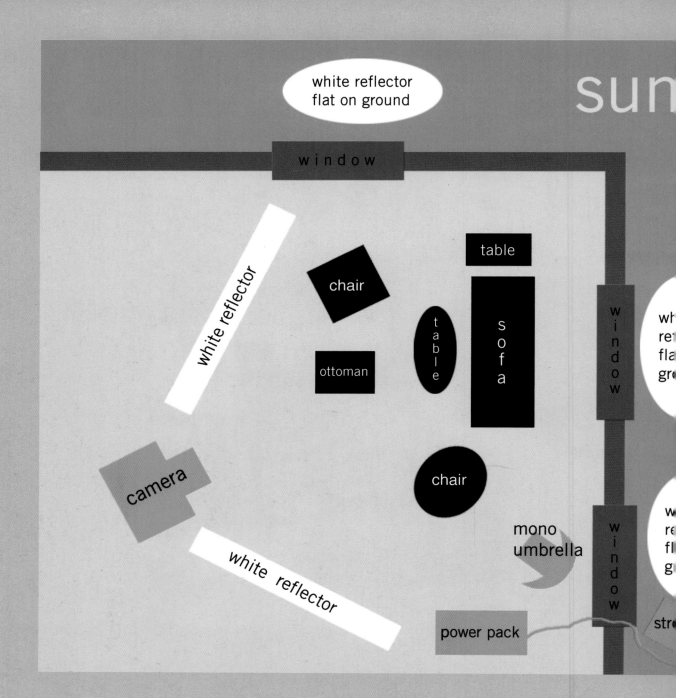

white reflector
flat on ground

window

white reflector

chair

table

t
a
b
l
e

s
o
f
a

w
i
n
d
o
w

wh
ret
fla
gr

ottoman

chair

camera

white reflector

mono
umbrella

w
re
fl
g

w
i
n
d
o
w

power pack

str

Coping with Monster Sunshine

I t is a sunny summer day, and you are shooting a living room in a country house. Beware, though, because underneath this happy exterior lurks a monster lighting problem. Sun is bouncing off the fresh green lawn, sending green light up through the windows and onto the ceiling. On the shady side of the house, deep blue skylight is coming down through the windows onto the floor. Sun is blasting the red barn out back, sending in some red light along with all the color casts.

This situation will require multiple solutions. First, take out the window screens for a clean look. Second, lay a large white tarp or some white reflectors on the lawn to clean up the green bounce light. Next, place a strobe light outside and point it through a window to clean

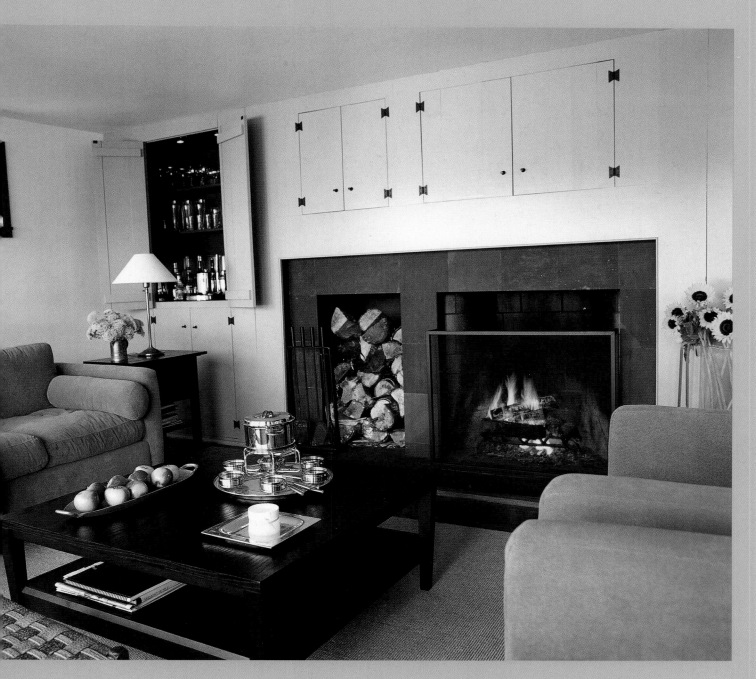

By preventing harsh sunlight from flooding this living room, I was able to create a soft, diffused light. The fire adds an extra touch of gentle warmth.

up most of the blue skylight and red bounce light. As always, secure any outdoor light stands with sandbags. If you don't have sandbags, you can clamp some other heavy object to the base of the light stand. A radio strobe synchronization system is more convenient and effective than a sync cord, and this is especially true when you are using a light source outside the house.

Now, you can come inside, and place an umbrella backlight and a few white reflectors to finish the job. The white light that you add is brighter and stronger than colored light. It will clean up color cast and help you win the battle for correct color.

▶ Sometimes the view creates the style and substance of a shot. The challenge here was getting sun at the right time of day. A polarizing filter and white reflector on the right were the only lighting tools I needed to use.

▶ Two strobe lights popped through a large diffusion panel way off to the right create enough interior light to balance the exterior brightness. A polarizing filter helps darken the sky and reduce reflections in the wall of windows.

Warming Up the Blue

You are shooting a cool loft space with northern exposure on a clear day. Cool indeed! Your Polaroids look quite blue and you aren't surprised. The color meter confirms the fact that deep blue skylight, though very glowy and beautiful, is going to need a major warm up. The meter calls for an 81EF filter, so you attach one to your lens, and, after taking the screens out of the windows for better clarity, you shoot another Polaroid. The result is gorgeous, and the shot requires only a few white reflectors near the camera to bounce light into the foreground.

Softening the Shadows

You are shooting an advertisement for a furniture retailer, and the location is the client's store. There is no daylight here, only the halogen track lights that dramatically highlight products. Luckily, you scouted here last week and came prepared with ten rolls of tungsten film, which is color-balanced for halogens. You also have a few hot lights with umbrellas, which you use to soften the harsh shadows created by the track lights. Some white reflectors also help fill in the shadows a bit.

Bringing Flat Light to Life

Your assignment takes you to a new office building to shoot a sleek contemporary furniture grouping. The recessed fluorescent ceiling lighting is a bit dull and flat, and as the Polaroids reveal, it is very green. The color meter indicates that for daylight film you should add a 30M (magenta) filter to neutralize the green. You would like to add a strobe and umbrella for more contrast, but the light from it will look magenta if you filter the lens. There are two possible solutions. You can put a 30G (green) filter on the strobe head and a 30M filter on the lens, which will enable you to combine the strobe and fluorescent lights. Or, you can turn off the fluorescents and completely light the shot with several strobe lights. Of course, no filtration will be necessary if you do this and use daylight film. You decide to go with the first solution and use the magenta and green filters and receive a natural effect from the fluorescent-strobe combination.

Settling for Perfection

You are shooting a new house on a sunny winter day. Bright light streams through the large windows and more light bounces off the snow and into the windows, so the place is absolutely glowing. Your Polaroids confirm it: This light is fantastic. A dark chair in the foreground needs lightening, so you place a white reflector near it. That does the job and you shoot. It doesn't get any better than this!

I set the mood for this furniture advertisement by placing bright tungsten lights on the right and making the most of the warm natural sunlight pouring through windows on the left.

LIGHTING EQUIPMENT

This is the stuff that strikes fear in the hearts of good assistants. Lighting gear can quickly get out of control if you're not careful and innovative about keeping it to a minimum. Too many tools can actually distract you from the most productive approach to your work. In other words, toys and gadgets can waste time.

My attitude toward all photo equipment, including lighting accessories, is pretty simple. The right tools are extremely helpful, timesaving, and stress-reducing. The old mantra "Keep It Simple" still stands as a beacon of truth. It takes time and experience to sort through what works best for you. Feel your way into the art of lighting by beginning with used equipment and gradually improving your kit as you become more comfortable with the technology and these new techniques.

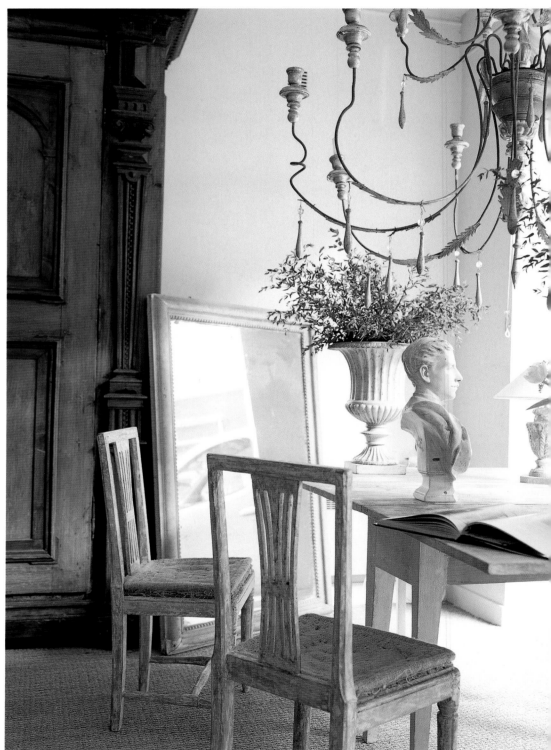

Huge storefront windows on the right admit the hazy sunlight that illuminates this Paris antique shop. A white reflector on the left finishes the look.

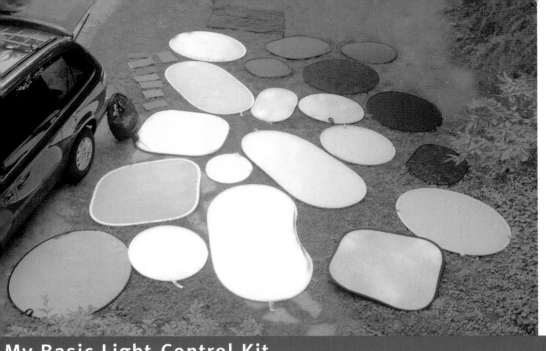

"Don't leave home without 'em" is my motto for the numerous reflectors that work wonders in allowing me to make the most of natural light.

My Basic Light-Control Kit

I use a wide variety of professionally marketed flexible light reflectors of many shapes and sizes. While you can achieve good results economically with white poster board and foil wrap, I prefer the folding portable reflectors for their conveniently small size when folded. I keep them, along with other non-powered light-control tools, such as scrims, silks, diffusers, and black cards, in a large disc-shaped bag that is made for drummers' cymbals and sold at music stores. This kit is a very effective "natural light control system," and I use anywhere from one to ten things in it for almost every shot I take.

REFLECTORS

White. A simple white reflector adds gentle, natural-looking light to a photograph. It is especially effective when reflecting sunlight or another intense light source.
Silver. A silver reflector provides light that is more directed and concentrated than that created with a white reflector. It must be held at a precise angle to reflect effectively.
Gold. Gold can be employed instead of silver to achieve a warming effect, which is useful in portrait photography for warming up skin tones. Gold can also help neutralize cool skylight when shooting interiors.

DIFFUSERS

A diffuser is made of translucent white material that softens and reduces the light passing through it. When used in conjunction with direct sunlight or a powered light source, a diffuser can create the appearance of soft window light.

SILKS

A silk is similar to a diffuser, but is thinner and sheerer. When sunlight is passed through a silk, the sun's rays are softened. The strength and character of the sunlight, though diminished and diffused, is still bright.

SCRIMS

A scrim is a black screen material that simply darkens the light passing through it but will not diffuse it or change its quality.

FLAGS

A flag is a piece of large solid black material that completely blocks light and prevents reflection.

WHITE CARDS

Sometimes a 12 X 18 card is all you need to add a bit of light on a small foreground object. It's easy to carry a few of these, so always pack a few in your bag.

BLACK CARDS

Throw in a few of these, too. They are especially handy when you have a bright backlight flaring into the lens; just place one on a stand near the camera to block the light. This usage of a black card is called a "gobo." It's like adding a custom lens shade. You can also use black cards to block light and darken a foreground object.

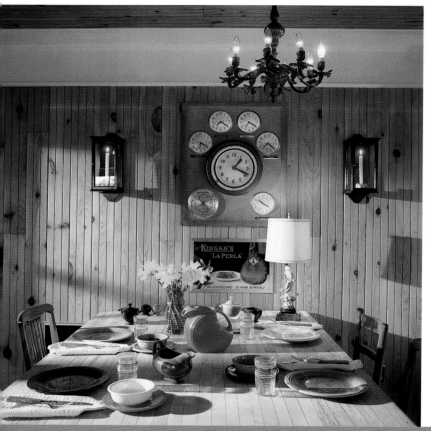

General Lighting Accessories and Gadgets

LIGHT METER

All you need is an accurate light meter that can measure flash as well as constant light. For interiors, a spot meter is unnecessary, since the standard incident and reflected light readings are perfectly adequate. Light meters with lots of extra features are too confusing; all those features are just a sales gimmick.

COLOR METER

Though expensive (about $1,000), this may be a wise investment. I've had my Minolta for ten years and it still works perfectly. You can do without one by using a little guesswork, but to achieve perfect color balance, you'll want a color meter. The meter reads the exact color of the light and tells you what filters to use according to whether you are shooting with daylight film or tungsten film. Of course, this item is more important for transparency film than negative film or digital shooting. Transparency film is balanced for only one color temperature, so corrections require precise filtration that your meter will specify. Negatives can be color corrected when they're printed, and with digital photography, you can set white balance controls to color correct wide ranges of light sources, then use Photoshop later to fine tune the color balance.

▲ A single, very bright tungsten light with a blue gel simulates morning light in this cheerful retro breakfast nook. The neon clock adds an extra spot of color and glow.

▲ Adjusting the dimmer to create just enough brightness in this custom chandelier was the only lighting control I needed to use here. Sun finished the job, creating vivid shading.

▶ Household lightbulbs, controlled by cord dimmers, enhance these warm wall tones. I added what I call "strobrellas"—strobelights outfitted with umbrellas—to the right of the foreground and in the room in the background.

▶ Recessed ceiling lights are important to the design of this room, so I wanted them illuminated for the shot. Dimmers softened their effect, and two side-by-side white strobrellas, off to the left, helped fill in natural light coming in through the windows.

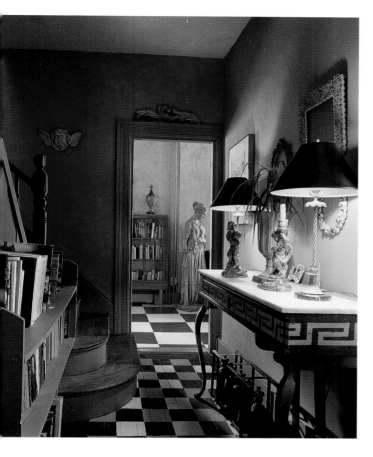

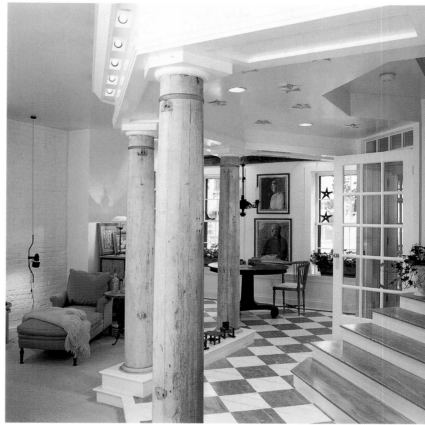

FILTER KIT

A kit usually consists of twelve or more filters to be used in combination with the color meter to correct color casts. Filters are made of different materials such as glass, hard plastic, and thin flexible plastic (gels). Though gels are the least durable, I prefer them, because they are less expensive and more compact than other types.

POLARIZER

This is the miracle filter. A polarizer can eliminate many unwanted glares and reflections quickly and easily. You'll probably need many sizes to fit different-size lenses.

LIGHT STANDS

It's good to have a variety of sizes. Compact ones are convenient for light indoor use and large ones are sturdier and often necessary when using heavier lights with umbrellas, especially when you want to place the lights at a considerable height.

SANDBAGS

Just as the name implies, these are cloth bags filled with sand, weighing about twenty pounds. Drape them on the base of a stand for extra stability, especially when using a light outside in a mild breeze. Never put a light outside in high wind.

CLAMPS

The springy kind from the hardware store come in handy for setting up reflectors, cards, etc.

DIMMERS

Standard dimmers with a plug-in cord, available at any hardware store, are simple yet effective for controlling the brightness of table lamps and floor lamps that appear in your photos. Using them is far preferable to carrying 25-watt bulbs around with you to achieve that softer-light look!

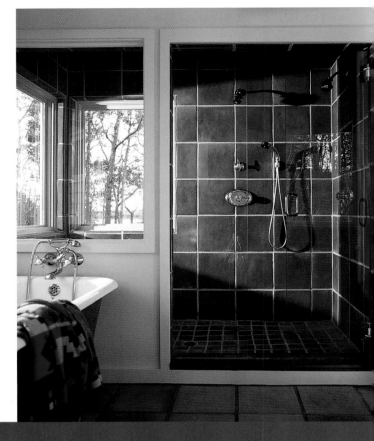

My Powered Lighting Kit

ELECTRONIC STROBE (FLASH) UNITS

Usually the most effective tool for lighting still photographs, strobes have some limitations and drawbacks, but their advantages, especially in interior photography, are considerable.

Monolights are self-contained strobe units mounted on light stands and have simple AC power cords or batteries. A sync (camera synchronization) cord runs from the monolight to the camera. Most monolights also have a built-in slave, which is a device that automatically synchronizes it with any other strobe that fires nearby. This enables multiple strobe lights to be set up for one shot, with only one sync cord required. Monolights are fast and convenient, and they are compact and lightweight. They usually aren't as powerful as systems with separate powerpack/heads, but for small or medium format work, I find their brightness to be adequate and their convenience very desirable.

Powerpack/strobe head units have an AC-powered electronic powerpack on the floor connected by a cable to a strobe head you place on a light stand. Since the strobe head is basically just a metal housing with a gas-filled flash tube and a reflector, it is simpler and lighter than a monolight. The two-piece design, however, makes these units slightly less convenient to use than monolights, but they offer more power and puts less weight directly on a light stand than monolights do.

Without exciting light, this foyer would look flat. In lieu of natural sun, a strobe blasts though a house plant about ten feet to the left.

Rich blue shower tiles pop under strobe light pouring through the window on the left.

A powerful strobe, blasting through a window on the left, brings this colorful family room to life.

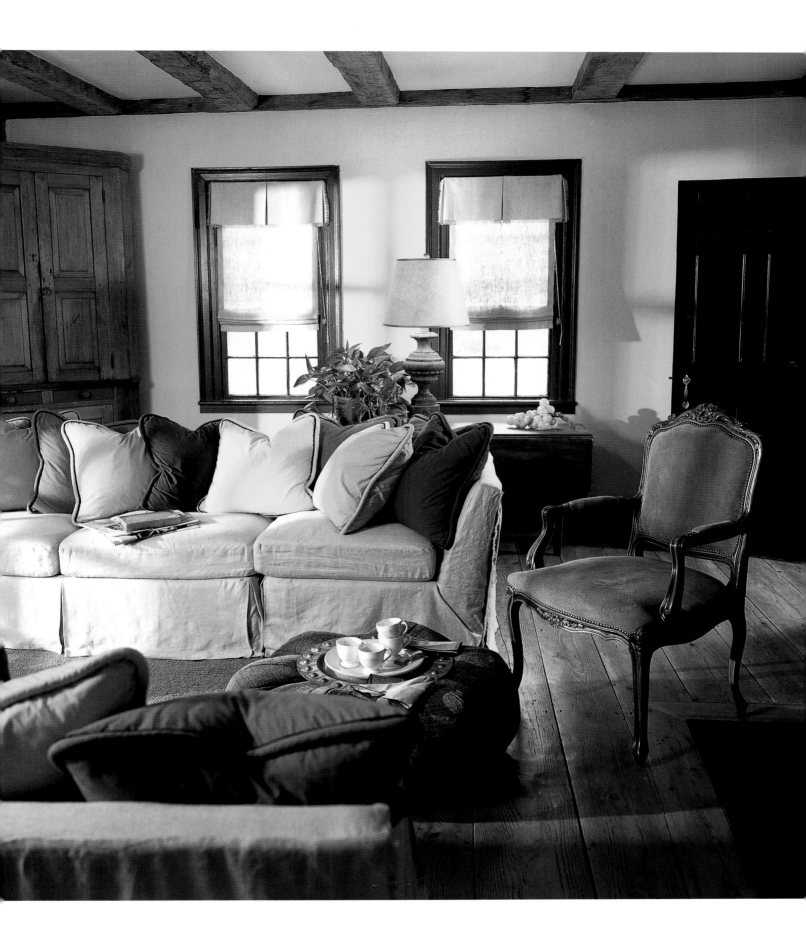

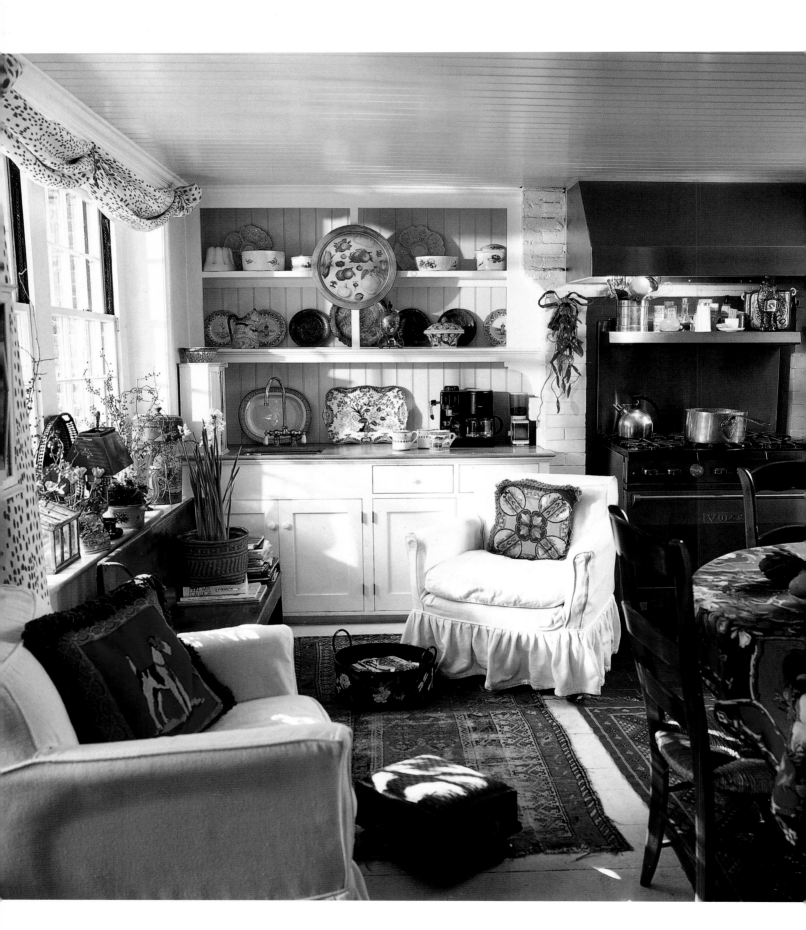

TUNGSTEN, QUARTZ HALOGEN LIGHTS

These are aptly nicknamed "hot lights," because they burn very hot, draw high wattage, and are very warm (yellow-orange) in color. Despite these disadvantages in natural daylight settings, they have numerous advantages. They are bright, small, lightweight, and inexpensive. Because of their color, they are very effective when mixed with existing incandescent room light, for low daylight or nighttime situations, and when you are using tungsten-balanced film or digital. They can be placed outside a window (only in good weather with sandbagged stands, please) to simulate warm sunrise or sunset light. You can also get heat-resistant cooling (blue) gels or glass dichroic filters to convert them to daylight. They provide continuous light, which has two major advantages over strobe light. First, what you see is what you get. There is less need for Polaroids, because with continuous light, you can visualize the lighting. Second, if you want a feeling of movement from people, pets, blowing fabric, a rolling ball, etc., you can blur your motion. Smooth blurs are a feat that the fast, image-freezing quality of a strobe will not allow.

HMI LIGHTS

A high-tech form of continuous light, these are used widely in the film industry. HMIs are perfectly balanced for daylight color, and are very bright. Sounds great, but their drawbacks are considerable for interior photography. They are very expensive, heavy, cumbersome, hot, and draw much wattage. I have not worked with them for these reasons but have spoken with photographers who have, and they recommend them. Maybe they are right for you.

A strobe outside the windows comes to the rescue to create a sunny look. Another strobe with an umbrella fills in the light on the right of the image.

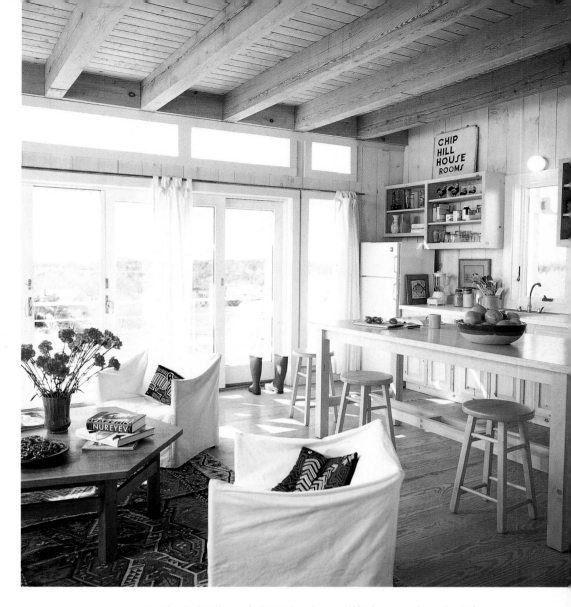

Strobe light directed through a large diffusion panel on the left works with natural sunlight to give this beach house a soft cheerful glow.

DAYLIGHT FLORESCENT LIGHTS

Also film industry favorites, daylight balanced florescent lights offer advantages for the still photographer. Though they are not nearly as bright as quartz or HMI lights, they burn cool, use very low wattage, and are reasonably priced. They provide very soft, natural looking light that can be quite pleasing for interiors as well as other subjects. They tend to be a bit bulky, but are usually not heavy. Florescents offer the advantages of continuous light and are an excellent complement to a strobe system. They may become more popular as digital catches on, and manufactures cater to that market.

Neon light can be beautiful and effective, as it is in this dining room. I added a strobrella on the right side of the room to enhance the effect.

Accessories for Powered Lights

UMBRELLAS

An umbrella is the perfect collapsible parabolic reflector: compact, convenient, and readily available. Whoever invented the umbrella was a genius! I prize umbrellas for their softening effect, and also for their facility in controlling the direction of the light. They afford the discerning photographer a "feathering" capability; by slightly revolving the light with an umbrella mounted on it, a photographer can provide subtle but effective changes. You can move the umbrella's reflective surface closer to or farther away from the light for variable softness, or even partially collapse it for a more "aimed" approach. Most lights have a built-in fitting to insert umbrellas, and they are especially effective with strobes. You can also use them with hot lights without burning, but make sure the distance from the light is sufficient. Note: Be prepared to laugh politely at onlooker's jokes, as in "Is it raining?"

White umbrellas usually come backed with black fabric that is removable. So, you can use the black backing to ensure that light will bounce off the white inside but not penetrate the white fabric and spill all over the room. But you can remove the black fabric for softer light diffusion, which is especially handy for portraits.

Bright silver umbrellas cause light to bounce off the surface, so the light is brighter, harsher, and more concentrated than it is with a white umbrella. This light is usually too harsh, unless it's coming through a diffusion panel or some makeshift softening device. Dull silver umbrellas can provide a useful compromise for lighting effects that are between those you achieve with a bright silver or white umbrella.

SOFTBOXES

Also known as "bank units," these are tentlike diffusion devices that attach to strobe heads, producing beautifully soft light. You cannot use them with hot lights because they have low heat tolerance. They are rather bulky to use on location; you'll end up bumping into things while you navigate through a house. I find them to be more useful for portrait and still-life work than for interiors. You can simply put a large diffuser in front of an umbrella to achieve a similar effect.

▶ This Bauhaus-inspired dining room has very graphic recessed florescent lights, and I wanted them to be illuminated so I could show them off. I used strobrellas on the left and right to work with sunlight to control the lighting.

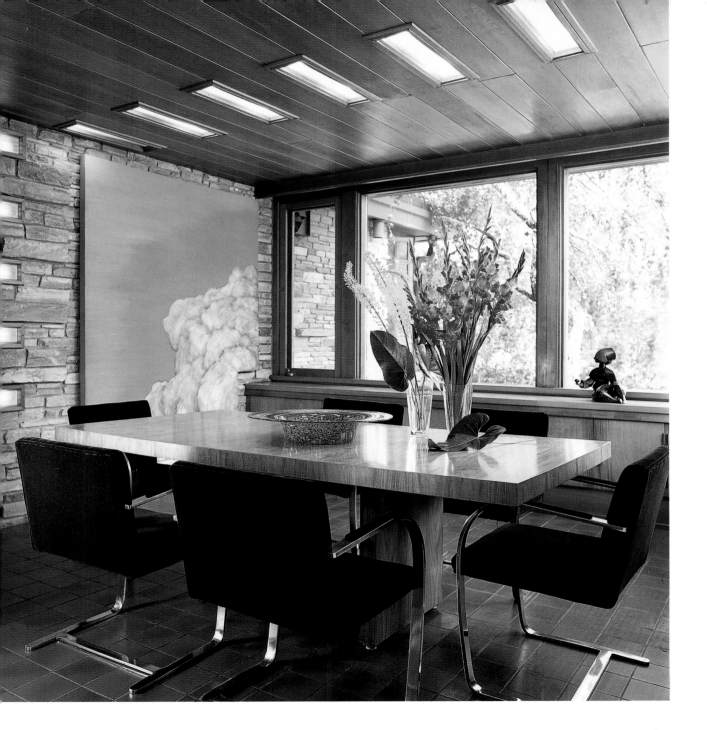

SNOOTS, BARNDOORS, GRID SPOTS, SCOOPS, AND OTHER ATTACHMENTS

Because of my constant emphasis on natural-looking light, I have found that these attachments, though very useful for a commercial studio, usually produce an artificial look on location. Anyway, my light sources are usually too soft and diffuse to require or allow for them.

Occasionally, though, I want to highlight a small object, so I use a small silver reflector. If the reflector is inadequate, I reach into the flat compartment of my bag and pull out a piece of thick, blackened aluminum foil.

This handy material, which is sold in photo stores, is designed to be molded into a snoot. It's much less bulky than a permanent snoot and you can adjust its size. It is also heat-resistant and very useful with hot lights.

When I want to phase the strobe light off of a part of the room, I clamp a simple black card on a stand and place it a chosen distance from the strobe head. This acts as a barndoor, and spares you the expense and storage requirements of a real set of barndoors.

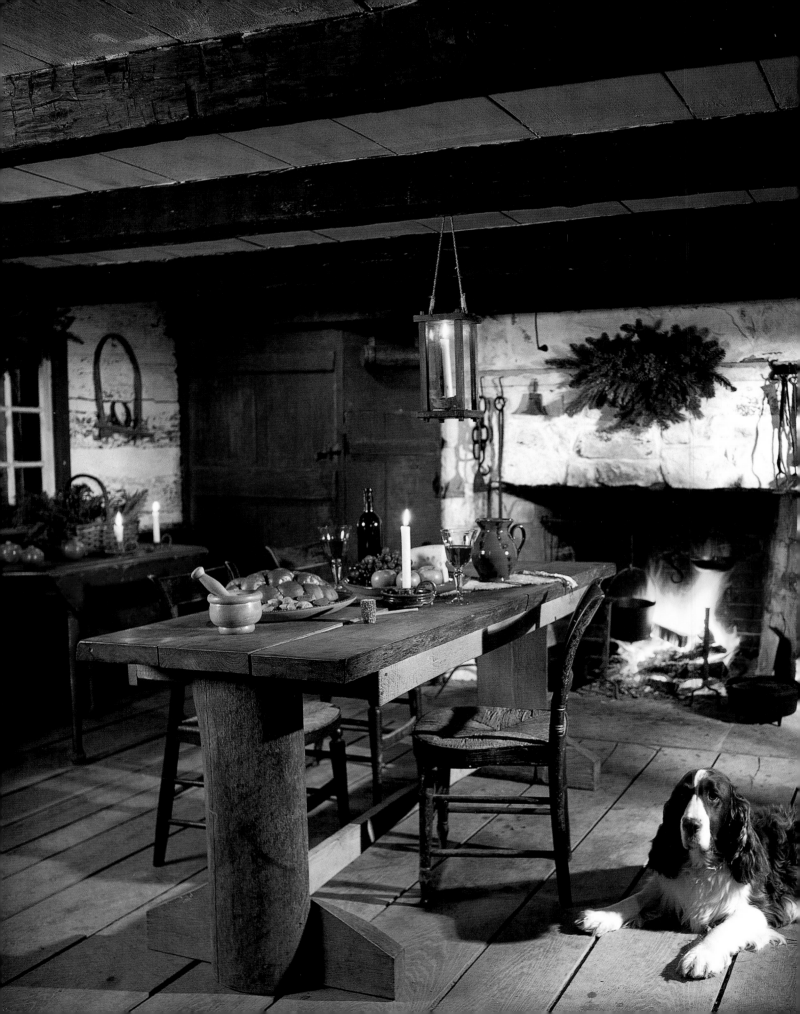

5 STYLING AND PROPPING

The simple truth is, an interior shoot would be nothing without good styling. The technical photographic part can be complicated, but I have found that the styling and propping is usually more demanding and time-consuming than fine-tuning the cameras and lighting. Fussing, rearranging, experimenting, schlepping, and furniture-moving are a big part of almost any interior photo shoot. Indeed, there have been times when I have felt more like a furniture mover than a photographer, and I'm not very good at moving furniture. But however strenuous the process can be, the rewards of good styling are well worth the effort.

SPEAK TO THE STYLE OF THE HOUSE

As with any aspect of interior photography, there is no set way, or correct way, to style a location appropriately and beautifully. Good styling will strengthen and support the personality of the house you are portraying, so it should draw on carefully selected items from that house. Indeed, picking the things that capture the style of a house is the fun part of styling. Keep it creative and spontaneous, because a formulaic approach would only result in predictable, boring pictures. Your audience is yearning for something different. We shouldn't do things that are trite, pretentious, or inappropriate, and we must be daring and try new ideas all the time.

(Pages 80–81) A rustic Early American keeping room is beautiful and dignified, and the classic Springer Spaniel adds just the right touch—an example of introducing only props that work with the style of the room.

◀ Red tulips against a deep blue wall, a bowl of fruit, the gold accents, the informal yet distinctive furnishings, even the warmth of the sunlight—all these add up to create the style of this house.

▶ Styling is an art that begins with the appreciation of beautiful things and their many qualities of color, texture, size, shape, and most importantly, their feel. It's this feel that creates the style of the house, and when you come to recognize it you'll be able to capture the essence of an interior.

GOOD STYLING IS A TEAM EFFORT

I have heard about photographers who stand at their cameras, surveying their subjects and watching professionals style the set. This is certainly not my approach. I'm a firm believer that even with a great stylist on the set, a photographer should contribute significantly to the style of the shot. As the photographer, it's important to know what results you want to achieve, and this requires a taste level about styling that you develop over time.

There are four different people who can contribute to styling, and some combination of one, two, three, or four will work best. Usually two is perfect, but a well-behaved foursome can be dynamic, if the tasks are distributed well. The four main players are: the photographer, the professional stylist, the editor/art director/client, and the homeowner. If a shoot is blessed with a well-prepared stylist and a strongly visual editor or art director, the photographer will have an easier time making magic. If the house is fabulous to begin with, the homeowner is probably very artistic, and the photographer and homeowner can enjoy composing and shooting their way through the house without outside help. Sometimes a homeowner will innocently try to sway the shoot in a nostalgic or narcissistic direction, and then the photographer should take the reins and make sure the shoot is providing what the client, not necessarily the homeowner, wants.

If you have already scouted the location, the scouting shots will be a valuable tool in determining your styling needs. If the place does need a lot of outside help, ask if the client is willing to pay for a professional stylist. Then, it's your job to hire one. If you don't know any stylists who are good at interiors, call other photographers in your area or look on the Internet.

When you find a stylist with experience and a feel for interiors, e-mail her (this is a female-dominated profession) the scouting shots, and call to discuss her contributions to the shoot. Try to inspire her to give the shoot a special look. Many of my shots have come alive with just one perfect prop in the right place, and this is the heart of a stylist's calling. You will probably find that she has to shop for a day to buy pillows, throws, towels, sheets, rugs, flowers, vases, fruit, and various artistic accessories. The ugly truth about styling is that most nonperishable props are purchased, photographed, and then returned; the poor shopkeepers are usually none the wiser. The stylists in my area (Boston) charge $450 to $750 per shooting day, with a half-day charge for buying and another half day for returns. So, you must allot $1,500 for a stylist. Good styling is very hard work, and a professional stylist really earns her keep.

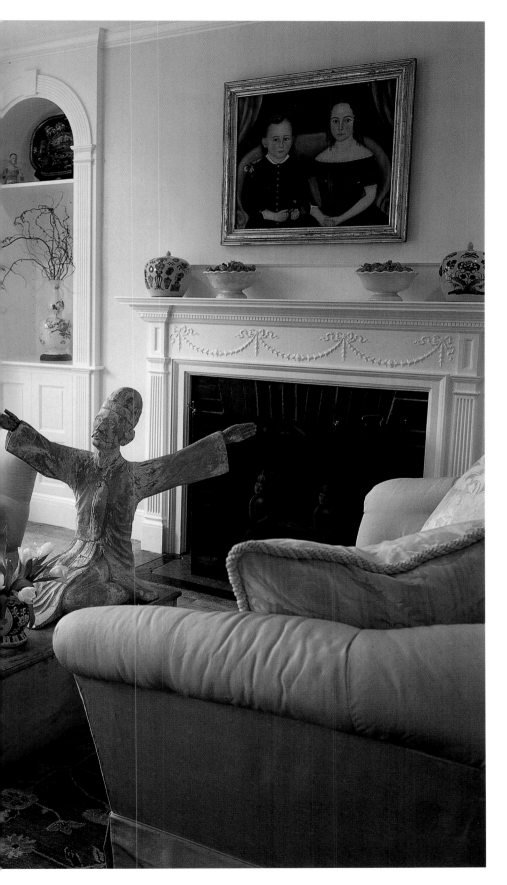

CAPTURING THE LIVED-IN LOOK

Remember, your goal is to produce photos that beckon your audience, asking them to step into the home for a moment, imagining they live there. Before the shoot, I talk with the stylist about styling and props and assign her the task of shopping and accumulating whatever things are needed to create a real, lived-in feeling. Sometimes I pick up fruit and flowers and bring a box of vases and other props that I've accumulated over the years. To give the house that "lived in" look, you'll use a combination of what's already there, extra things you've brought in, and a bit of spontaneity and innovative magic.

I made a daring move when I placed a large sculpture on a small, centered trunk, but this gutsy approach makes the shot. If you block the sculpture with your thumb, you will see that without it you have an ordinary and rather boring living-room shot.

▲ Many good architectural projects don't translate into good interior photographs, because the furnishings are not up to standard. Some magazines will commission a professional stylist to completely replace the homeowner's belongings with furnishings to create a room that is both photogenic and livable—as in, the viewer wants to step into the image and take up residence. Refurnishing for the sake of a shoot is expensive, but the expenditure is worth it when a room turns out as well as this one did.

▶ An appealing tray of food is a logical adjunct to an outdoor dining theme and adds a bit of romanticism as well as realism to the shoot.

▶ The right elements in perfect balance, however simple, can add a Zenlike quality.

▶ The key is to include enough, but not too much, of a room, beckoning the viewer to step inside.

▶ A chicken seems quite at home in this garden and makes the scene look natural and inviting.

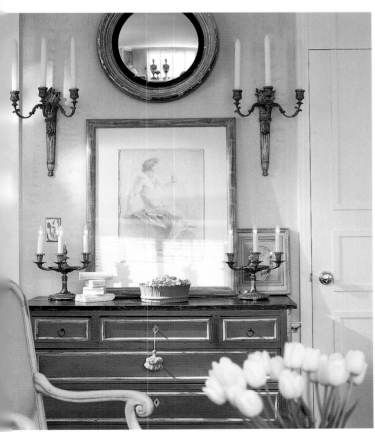

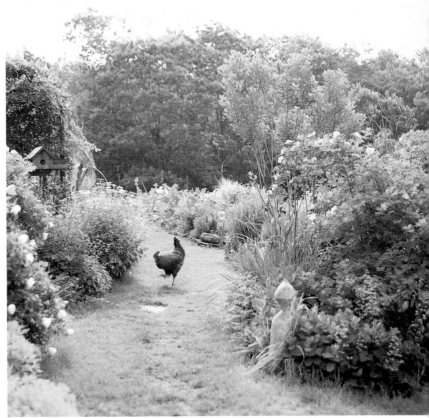

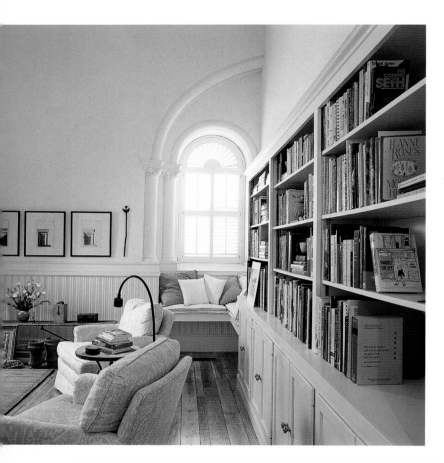

KEEP IT SIMPLE, SILLY

Styling is all about walking a fine line between not enough and too much. Usually, the styling feels right when the overall look is clean and simple, but not sterile. Where does one draw the line? That depends on the style of the home and the theme of the story. A few interesting objects will give an interior a certain personality, but clutter is distracting. You sometimes need only add a few items to suggest that someone has been sitting in the scene and walked out just before the photo was taken.

Refrain from falling back on clichés, such as eyeglasses on a book or a bowl of apples with a stray one below on the table. You can probably come up with something more clever. We've all heard the acronym "KISS," for the phrase, "Keep it simple, silly." Well, this has proven true over and again when it comes to styling. The camera will usually not translate as many objects as the eye can. In other words, take out whatever things you don't need. A place will look cluttered very easily. I sometimes think that another often-used phrase, "Less is more," was invented for photo styling.

◀ A church turned condo is the backdrop for simple, clean styling. The curve of a contemporary gooseneck lamp cleverly mirror an arched window above it.

▲ The interior designer who lives here knows the beauty of simplicity. All I had to do was fine tune a bit, light, and shoot. Oh yes . . . and enjoy the surroundings!

▶ Unexpected color collaboration somehow makes this simple vignette powerful. It just works, that's all!

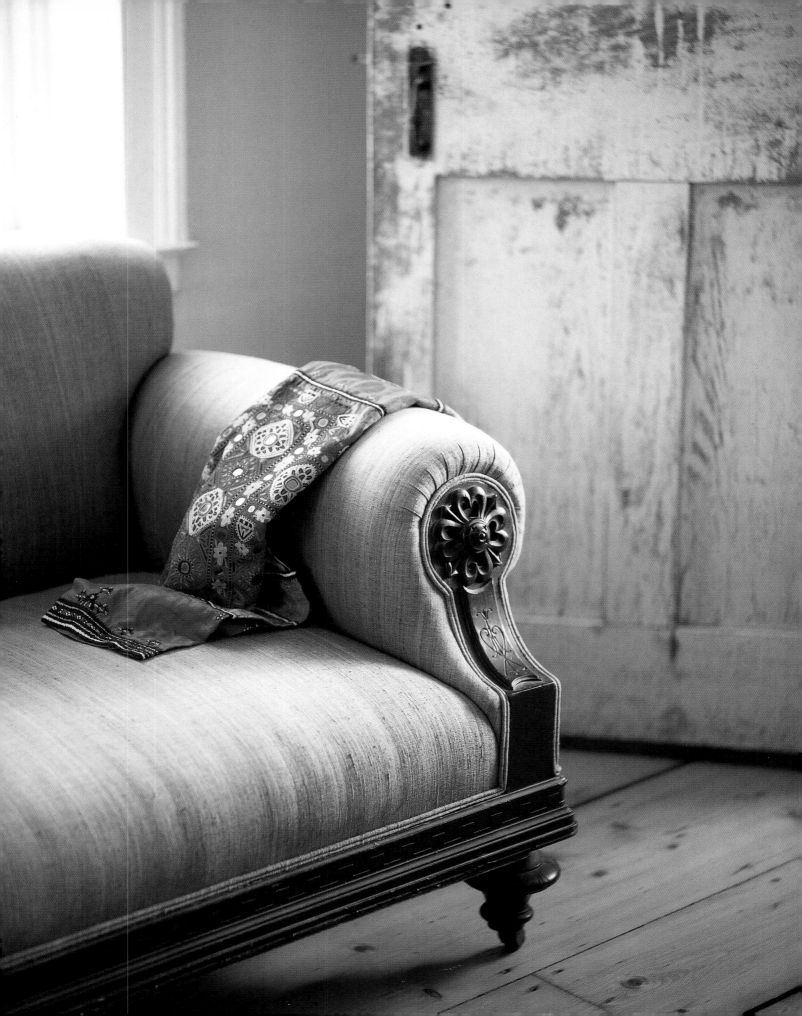

STYLING THE LIVING ROOM

This most treasured room in the house can be purely beautiful and reflect the owner's taste in a way that goes beyond the functional. The living room's purpose is to invite, comfort, and stimulate conversation. So, style it to feel beautiful and peaceful, with enough objects to give it personality and history: Flowers in bunches and uncomplicated arrangements, art books, small sculpture, a bowl of fruit, a tea set, or whatever else adds a bit of life and beauty will strengthen your message.

Props for the Living Room

FLOWERS AND VASES. Make sure both complement the colors of the room.

PILLOWS AND THROWS. They add texture, color, and personality. In a living room that just lacks a bit of personality, the success of a shoot can hinge on the pillows that you bring in.

LAMPS WITH NON-WHITE SHADES. White shades are distracting. For some reason, many perfectly decent lamps look ugly in photographs, and many lamps are just plain ugly. I'd suggest taking out ugly lamps, and if the space feels deficient without them, try bringing in different lamps that will photograph better.

SMALL ACCESSORIES AND BOOKS. But don't overdo, because clutter is distracting.

SMALL ARTWORK. Make sure it is in keeping with the style of the room.

▸ A rose is a rose is a rose . . . but lavish quantities say a lot about luxury and indulgence, ingredients of a welcoming room.

▸ For a moment, forget everything I've said about styling and adding props: Occasionally you come across a home, such as this one belonging to a designer, in which all you need to do is walk in and start clicking away. It's unnecessary to tamper with an interior of this caliber.

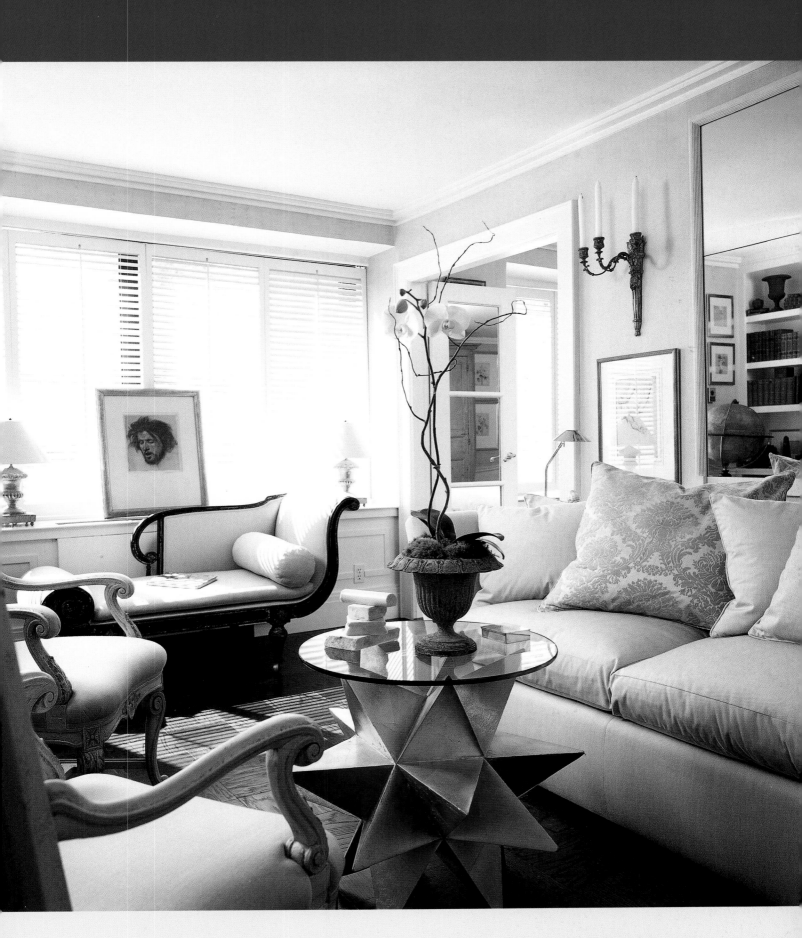

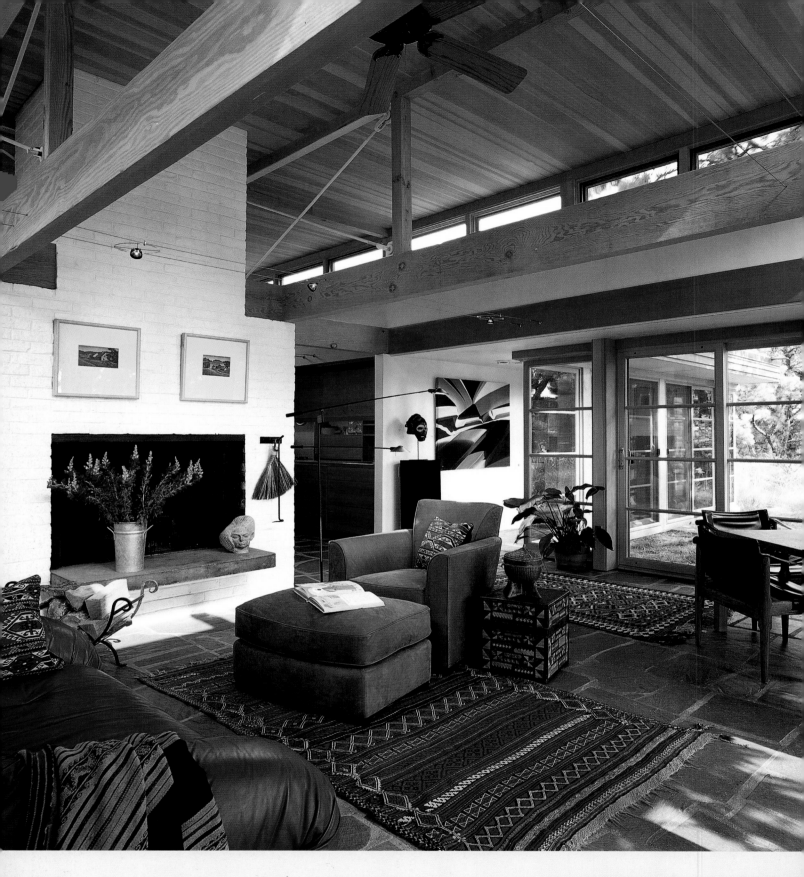

▲ Every article in this room reflects the owner-architect's love of modern design. In winter or fall I might have lit a fire to add warmth, but on this sunny day I opted for a bunch of flowers.

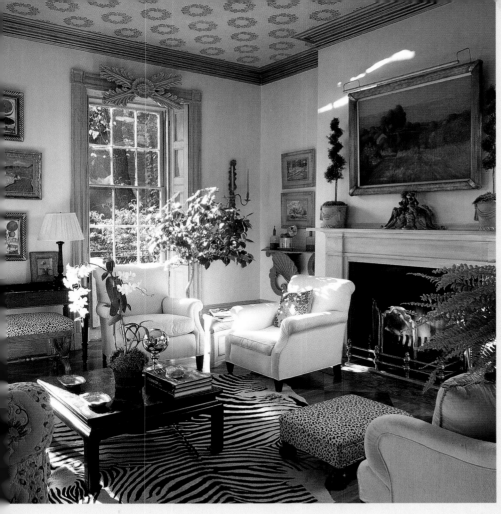

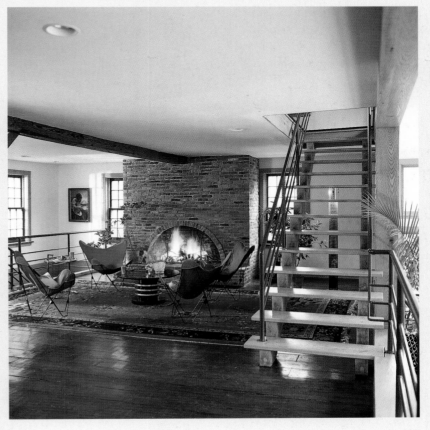

◀ Each piece of furniture and accessory works together to create a sophisticated, lively room that's anything but stuffy.

◀▼ Clearly a habitué of flea markets, the owner of this home loves to style his collection. How could I resist this easy shot, for which all I had to do was photograph what was in front of me?

▼ If you don't have a big budget, be especially creative. The stylist on this shoot bought a quartet of butterfly chairs to add color and a casual feeling. She made sure no one sat in them, so she could engage in that age-old trick of the styling trade and return them when the shoot was done.

STYLING THE DINING ROOM

Most families only use this room for company, so it often has a dry, formal quality. But shouldn't entertaining be fun? And shouldn't our guests feel relaxed and welcome, not like they have to sit up straight and behave? So let's entertain our viewers with pictures that capture the stately beauty of a dining room and inject a little fun along the way.

If you stand back and shoot an entire dining table and chairs, set for eight, you could have some big numbers: thirty-six legs, forty pieces of flatware, twenty-four plates and bowls, sixteen glasses, and all those candlesticks, flower vases, and salt and pepper shakers. That's an awful lot to look at in one photograph; in fact, it's absolutely way too much. Move closer. Shoot across the table, and crop out half or two thirds of it. Take out a chair or two. It's better to capture a select sampling of all these things and communicate the owner's taste and style without showing every darn last bit of it. Intimacy is a wonderful quality to strive for, but materialism is not.

Beauty usually beats information. You can set the table to dress the room up, but that may not be the most expressive styling approach. You might just want a stack of plates, flatware, and napkins, as if the host was in the process of setting up. Sometimes, a vase of flowers in the center of the table is all you need. You can even try a food shot. Hey, shooting a dining room can be fun! Just remember, there is no right or wrong way to style a room; there is only beautiful photography.

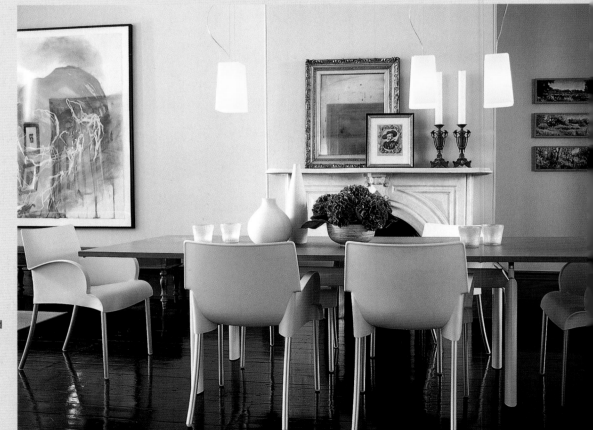

▶ Rich purple hydrangeas add a little punch on an otherwise calm dining table, providing a beautiful focal point.

▶ The stylist on this shoot decided to augment lively wall colors and colorful plates with a rich-looking bounty of food.

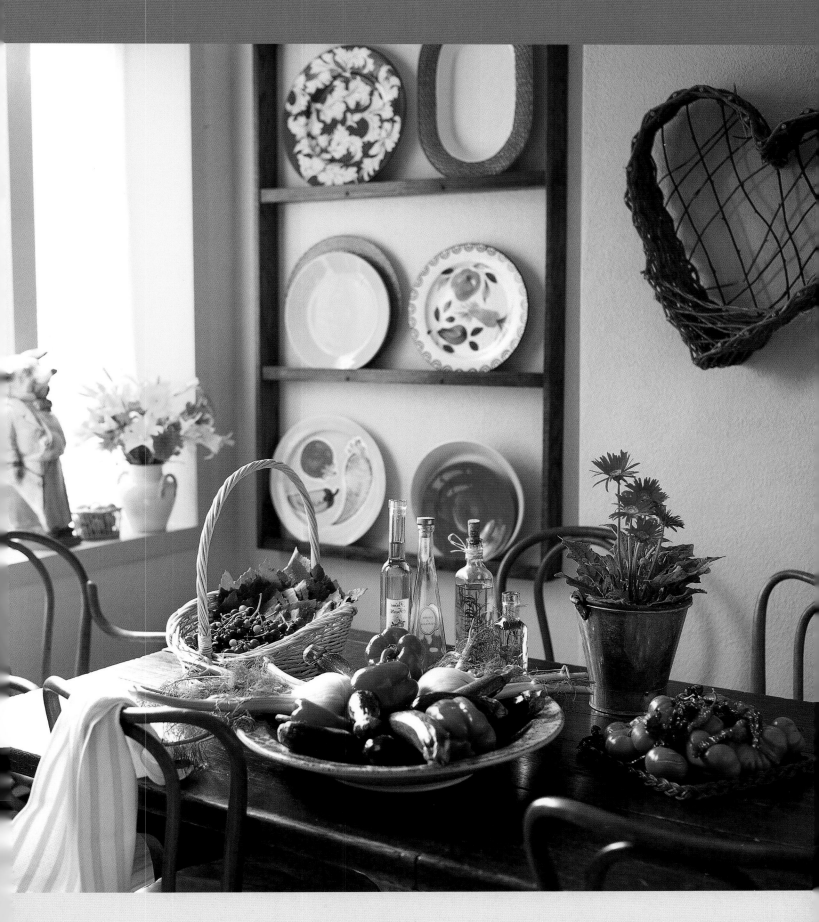

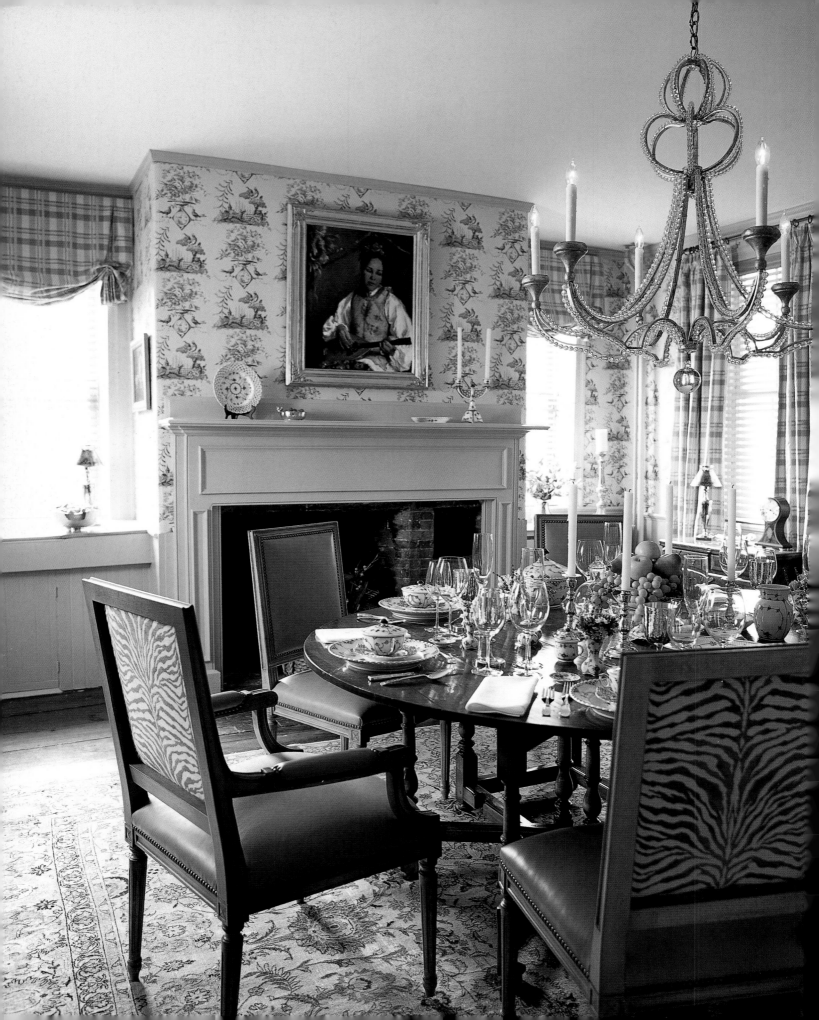

◀ Wow, is this table set! Though the tabletop is completely full and then some, the seductive sparkle of glass, china, and silver is just plain beautiful.

◀ For this strong, beautiful dining-table treatment, I only needed to add a very few items.

▼ Nothing traditional about this dining room: The styling is more about art and creative style than preconceived notions.

Props for the Dining Room

FLOWERS AND VASES. A beautiful and often simple arrangement can work magic.

TABLECLOTHS, PLACE MATS, NAPKINS. They needn't be perfectly folded; a slight wrinkle or two or casual placement can add interest to a photo.

DISHES, SILVERWARE, GLASSES, OTHER TABLE ACCESSORIES. I usually use whatever I find in the house.

FOOD. This is totally optional, and don't even attempt to use food unless you can make it look beautiful and appetizing.

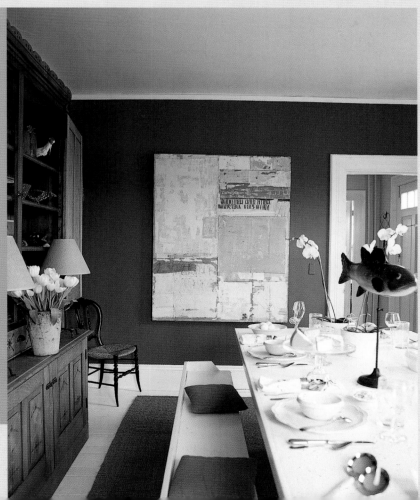

STYLING THE BEDROOM

Dreams are made here. The bedroom is soft, warm, and pretty. It will need beautiful linens, pillows, blankets, and bed coverings, and probably not too much else. Bed styling is a form of sculpture, requiring expertise. The pro stylists use a large steamer to eradicate every last wrinkle. At the very least, I hope you have an iron at your disposal, because wrinkles are a no-no on beds. The bedskirt needs to be shaped and evened out. Beds are usually completely made up for photography, but it's often fun to try pulling back the covers a bit with a soft, playful ripple or two. Keep the lighting soft enough to minimize fabric imperfections, but never let the light go flat.

Beds are very large and look even bigger in photos, so seek ways to shoot across them or over a table, chaise, or chair, or sometimes refer to the bed by including only a corner of it.

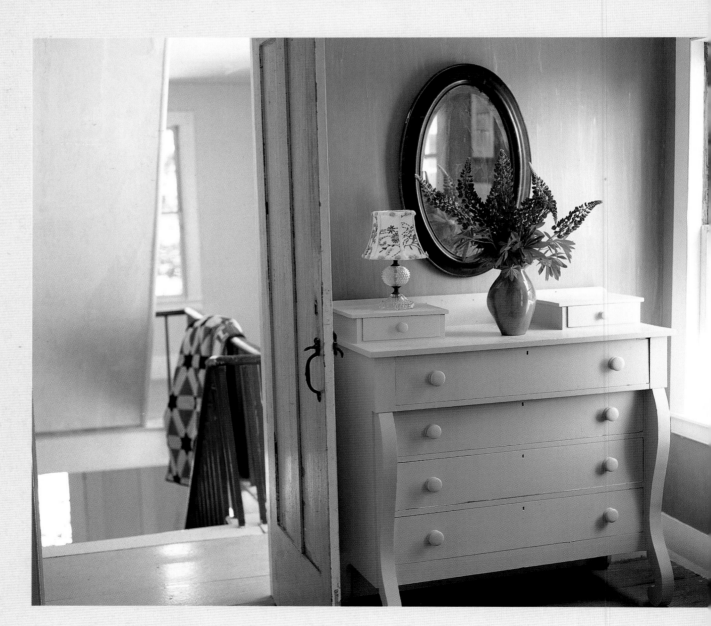

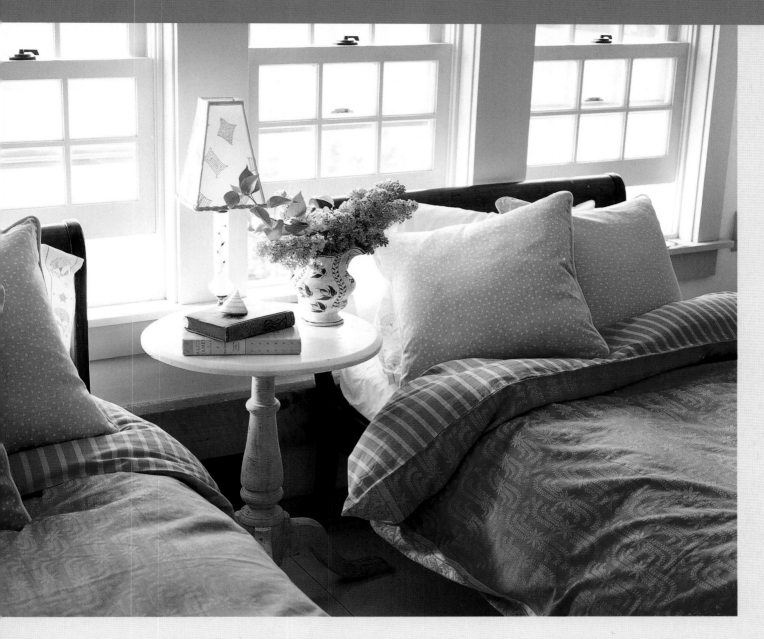

You might also shoot an additional soft detail of the pillow arrangement. The distortion encountered when shooting a large bed in a small room can be one of the biggest problems of interior photography, so don't fight it. As with a busy dining room table, try to communicate the essence of the bed without showing the whole thing.

After you've removed the owner's telephone answering machine and digital clock radio, try introducing a bud vase with roses, freesia, or other subtle sweet flowers to keep the atmosphere dreamy. If possible, resist the glasses-on-book cliché, but go ahead with it every so often.

◀ **Fresh lupines are so beautiful, just let them stand on their own!**

▲ **Bed styling is soft sculpture. These twins are relaxed and colorful.**

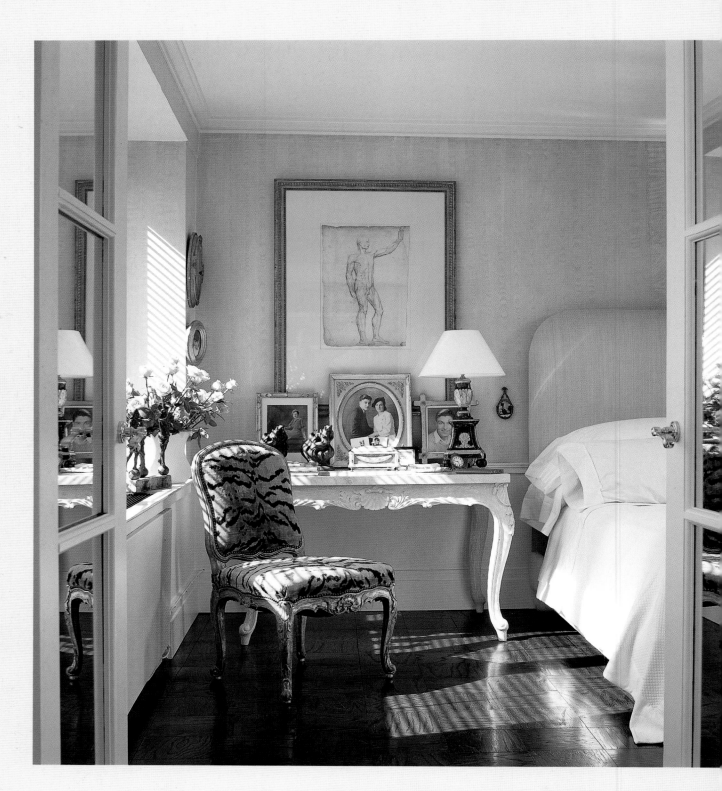

▲ This bedroom conveys beauty and elegance.

▶ Here, elegant simplicity suggests restfulness.

▶ This gorgeous cottage bedroom playfully blends formal and casual elements.

▶ Vintage styling often becomes too fussy with overzealous propping, but the stylist for this bedroom resisted that temptation and allowed fewer items to stand on their own. As a result, each item seems more expressive because there is less to look at. The rippled throw breaks up the bed's flatness.

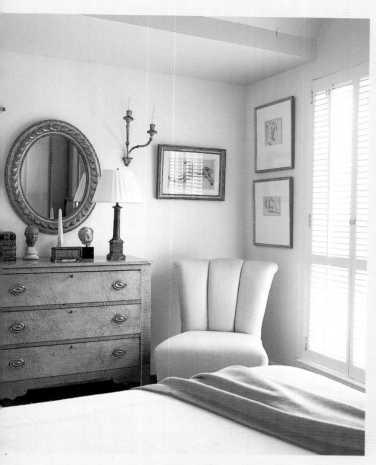

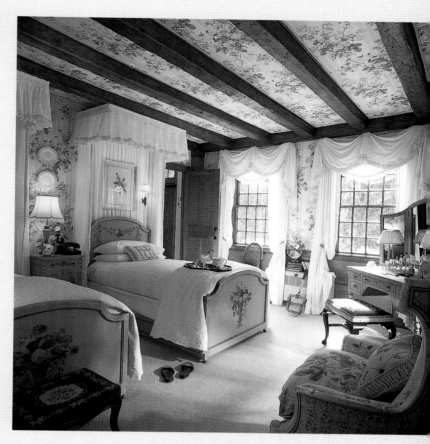

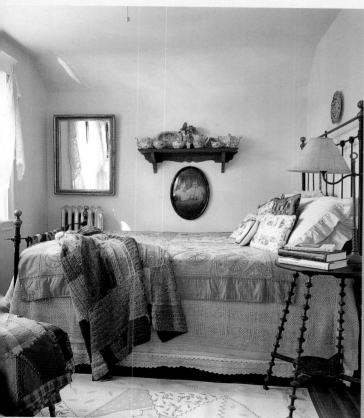

Props for the Bedroom

LINENS, BLANKETS, DUVETS, BEDSKIRT, ETC. Remember to bring an iron or a steamer to keep them wrinkle-free.

PILLOWS. Fluff them well.

NIGHTSTAND, CHAIR. Use furniture other than the bed sparingly, so you don't distract from the mood of the room.

SMALL VASE, SMALL FLOWERS. These lend a dreamy atmosphere.

LAMP, CLOCK, BOOKS, SMALL FRAMED PHOTOS, EYEGLASSES, WATER GLASS. In most shoots, you'll want to make sure these are attractive, and avoid clichés: A big digital clock is likely to be a distracting element, and we've seen the slippers next to the bed too many times.

STYLING THE KITCHEN

Though mostly functional, the kitchen is a lively gathering spot in any home. People socialize while they cook and eat, so kitchen photos should have a feeling of action and life. You can capture this feeling with or without people in the shots, through clever and creative styling.

Kitchens can be the most time-consuming rooms to style, because there are so many different objects, surfaces, and details, and as many possibilities to consider. A good recipe for styling a kitchen is to start by completely clearing the decks, then carefully adding props in key places; you'll be surprised at how little you need to create a handsome scene. The trick is to create the impression that someone was in the middle of cooking and had to run to answer the door. Hide electrical outlets behind objects on the counter, along with the homeowner's toaster, coffee maker, blender, mixer, and all the other ugly objects of everyday life, because they just don't photograph well. Create realistic but beautiful cooking, baking, serving, or eating scenes sparingly in various areas, and work the styling until the effect is simple but welcoming.

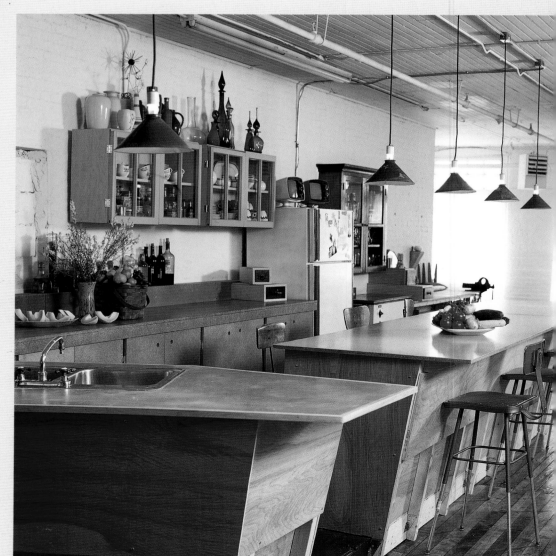

Kitchens that are really unusual or graphic, as these two are, can stand on their own with very few props. Call it "stylist minimalism."

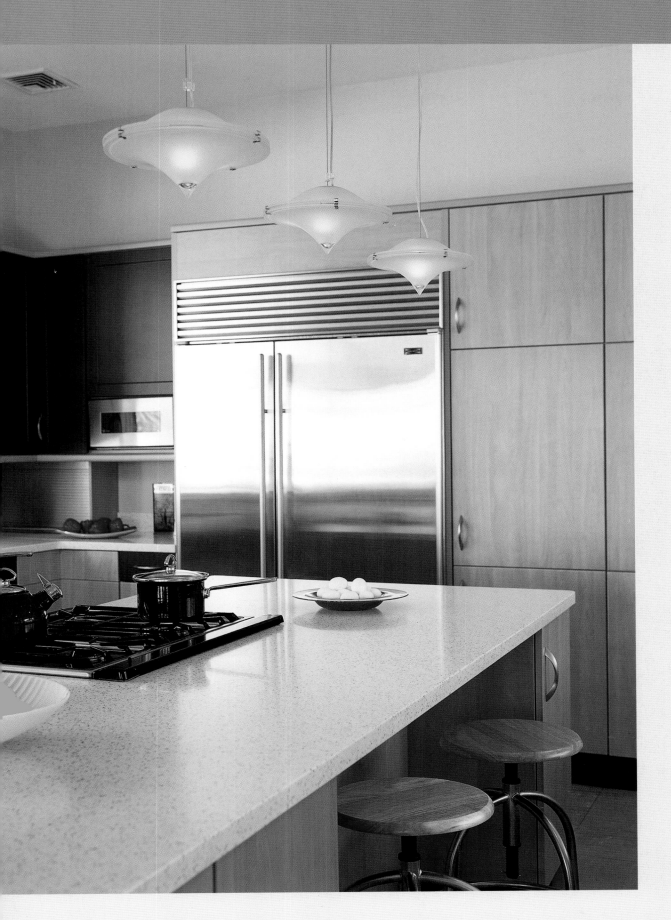

Props for the Kitchen

COLORFUL FRUITS AND VEGETABLES. You'll have to do some careful arrangement to make sure they look natural and appetizing, but not too perfect.

EGGS, PASTA, BREAD, HERBS, OIL BOTTLES, CANISTERS WITH PASTA, BEANS, ETC. Don't overdo props like these—it's a kitchen, not an Italian deli.

BOWLS, PLATES, CUPS, MUGS. I often use what's on hand. If a homeowner has a kitchen worth photographing, chances are he or she will have attractive tableware.

FLATWARE, COOKING UTENSILS, CUTTING BOARDS. Make sure they're not worn and dull.

CLOTH NAPKINS, DISH TOWELS. They must be clean, fresh, and pretty.

TABLE CLOTHS, PLACE MATS. As in the dining room, make sure they are ironed and well placed. But a wrinkle or two is fine.

FLOWERS AND VASES. In a kitchen, informal flowers, even an arrangement of herbs, are suitable.

TEA KETTLE, POTS AND PANS, OTHER UTENSILS. Use only if they're attractive and distinctive in some way.

Fruits, vegetables, and flowers liven up these two handsome kitchens, and sometimes they are all the styling you need.

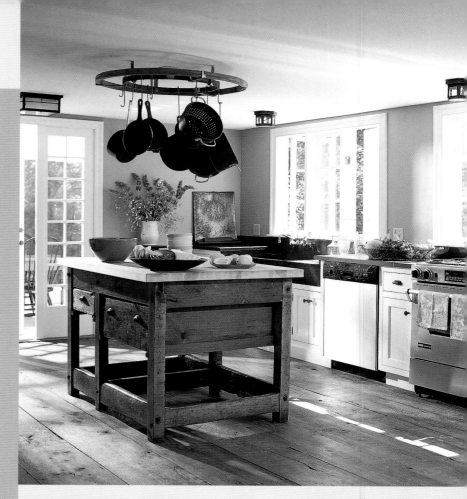

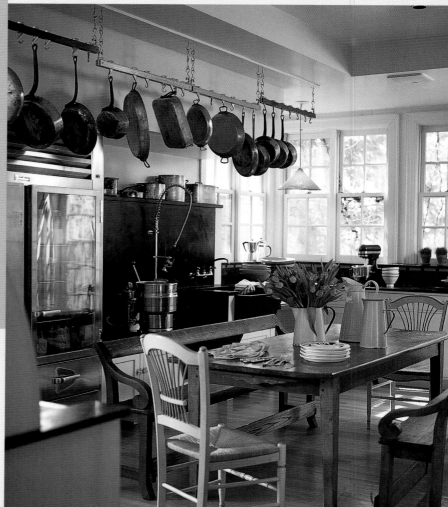

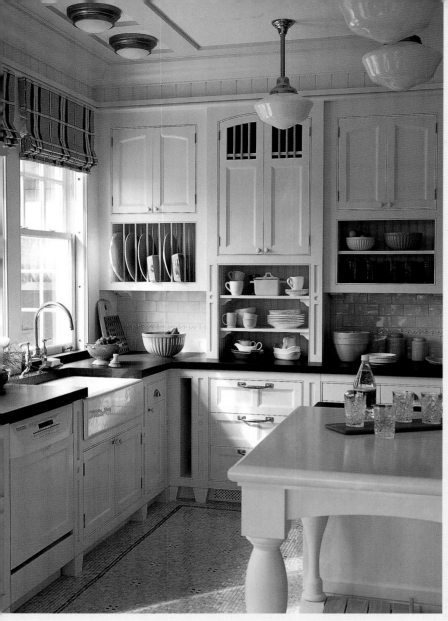

◀ A collection of pastel pottery complements these quality yellow cabinets. This is an example of kitchen styling that's pretty and looks real, too.

▼ The objects in this pantry make their own design statements. Onions, though not the prettiest vegetable, provide a realistic touch.

▼ Careful styling enhances this colorful orange-squeezing scene: A few blue touches strengthen the brightness of orange tones, and dabs of color pop off the neutral kitchen backdrop.

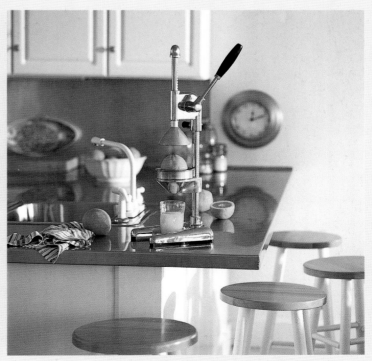

STYLING THE BATH

The bath is only rarely considered a top priority on a shoot. But photographing an attractive bath can deliver great rewards, because let's face it, we all lust for a beautiful bath. Since few of us have one, let's indulge our viewers' fantasies. Sun, glass, metal, porcelain, and water converge in a bath, and the effect can be stunning. These surfaces can also present technical difficulties, because mirrors and glass doors reflect the photographer and lights. You can often solve such problems with a strategically placed vase of flowers, and you can create a feeling of luxury in the bath by softening and warming hard shiny surfaces with towels, soaps, and accessories. While an unwritten law dictates that the toilet should not appear in a photo, that can be unavoidable. In this case, a stack of towels or draped robe can take the curse off it.

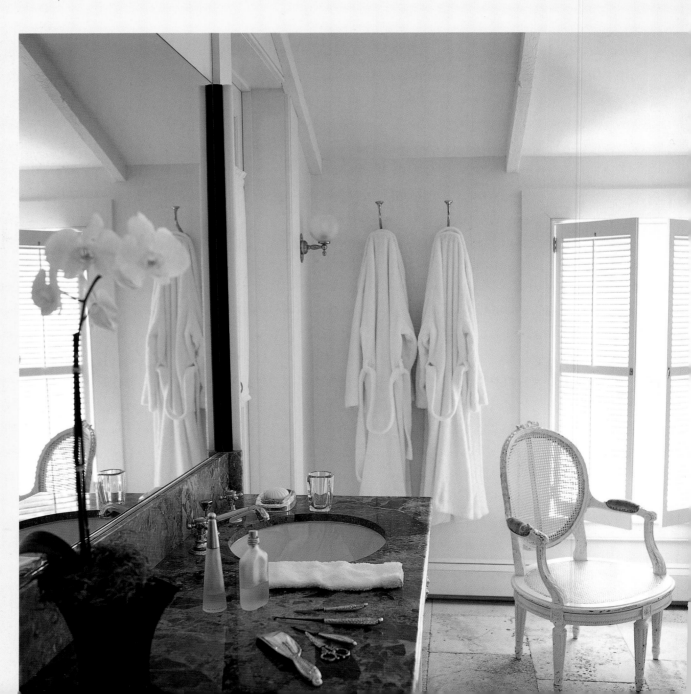

◀ Simple and beautiful, and styled with restraint, this bath is quietly elegant.

◀ You will rarely see a photo of a toilet in shelter books and magazines, but sometimes a good design idea will compel commode exposure. Here, a stack of towels softens the intrusion.

▼ I love the simplicity of this sink, which elevates plumbing to sculpture status. But what really makes the shot is the tiny spot of life and color the single pink beach rose adds.

Props for the Bath

LOTS OF TOWELS, BATHROBE, BATHMAT. Fluffy, clean, and attractive is the standard for these.

SOAPS, SEA SPONGE, BATH BRUSH. Make sure they are fresh-looking and appealing.

SOAP DISH, TOOTHBRUSH HOLDER, TOOTHBRUSHES. Only if they are distinctive.

A VASE OF FLOWERS. But please, don't overdo the floral look.

OUTDOOR SPACES

Be it a porch, garden, terrace, or just some quiet natural spot, the outdoor retreat can be the ultimate in beauty and freedom. It won't need much styling because it should represent fresh air and enjoyment of the view. If there's anywhere to keep your styling spare, this is the place—less is definitely more when shooting outdoors. Often, the key is to suggest a very relaxed person's presence, somewhere nearby. As usual, the styling should appear easy and uncomplicated, and found elements often tell the story best. Perhaps a watering can, bicycle, basket of picked flowers, jacket, wheelbarrow, or anything else with authenticity and character can give your shot a bit more depth and personality.

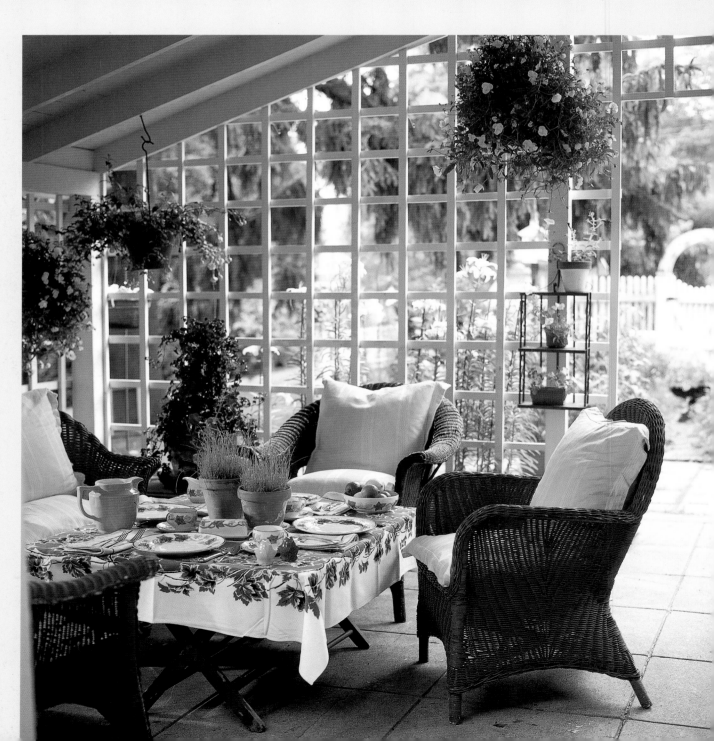

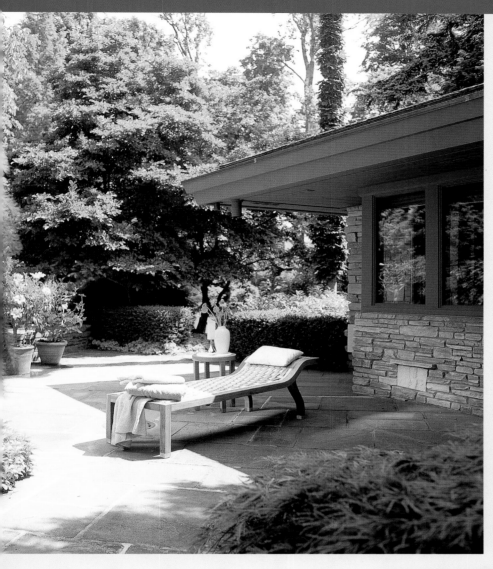

◄ A romantic outdoor dining area is shady and inviting, and a table set for a meal beckons viewers to take a seat and settle in for an alfresco feast.

◄ A terrace needs a resting point to make it livable, so the stylist chose a sleek chaise that reflects the style of the modern house. Colorful, summery towels and flowers add zest.

▼ A roof deck offers the attractive contrast of city rooftops and greenery. The stylist lugged a rustic chair up here to provide a visual resting point.

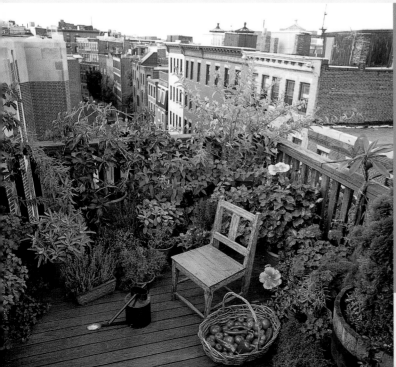

Props for Outdoor Spaces

POTTED PLANTS. Pots and the plants in them should be fresh and attractive.

GARDENING TOOLS, GLOVES, BASKETS, AND OTHER IMPLEMENTS. But don't go overboard.

OUTDOOR FURNITURE. Use the same high standards you would for an interior shot.

ANYWHERE VIGNETTES

If there is ever a cover shot lurking about at a location, it is likely to be in a vignette: a shot of objects, usually smaller accessories, combined in an expressive, beautiful montage. Books and magazines will often use a vignette for a cover or story opener because it communicates a strong, pure feeling. A vignette is poetry, revealing the essence of a place, while the overall shots are the unabridged novel. In a way, the art of a vignette is more about styling than any other interior shot. Each element's characteristics of size, color, texture, and style should complement one another, and not compete. In musical terms, a great vignette will have rhythm and harmony. A vignette is especially successful when it is a microcosm capturing the feeling of the whole house.

▲ A vignette can be a microcosm of an entire home. This shot of a mantle expresses the owner's style and sensibilities in a lovely, intimate way.

▶ We fabricated this vignette in a designer showroom for a magazine story on stripes. A woman working nearby was good enough to loan us the boots she was wearing.

Very close snippets offer an art director helpful bits of imagery to work with on layouts. They can provide visual punctuation marks and breaks from the large, complicated shots, or occasionally, the art director may be inspired to play a detail shot really big in the layout. I find it kind of exciting to submit shots like these, because I never know how they'll appear. But one thing is for sure—designers love the flexibility they provide. I often shoot them 35mm because it's nice when they look a bit soft.

ADDING PEOPLE, PETS, AND ACTION

Have some fun! If you are bored on a shoot, chances are your pictures will be boring, too. You've arranged flowers, poofed pillows, and thrown throws, and yet the shot still seems to lack that focal point. It just has a lifeless, empty feeling. Children and pets are guaranteed to liven up any shot. In fact, if there's anything I've learned in all my years as a photographer, it's the power of the puppy. What sex does for fashion, puppies do for interiors. They may not be appropriate in every setting, of course, but it often doesn't hurt to try. Magazine and book publishers have found that their readers do not relate to adults (other than themselves) lounging in featured homes. Rather, they want the readers to imagine, be it just for a second, that they live in that home. This is the reason why kids and pets (who, when it comes to styling a photo shoot, are more like possessions) can be added to a room shot without spoiling the "this could be my home" fantasy.

It was a great stroke of luck that this earnest little gardener didn't have to be coaxed to water his flowers. And how fortunate the can is bigger than he is.

Repeat shots with and without kids and pets. The puppy might look cuter in the living room than she did in an earlier shot on the bed, and you can't have her in every photo! The "with and without" technique will be one of your best tools when it comes to shooting the perfect shot. Use it.

TECHNICAL CONSIDERATIONS

When you do allow real living things in your shots, prepare to use much more film and to equip yourself with some extra patience and spontaneity. Keep in mind, though, that while spontaneity is a good thing when you want to add excitement, the presence of moving beings changes all the technical dynamics of interior shooting.

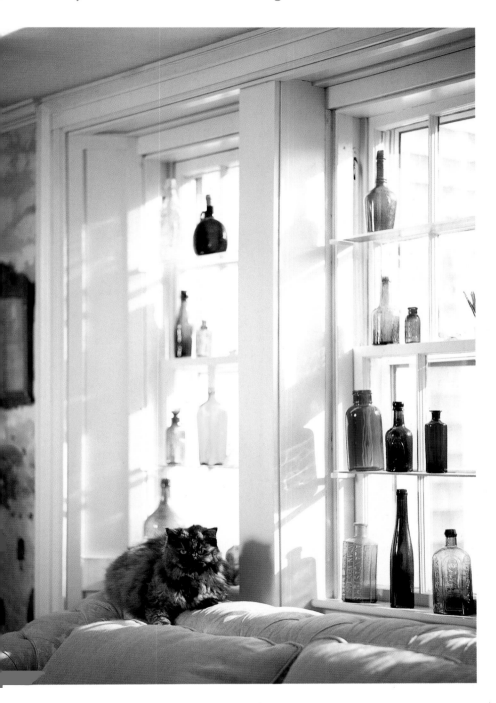

If you have natural light with a slow shutter speed, say $\frac{1}{15}$ of a second or slower, the interior, which doesn't move, looks sharp, but kids and dogs, who do move unless they are sleeping, will be blurry from movement. Blurs are often interesting and publishable, but some editors and most commercial clients will find them unacceptable. It gets even worse when you are mixing flash with your natural light. First, the flash freezes the moving being at the beginning of the exposure, and then the longer, natural-light part of the exposure adds blur to the moving being. The result is a "freeze-blur," which is usually eerie and ghostlike, and while cool on a rap album cover, understandably not suitable for *House Beautiful*.

Cats are almost never easy to pose, except on those extremely rare occasions when they feel like cooperating. I had to bribe this one with kitty treats to make an appearance in my photo.

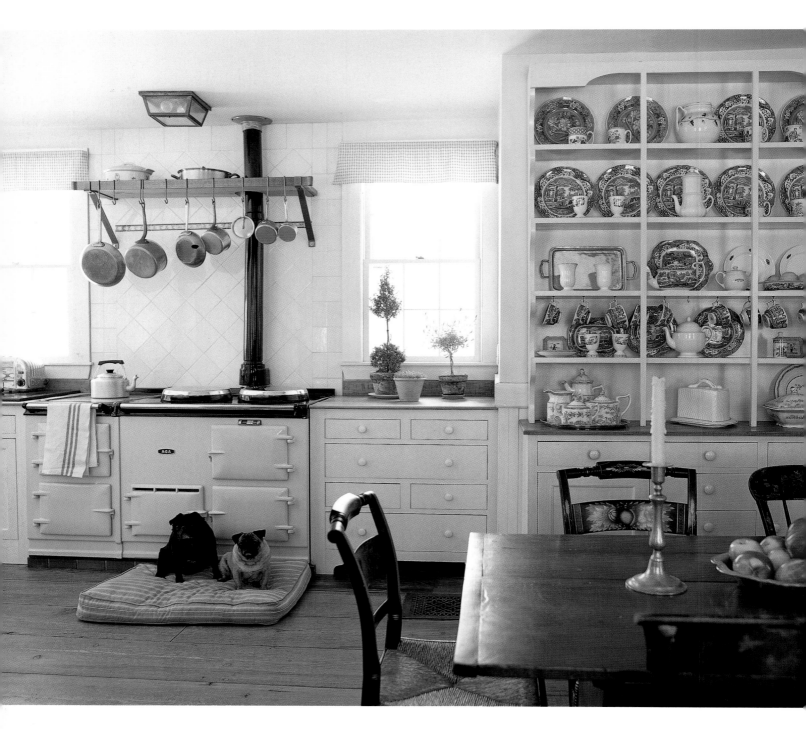

- A pair of pugs adds a touch of humor and homeyness to this English style kitchen.

▶ A blurry boy communicates the passage of time, and his red shirt adds a pop of color and fun to the kitchen.

▶ The owner of this kitchen loves her dogs and was happy to see one immortalized for a magazine story. The blurriness conveys the sense of a very hungry eater.

▶ Teenagers hangin' out give this room context and attitude. The slight blurriness of the girls emphasizes their joyful movement.

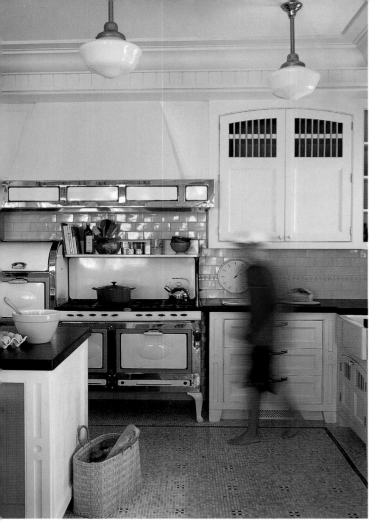

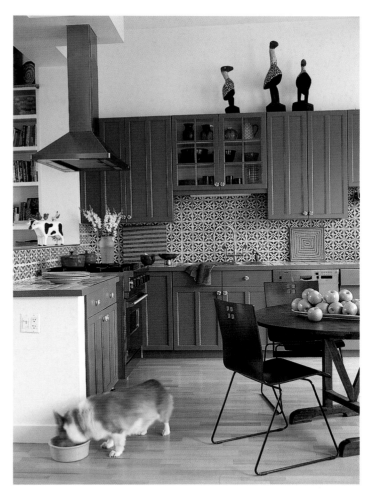

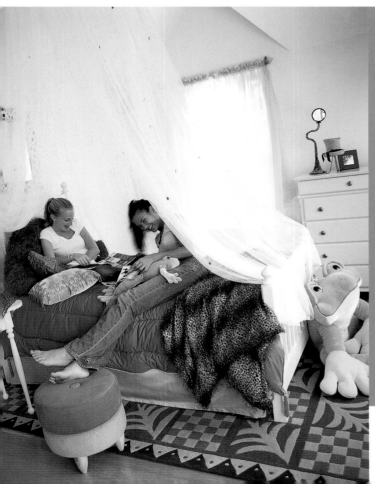

The Blur Effect

The way to avoid blur is to increase your shutter speed to be faster, or to slow down the child, dog, or cat you are trying to photograph. You'll probably have better luck getting your shutter to cooperate. Keep in mind, though, that if you speed up the shutter, the picture will get darker unless you employ the following tactics:

◎ Use a faster film, resulting in a grainier photo.

◎ Use a larger lens aperture, resulting in shallower depth of field.

◎ Use more natural and artificial light, which may compromise the mood.

MEET THE HOMEOWNER

If you are shooting a magazine story, the editor will want a "portrait of the homeowners," which sounds formal and possibly boring. The answer is to resist anything stiff in these situations and have your subjects lie in a hammock, look out a window, cook, sit on the stairs, walk the dog—do anything rather than strike a formal pose, unless they are so attractive it doesn't matter.

The best scenario is often a casual candid shot, taken with a 35mm handheld camera that has a very fast lens and a fast shutter speed and 400-speed film. (I find that skin tones are nice and mellow on this film, and it has surprisingly fine grain.) This fast, small-format, handheld approach adds spontaneity, and frankly, your subjects will be more relaxed when they're looking at a person holding a small camera without the tripod. The natural light will caress your subjects and the fast lens will allow them to be sharp with a very soft background.

▲ This image of three generations of women playing cards captures a precious moment on film. The single blurry hand is a subtle but effective suggestion of movement.

▶ A colorful and graphic staircase serves well as a backdrop for a portrait of this homeowner. I like the boldness of her black outfit and funky shoes.

▶ What better way to top off a story about the home of an architect than with a shot of the master of the house working at his drawing board . . . and what would this cheerful florist shop be without the florist?

Relax!!!!

The problem is, nothing intimidates the average person more than two things: public speaking and having their picture taken for a magazine. Any subject short of a professional model is likely to stiffen up when posing in a well-lit scene in front of a camera on a tripod. So, I try to approach my portrait subjects under the most relaxed and casual conditions possible. To capture their personalities and make them look better, I relax myself, move around, and talk to them. If they are still terrified, I make a fool of myself to help them relax. I make faces, tell jokes, whatever it takes to distract them from their extreme self-consciousness. While putting on this sideshow, I'm shooting 35mm Provia 400 handheld, so I can move around and use natural light, and they can respond directly to a person, not a piece of equipment.

6

SHOOTING IN THE GARDEN

Few subjects are more beautiful to photograph than a colorful, dewy garden at daybreak. What could be more peaceful and contemplative? Well, when the weather conditions are right, when the light is good, and when the garden is in bloom and well groomed, gorgeous photos can indeed seamlessly flow through your camera. But, as you will see, there are a lot of variables. And beware, if your schedule doesn't mesh with all these variables, capturing this would-be bliss can be tragically stressful.

LET THERE BE LIGHT

First, the light. Bright, overhead sunlight is the worst thing you can have for a garden shoot. The harsh highlights and sharp black shadows will look like a confusing and busy mess in the photographs. But, there may be times you absolutely have to shoot in bright sunlight, so get out your best weapon against the harsh sun: the polarizer filter. This marvel will reduce bright reflections on the foliage and provide much richer, more saturated greens. All the other garden colors and blue skies will also pop with a polarizer (see page 73). Don't forget the one drawback presented by the polarizer: The darkness of this filter robs you of $1\frac{1}{2}$ f-stops, which you must compensate for with a longer shutter speed or larger aperture. A better-quality linear or circular polarizer is an indispensable tool in your bag of tricks, but nowhere is it more of a lifesaver than in the garden.

(Pages 118–119) A rustic shed ga den is artistic, but down to earth the same time. The graphic she design and colors give structure this shot, and the flowers add beauty and softness.

Soft autumn sun, along with a pleasing palette of fall colors, cc bine for an evocative and invitin; image. Don't you want to fall int the hammock?

Another way to combat the harsh midday sun is to get out your sunglasses and look for a cloud. If there are any moving puffy clouds, wait for one to waft by and soften the sun, like a giant diffuser. Clouds can provide lovely soft garden light, unless they are very heavy and render the light a bit flat. You can judge the contrast of light in a garden the same way you recognize contrast levels in a photograph: Too much sun, too harsh; too many clouds, too flat.

If the midday sky is devoid of clouds, you may find good light in shady areas of the garden where the light is soft, lightly dappled, and beautiful (as long as the dappling is not too strong and harsh). The very shady areas will usually have a cool color cast from the blue sky light (this is called "skylight"), which must be neutralized with an amber warming filter such as an 81D, 81EF, or 85 (see page 73). A color meter, Polaroid, or even a digital LCD screen can confirm your suspicion of blueness, but in the end, your eye will be the best judge of the quality of the garden light.

If the weather forecast is sunny, be an early bird. Try to get there before dawn, maybe even, ugh . . . at 5:30 A.M.! At dawn, the garden is fresh and dewy, and the flowers have had a chance to rest and recover overnight. You can warm up with a few shots in the predawn bluish light, using your warming filter. Soon your sunlight will begin to spread soft, glowing brush strokes in small areas. This effect is usually lovely and exciting, but just within the first hour after dawn. Then the sun will rise and strengthen, and will soon become overpowering until twelve hours hence, when the magic hour before sunset approaches.

▲ You can often use a polarizer filter to tame bright sun, minimizing harsh glare and allowing rich colors to emerge. Here, greens and yellows are striking against an incredibly blue sky, as rendered on Fuji Provia film.

▶ Backlight gives this quaint gate a bit of sparkle and magic.

COME RAIN OR COME SHINE

If the forecast is cloudy or slightly rainy, but you and the garden are ready, go for it! Believe it or not, I have often been very pleased with garden shots taken during light rain. Those English garden books are so beautiful because it's usually cloudy and misty in Britain. Just bring a soft cloth to continually dry your lens; a single water droplet can cause a bad blurry spot on the picture . Your worst enemy may be wind. If it is very windy, you will need 400-speed film and an f 3.5 or faster lens, because to prevent blurry plants due to wind movement, your shutter speed should be no slower than $\frac{1}{125}$ of a second. On a gusty day, be patient and wait for lulls in the wind to make your exposures.

▶ Start with a pond and a bluebird house, add a table and chairs and a boat, make sure hazy light is playing off verdant grass, and—voila!—a beautiful picture.

▼ July, and a 5:30 A.M. wake-up call. Don't expect the art director to join you for this shoot. At that hour, it's amazing I remembered to pack the polarizer and to go for the extra hit of richness from Fuji Velvia.

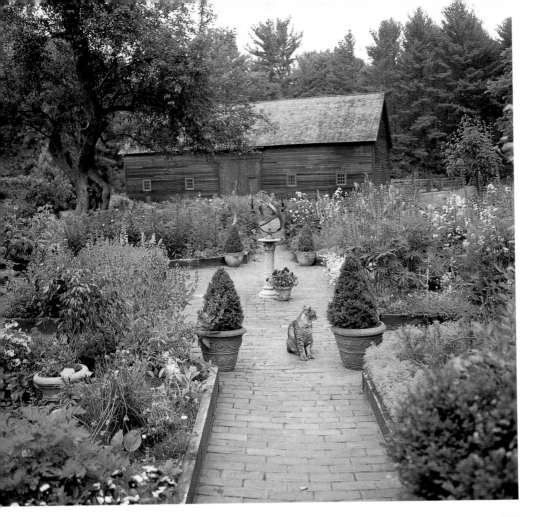

SEIZE THE SEASON

Gardens change constantly. Flowers bloom and die, to be replaced by different flowers. Some gardens are filled with springtime bulb flowers, like daffodils, tulips, and irises. Next come many blooming perennials. The weather patterns will greatly affect the quality and timing of everything. Severe wind and rain will ruin a garden, and if they do, don't waste your time; just put the garden on the books for next year.

When you arrive at a garden, almost every gardener will lament, "Oh, you should have been here last week, the tulips were gorgeous" or "It's a bit early; next week the garden will have more color." I recommend a cheerful response, like, "Oh, these peonies and roses are perfect." Always accentuate the positive, and shoot what you can. But be patient: You may have to shoot a garden four or five times through the season to do it justice.

▲ The brick path leads the eye to many visual treats. A cat, an armillary sphere, potted evergreens, a gnarly old tree, and the old barn all work together, supporting lovely summer flowers.

◄ The stone wall adds texture and structure to this well-manicured garden, in which roses and other flowers provide impressionistic dabs of color.

▶ A golden house, bathed in warm sunlight, pops against the cool snow and winter sky. No need for a polarizer, which would have darkened the sky too much.

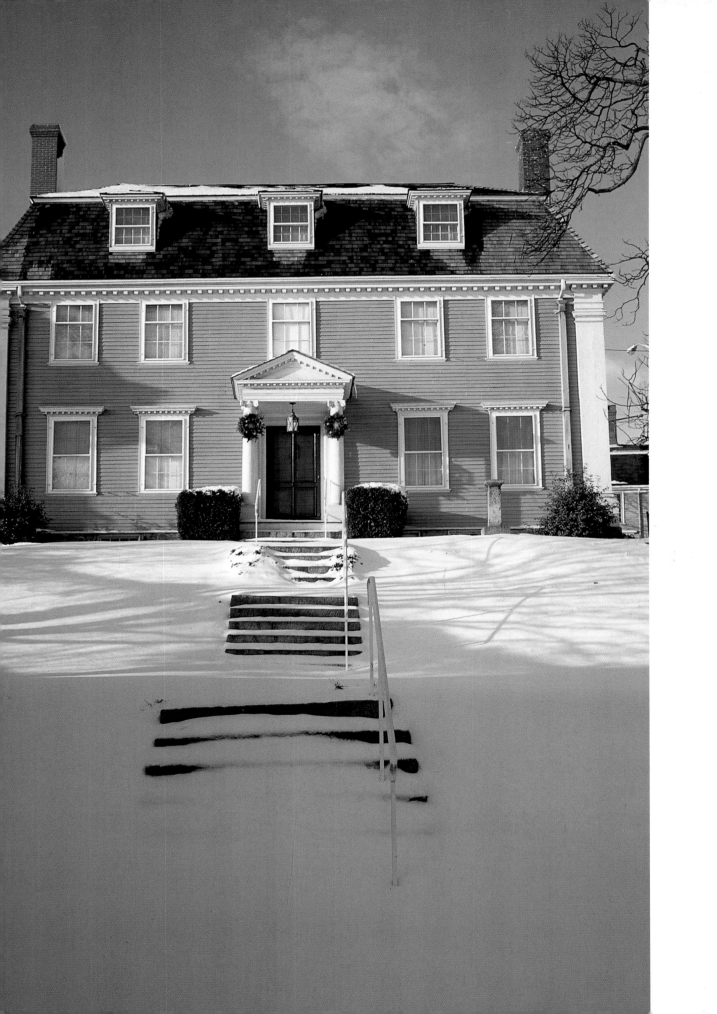

TIMING IT RIGHT

My suggestion is to try not to schedule garden shoots much in advance. Just stay in ready touch with the gardener, watch the weather reports, and make your move when you can. Many garden owners will allow you to stop by to shoot without prior notice, since you don't have to go in the house and won't disturb anyone. Ask the owner if that arrangement is possible. (And as you work, resist the temptation to look in the windows.)

A garden-house retreat evokes romance and the easygoing ways of a summer afternoon.

If you have to drive an hour or more to shoot a garden, you may want to plan your schedule to arrive in the late afternoon, shoot the garden under sunset that evening, stay overnight in a motel, and capture the beauty of the garden at dawn. You'll feel the satisfaction of having a full day's work under your belt as you enjoy bacon and eggs at 8:30 A.M.

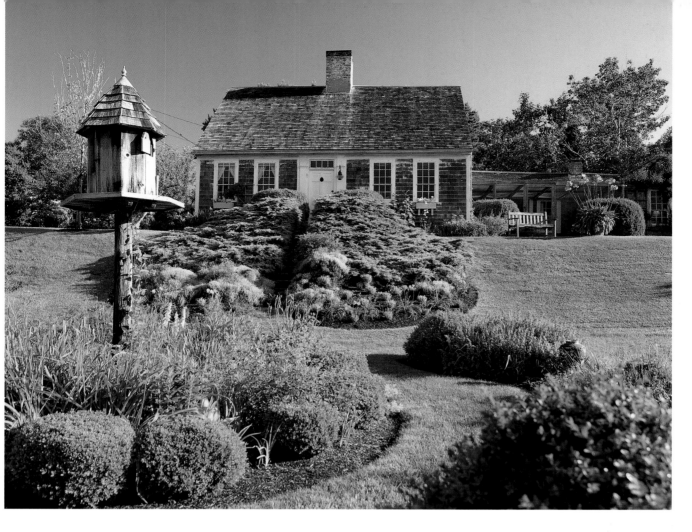

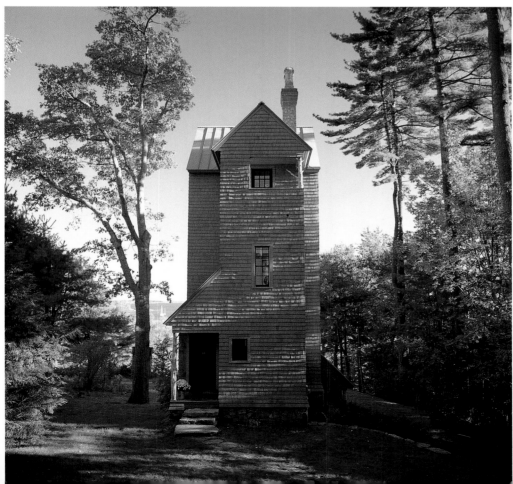

▲ An alarm clock came in handy when I had to get up at 5:30 A.M. for this July shoot. Had I waited until later in the day, the light would have been too harsh.

◄ This curious cottage faces northwest. It only gets a bit of dappled sunlight on the front façade in the early evening around the time of the summer solstice. I strapped a tall tripod to a stepladder and waited for the perfect moment to arrive. I had hoped for a little more sunlight than I got, but, not surprisingly, I was not allowed to remove several trees that were filtering the light.

THE BEAUTY IS IN THE DETAILS

Like interiors, a garden can tempt the eye with depth and detail. By choosing various angles that convey a sense of the overall setting, smaller nooks of delight, and close details, the photographer can simulate the experience of being there. The ideal garden will sprinkle color and texture over the interesting landscape that contains it. Your job is to use as much structure as possible to create striking, orderly compositions. Lead the eye down the path, past the perennial border, to the resting place on the bench at the end. As with interiors, try to capture foreground, middle ground, and background. Walls, ornaments, rustic fences, or classical structures will all contribute to depth, definition, and beauty.

You can liven up your garden story with a bit of styling. Gardens are spiritual places that people create and enjoy. By placing a few personal articles on a bench or table, you make the owner's presence felt. A great garden shot will depict beauty with a bit of personality. Look for found objects such as hats, garden tools, gloves, watering cans, and clay pots, or for cats and kids — whatever looks real in a particular setting.

◄ A meandering mandavilla vine beautifies a fountain to provide a romantic detail shot. In Photoshop, I could easily remove the length of pipe extending from the urn.

◄ Textures, like those in this study of zebra grass, make wonderful graphic elements for an art director's design palette.

◄ Antique watering cans have attained folk-art status and are always a hit in garden stories.

▲ I find the broken-down bench in this secret garden to be endearing. It shows the owner's individuality, because most people who go to the trouble to mani-cure hedges would simply buy a new bench.

◄ You never know where you'll find an interesting collection. These license plates on the wall of a garden shed just begged to be shot.

THE OUTSIDE VIEW

One or two simple, clear exteriors can add more meaning to your interior shots. The style, size, age, surroundings, and even locale of a house can be quickly communicated with a view from the right vantage point. I always look for unique features of the house and property, something a bit different that makes a statement. Whenever possible, include gardens, water views, stone work, trees, mountains, or anything else distinctive. Then push the atmosphere a step further with an added touch. Try a dog on the porch, children on the swings, a vintage car in the driveway, horses in the paddock, colorful lawn chairs in the yard, people swimming in the pool or eating breakfast on the terrace, or whatever strikes your fancy. Don't settle for something boring. There's always some way to spice up a scene, and doing so becomes your personal way of creating a better shot.

Larger houses often look better if you only photograph part of them. Here, the turret is allowed to star, without too much distraction from the rest of the house. Also, whenever possible, it's great to relate a house to the ocean or any other important surroundings.

Very often, exterior building shots are really just used to support a story about the interiors. Many times, they are printed small and may be considered less important than the beauty inside. Regardless of their importance, you can do yourself a big favor by checking the exteriors first thing, before you even go in the house. If the light is good, shoot! Good exterior light is the one thing you have no control over, so give it first priority, but don't spend too much time on it. Then you'll have completed one shot before you even bring the cameras inside. You won't have to worry about it later, and you have probably captured the exterior view in its best light.

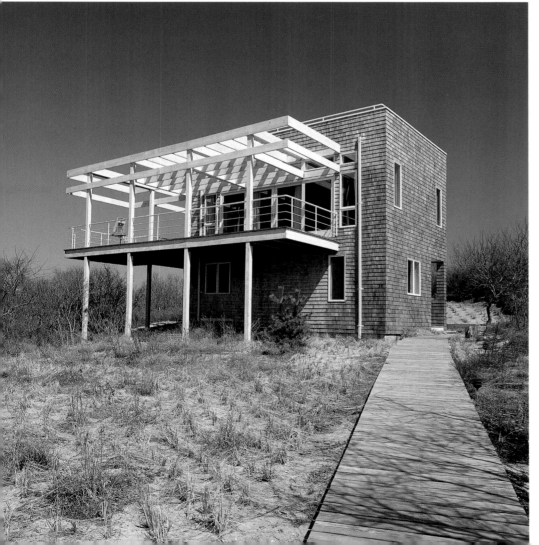

These two shots work together to create a straightforward appreciation of the simple, yet interesting, lines of this beach house.

TOOLS OF THE TRADE

Photographers are born with their most important pieces of equipment, their eyes and brains. The most advanced camera will never make a great picture without visual thought and artistic guidance. Conversely, a relatively inexpensive camera can produce world-class results. Whether you are a seasoned professional or a novice who's never shot interiors, or any other subject, before, your goal as a photographer is to achieve the best results for the most reasonable investment. Your choices are broadened these days with the technical explosion known as digital photography. Whatever equipment you decide to use, your success will also depend on two assets money can't buy—your creative ideas and your business sense.

DIGITAL VERSUS FILM

At the risk of sounding promotional, this is a very exciting time to be a photographer. Throughout the 150-plus-year history of photography, technology has continually expanded and improved the photographer's ability to capture and create images. Digital is definitely a giant leap. The advent of digital imaging is easily as important as the invention of roll film, handheld cameras, reflex viewing, or any other major advance. If we have the money, we can now allow ourselves to be showered with a dazzling array of quality options for making photographs. Since these options are proliferating, we owe it to ourselves to examine their potential as creative tools.

Going Digital

For the professional photographer, "going digital" is no small undertaking. When you compare digital technology with film, you'll find many similarities and many differences. In any case, film-to-digital is a major transition of money, time, and effort. The first digital camera purchase is just the tip of the iceberg. Before you are done (if there is such a thing), you'll probably have multiple cameras, computers, scanners, printers, media cards, PC cards, card readers, cables, external hard drives, and lots of other things you never heard of before you took the digital plunge. A lot of these things you buy won't quite work right. You will be talking about subjects that once bored you. You will become adept at data management techniques, because if you don't, your huge digital-photos data files will soon be out of control. In fact, each digital photo shoot probably generates more megabytes and gigabytes of data than a NASA experiment! As you might have guessed, I've been swimming in this stuff for a while and wondering when I can come up for air.

An amazing shift of resources occurs when the photographer switches from film to digital. He is suddenly not just in the old role of photographer, but also that of film supplier, photo lab, and scanning technician. In fact, sadly, many photographic support jobs are rapidly disappearing. Digital technology actually bypasses many steps required by film. Why would anybody shoot a roll of film, drive it to the lab and drop it off, drive back to the lab to pick it up, drive to the lab with a print order, and drive to the lab to pick up the print? That's four round-trips to the lab for one print! That's a lot of time and gas. Why not just shoot digital and make a nice inkjet print? That's no trips to the lab. That's ten minutes from shoot to print. The images are easily and perfectly filed in the computer. They can be burned onto a CD or DVD, e-mailed, or put on a Web site. The client can now receive press or Web-ready images faster, cheaper, and possibly better than before. This is a genie, and the bottle is now open. Yes, digital photography is a very powerful tool, but is it the best way to photograph? Maybe. Is it right for every situation or photographer? Absolutely not. I hope the comparison of digital and film on page 137 is helpful to you when pondering or undertaking this transition.

▶ When shooting an oceanfront home, it's nice to get blue ocean views in the windows. But, as the "before Photoshop" shot at top shows, I was plagued with the usual blown-out window problem. So, my Photoshop-genius assistant Russ enhanced a shot of the room with elements taken at four different exposures, adding the windows, window shades, painting, and even the ocean reflection in the mirror.

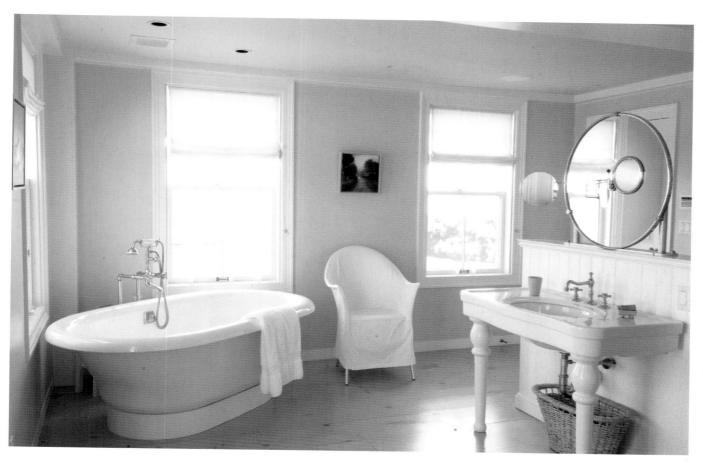

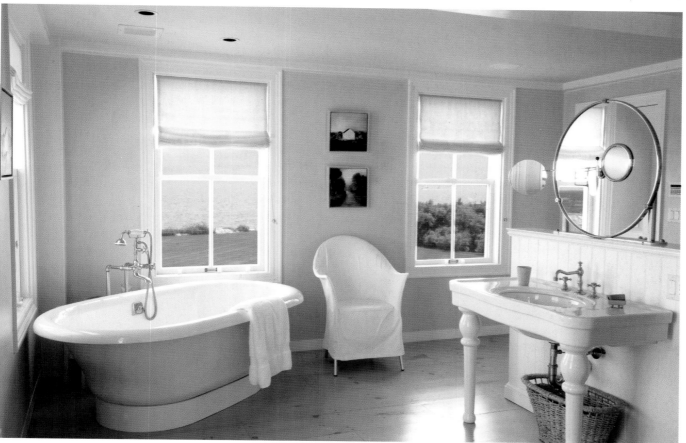

The Phase One 20 megapixel medium-format digital back is a very high-end, expensive system for ultimate quality. This one is attached to a Mamiya 645 medium format body.

The wonderful 14 megapixel Kodak DCS pro SLR: This is a fairly economical combination of superior image quality, convenient features, and advanced software, and hey . . . it's a Kodak!

Digital and Film: The Pros and Cons

Perhaps you can tell by now that I am thrilled but somewhat frazzled with digital photography. For someone who has worked with film for many years, working in a digital environment is incredibly liberating. You can relax about taking risks that once would have cost precious film. Your time investment in creating a digital image can be so productive! No film, no lab! I find that the immediacy of digital viewing allows me to have greater continuous involvement with the image. It is more about actually seeing, and less about intuition, estimation, and guesswork. It is therefore more precise, and for many shoots, I can feel great improvement in my work.

For the time being, due to client and stock photo requirements for film, I am largely using digital in place of Polaroids, saving the digital files, then covering each shot with medium-format film as well. This process entails a bit more work than was once necessary, but once you get used to it, it's not bad, and it adds so much value to your day's work. I am very happy not to be dependent on slow-developing, poor-quality Polaroids, and I don't have to contend with a

garbage bag full of chemical waste at the end of each shoot. I know that the quality of digital, which has come a long way and is now very good, will continue to improve. We can also expect prices to keep coming down. Digital seems destined to become the chief photographic medium, with film filling a dwindling, more specialized role.

As with any tool, however, digital or film should only be seen as a means to an end, the goal being a great photo. Often, some combination of both tools will provide the best approach. You can't run around with a laptop at a garden shoot. You, or the client, may find the small LCD screen on the digital camera inadequate, so a Polaroid will still be a handy testing medium in some cases. Film may be easier and more artistic for the travel photographer, as long as your film is hand-checked at the airport X-ray belt. Just because we have new ways of doing things, we shouldn't just throw away the old. We are lucky to be photographers during this transitional period when digital is really coming into its own and film is still being improved and aggressively marketed.

PRO DIGITAL

◎ Does not require the use of environmentally toxic waste

◎ Instantaneous results; you can see your final work as you shoot

◎ Images can easily be downloaded into Photoshop

◎ Computer proofing can save time

◎ Imaging media is erasable, reusable, and economical

◎ Image files can be easily duplicated at full quality, quickly and cheaply

◎ ISO speed, color correction, and other adjustments are done in camera

◎ Many supplies can be purchased at retail stores everywhere

◎ Not susceptible to airport X-ray damage

◎ Images are easy to print

◎ Digital photos cannot be damaged during repeated usage

CON FILM

◎ Film and Polaroids create hazardous materials during shoot

◎ Must be processed at photo lab: Polaroids are required to simulate results during the shoot

◎ Film must be scanned into Photoshop

◎ Polaroid proofing can be very slow

◎ Film can be used only once and is very expensive

◎ Film can be duplicated, but at less than full quality, and with difficulty and expense

◎ Many kinds of films and filters must be stocked and brought to a shoot

◎ Most items can be found only at professional suppliers

◎ Can be damaged by airport X-rays

◎ Images are difficult to print

◎ Film can be scratched, soiled, or lost

PRO FILM

◎ Quality is unquestionably excellent

◎ Produces beautiful skin tones and other tones

◎ A high-quality starter system can be purchased on a budget

◎ Can be shot with simple, reliable mechanical cameras under all external conditions

◎ Simple, straightforward process

◎ Batteries not always necessary

◎ After the shoot, film is handed to lab and then sent to client

◎ Film can be held and viewed; photos are a known quantity

CON DIGITAL

◎ Quality is not yet accepted by many clients and professionals

◎ Questionable skin and other tones

◎ Expensive hardware investment is unavoidable for professional gear

◎ Electronics are sometimes finicky and unreliable under various conditions

◎ Potential for frustrating complications and much more equipment

◎ Battery-thirsty cameras and computers require continual recharging

◎ After the shoot, photographer has to work extra hours on the computer

◎ Digital files intangible, can only be seen and judged by experts on computers

Digital on Location

Taking digital on location with a laptop for large image viewing can be complicated. Your new technical environment is ratcheted up considerably from the film days, and knowledge of computers and electronics is now crucial. Problems will arise and you must be prepared and stay cool in the client's presence. Logistical issues like laptop placement and cord management are now necessary. The firewire cable, USB cable, power cords, adapters, and plugs are fragile and vulnerable during a busy day of shooting. Other than the U.S. military models, digital camera and computer devices are not really built for rugged use, so you will have to be resourceful and inventive in adapting the equipment to your needs. I have built a variety of portable computer trays, cord support brackets, and other little devices to protect and streamline my system as much as possible. As always, the more fluid your technology, the less you have to fidget with equipment, and the more creative you can be. Above all, prepare to spend long hours before the shoot getting to know the equipment and software.

The Wonders of Photoshop

Photoshop is arguably the most magical, powerful, and highly refined tool ever placed in a photographer's hands. With it, we can perform photographic miracles quickly, cheaply, and easily. Just the simple controls of brightness, contrast, color balance, sizing, and cropping are enough to hope for, let alone the worlds of possibilities when you employ color-saturation controls, brightness curves and levels, cloning, selections, masks, and countless other options. I would say that good photographs do not need Photoshop to be good, but Photoshop can improve their chances of being great. This software simply lets us take a well-captured image and refine and craft it a bit more to our liking. As with any other tool, however, Photoshop is only as good as the hands that use it.

If I'd only had Adobe Photoshop years ago, what a lot of time and trouble I could have saved! All those hours of moving chairs and tables to hide electrical outlets, putting sofas in front of radiators, running around looking for plants to cover light switches, pictures to hang on thermostats. Vents, smoke detectors, ceiling fans, exit signs, ugly window views, and all the other facts of modern life are not pretty in a picture. With exteriors, there always seem to be hideous power lines, the house next door, the dead tree or bush, the satellite dish. Before Photoshop, we often had to sacrifice the best angles, furniture and prop placement, and styling desires just to hide some extraneous blemishes that, barely noticed in real life, will distract and bother someone viewing a photograph. Sometimes it's okay to leave reality completely alone, but most interior and exterior photos will benefit with a little cleanup, and Photoshop is usually the best and easiest way to clean up a photo.

Digital Printing

Photographic printing may be the weakest link in the whole picture-making business. For one thing, a photographer can't personally make his own photographic color prints. A color print processor is very expensive, the chemicals are toxic, and who can bear the thought of spending hours in a darkroom? With so many artistic choices going into each print, there is little chance the photo lab will make you a perfect print. Let's face it: Even the most conscientious lab person just can't care as much about your photograph as you do.

Well, along come computers, Photoshop, and affordable digital printing, and suddenly we can make beautiful prints at home! Not in a damp basement darkroom, but upstairs in a warm comfortable chair. No chemicals! And as with all aspects of digital photography, the beauty of inkjet prints has really come into its own. Now, almost all photographers can make their own prints, and will probably end up being happier and spending less than they did when they worked with the photo lab. Not only are you able to choose paper surface, size, cropping, brightness, contrast, and color balance, but you can click your mouse on the magical controls of Photoshop for many other options.

FINDING THE CAMERA THAT'S RIGHT FOR YOU

The best camera is the one that feels right and most efficiently does the job. At one end of the spectrum are the easiest, most convenient cameras, usually 35mm, offering maximum spontaneity, but the lowest level of image quality. At the other end of the spectrum, large-format view cameras rule with their maximum image quality, but they are very cumbersome and time-consuming and difficult and expensive to use. Middle ground is occupied by the medium-format camera, refuge of the practical, quality-minded photographer on the go.

I rely on medium-format as my mainstay, with details and portrait support from 35mm. The quality of a 6 x 7 centimeter (2¼ x 2¾ inch) roll film image, though obviously not as sharp and rich as a the image I get from a slow-working 4 x 5 inch view camera, is still excellent. Any compromise in image quality is more than offset by the many advantages of the smaller camera. Besides offering speed, maneuverability, and economy, the medium-format camera seems to evoke a much more spontaneous feeling in capturing the life of a location. I often feel that a medium-format interior photograph looks and feels like being in the place, and a 4 x 5 looks more like a formal, almost studio-like photograph of the place. The 4 x 5 photos feel stiff, possibly owing to the fact that the photographer has to pay more attention to the camera and has often labored to create much more light to accommodate the slower large-format lenses. Though a few magazines, such as *Architectural Digest* and *Veranda*, do prefer the rich, formal quality of large format, most editors and art directors would not put up with the slow shooting pace and expense of it. Anyway, the sharpness of a good 2¼ x 2¾ transparency tends to exceed the resolution of most magazine and book reproduction capabilities, even on a double-page spread.

Here's the large (and still-growing) selection of bargain-priced cameras I've purchased on eBay—a great source for photographic equipment.

Choosing the Lens

Besides your vision, what is literally between your subject and film? The lens! In executing your vision, your choice of lenses is an important artistic tool. I will again state that there is no "correct" lens to use for a given purpose; the choice is a creative decision. An extremely wide-angle lens is very effective for overall establishing shots, but it can be easy to overuse this lens. If you rely on it too much, you are showing, but not exploring, the space. Furthermore, it will exaggerate the foreground and diminish the background, often rendering a "warehouse" effect of a huge, cold space. For a less vacuous, cozier effect, use a slightly wide-angle lens from as far away as possible. Then, press your normal or slightly telephoto lens into action for painterly vignettes and details. I like very fast lenses for details (lenses with small f-numbers like 1.4, or 2 are considered very fast). The short depth of field from fast lenses lets me focus on the subject, while keeping the background very soft.

Now, I'll let you in on my secret weapon. After a thirty-year quest for the perfect set of lenses for interior work, I have found that a zoom lens is fabulous, in fact, perfect, for my needs. The fluid precision of a variable focal length lens is great for composing any photograph, but especially in the exacting spatial parameters encountered with interiors. You will usually find a "perfect spot" to position the camera for each shot. This is the place where everything in the shot looks good and feels balanced with everything else. The zoom lens enables you to plant your tripod exactly where you want, and then easily and luxuriously dial in the exact focal length for the absolute best framing. With fixed-focal-length lenses, you have to move the camera closer and then farther away to frame each

Hasselblad is the best name in medium-format cameras and has set the standard for years. I loved using this camera for twenty years, but eventually found the square format and the mounting costs of accompanying wide-angle zoom lenses to be problems.

The Fuji 680 is an amazing, very high-tech camera, offering view-camera-type lens movements with reflex viewing and many automatic features. It's actually a great architectural camera, but guess what? No zoom lens. Guess what else? Very expensive. It's also a bit large and heavy to drag around all day.

shot. In the end, you are often sacrificing your "perfect spot" and compromising the look of the shot, just to get the right cropping. This is an especially undesirable situation in a room filled with pieces of furniture, which are obstacles to your movement. The zoom lens can make the process of composing the best photograph astoundingly accurate and easy.

That's the good news about zoom lenses—now for the bad. For interiors, you need a wide-angle zoom lens, and there are only a few manufactured for medium-format cameras. At this moment, the only wide-angle zoom lens available for my favorite format (and also a format that impresses clients), 6 x 7cm (2¼ x 2¾ inches), is the 55–100mm made by Pentax for the Pentax 67. Though this is a nice camera, it lacks interchangeable backs, which is another very useful feature for interior work. Yet I am so dedicated to zoom-lens shooting that I forego interchangeable backs, and switch camera bodies when going from Polaroid to chrome, and again to negative, and back to Polaroid, and so on. Of course, now that I'm using a digital camera and laptop for previewing, my Polaroid

backs are starting to collect dust. I'm switching from the digital camera to the film camera, and interchangeable backs are a moot point. Quick release plates on the tripods and cameras help streamline the camera switch-over operation.

In the smaller, less desirable 6 x 6 cm (2¼ x 2¼) square format, Hasselblad has a beautiful 60–120mm wide-angle zoom, but it is not as wide angle as the Pentax entry, and the Hasselblad system is quite expensive. Then there is the popular 6 x 4.5 cm, or "645" (2¼ x 1¾ inch) format, which is much better quality than 35mm, but not as sharp and rich as 6 x 7. Mamiya, Contax, Pentax, Bronica, and Hasselblad all have wide-angle zooms in this handy format, though again, with interiors in mind, Pentax wins my vote with a wider zoom and more reasonable prices than the others.

The Pentax 645 (6 x 4.5cm) is a nice camera for portraits, gardens, and details, and is good to use when the larger 6 x 7 format isn't necessary. It handles easily, gets 31 exposures on a roll of 220 film, and has a wide-angle zoom lens. It's also fairly economical.

Piecing Together Your Perfect Camera

Think of camera shopping as a puzzle to solve. A wide-angle zoom lens on a 6 x 7 camera has become my pet priority. Pentax is the only one on the market, so I built my system around that. There are a multitude of features and as many cameras on the market, each one offering different combinations of features. No one camera will have every feature you want, and your best approach is to prioritize and choose the best for your specific needs. Here's a list of features to consider when shopping for a camera. I haven't listed popular features that I find unimportant for interior work, such as autofocus, autoexposure, red-eye reduction, image stabilization, and other bells and whistles. You can modify your equipment in little, helpful ways. Simple time-saving adaptations and ideas can save minutes per shot, and hours per week. The closer you can get to what you want, the faster and more efficiently you can work, the more creative you can be.

- ◎ Wide-angle zoom lens availability (my major priority).

- ◎ Square versus rectangular format (rectangle is usually preferred).

- ◎ Interchangeable film and Polaroid backs, which enable quick and flexible film loading and switching from Polaroid to film; also enables possible digital back attachment.

- ◎ Built-in light metering system.

- ◎ Perspective correction, either with a PC lens or view-camera lens movement (very important for formal architectural shooting).

- ◎ Affordability (not a priority in a perfect world, but since when is this a perfect world?).

- ◎ Size and weight (the smaller and lighter the better).

- ◎ Easy, perhaps motorized film advance.

- ◎ The right feel in your hands.

- ◎ Quality and reliability (they all seem to be good).

Choosing Film

Almost all nondigital professional photographs intended for magazine and book publication are rendered on transparency film. Though negative film has many practical advantages, such as wide exposure latitude and color correctability, publishers rarely request it for reproduction. Transparencies are immediately viewable, enabling editors and art directors to judge and work with the photographs. The printing and production staff can refer to the transparency for matching color, brightness, and contrast. Though photographers would usually find it easier and more efficient to shoot negatives, the publishing industry is geared around transparencies.

Kodak and Fuji each produce a line of transparency films designed to represent colors at varying degrees of saturation. In order to capture the many subtle tones and hues of interior design, illuminated by mixtures of daylight, strobe, tungsten, and other light sources, your film has to be realistic, clean, stable, and reliable. My choice is usually Fuji's softer, less-saturated entry in the market, a beautiful, trustworthy film known as Astia. Sometimes, I may want to beef up the color a bit, particularly on a cloudy day, and I carry Fuji's punchier, saturated film, Provia, for that purpose. Astia and Provia have proven their merit for garden and building exterior shooting as well. They are both available in ISO 100, which is usually a good speed for tripod shooting of stable

interiors. If you want to add moving dogs and kids, you can reach for your stash of the amazing but expensive Provia 400 and use a faster shutter speed to minimize the blurriness.

As with any topic in this book, when I recommend something, it's what works best for me now. Everything can and should change over time, so I advise you to experiment with different films to find the ones you like best. I occasionally test Kodak and Fuji films side-by-side on interior shoots. My regrets to the folks in Rochester, but I find Kodak films to be disappointing when compared with Fuji, for my work. The Fuji seems brighter, cleaner, and more accurate than Kodak does. You may have different results, and I encourage you to compare films for yourself.

▲ The Mamiya RZ67 may be the most popular camera for interiors, offering many features and excellent quality. I've passed it over, though, because it doesn't have a wide-angle zoom lens.

▶ My favorite camera for interior photography: the Pentax 6X7 with 55 to 100mm zoom lens.

A Case for the Negative

Forget, for a moment, what I've just said about most magazines preferring transparencies. There is still good call to consider color negative film for certain publishing projects. Many film experts believe that the range and color quality possible with negatives is superior to transparencies. Though the color separation and printing industries are geared for transparencies, four-color printing can achieve excellent results when a negative is scanned and color separated properly. The main advantage of negatives is their exposure latitude; using negative film, a photographer can feel secure with three or four different exposures of each shot rather than ten to fifteen transparencies. After a big shoot, transparencies generate a lot more film to hand carry through airport security, avoiding X-ray checks. If you are shooting transparencies in public, people are bewildered by the vast quantity of exposures, and the photography can then become less fluid. Negatives are also more forgiving with color correction. In the end, there is more material on the negative film emulsion for post-production improvement. When I'm on the go and can't control the lighting conditions, I find knowing that I'm working with a forgiving, flexible, high-quality medium most valuable for my peace of mind. For these reasons, when I'm traveling abroad or shooting in public environments, I find negatives far more efficient than transparencies.

YOUR CREATIVE TOOL BOX

Any quality endeavor in life requires hard work, but without inspiration, all that perspiration will be for naught. As artists, it's inspiration that sets us apart from average people, but where does inspiration come from? Inspiration is a state of mind that combines excitement with imagination. Boredom and nit-picking are inspiration's evil enemy. Sometimes, especially in commercial situations, we are bound up by requirements and political limitations. We need inner creative resources to emerge from the shoot with photographs that not only fulfill the requirements, but rise above the mundane world with artistic value.

Your tools include image controls, which are a variety of camera, film, and equipment options that can improve your work. These include lens and angle selection; your choice of camera, film, and film format; the use of a variety of close-ups, vignettes, and overalls; compositional variations (vertical versus horizontal, negative space, asymmetry, tilted framing); depth of field and aperture control; and motion and shutter-speed control.

Ideas are your most valuable commodity. Think of your ideas as comprising a "creative tool box," your personal collection full of ideas, techniques, and tricks of the trade. These build and grow and become what your work is, and eventually, if you're lucky, who you are. They are free, but precious. When you conjure and use these tools, they can take you to the stars. On the following pages I'm presenting some examples of fun ideas you can work on while shooting interiors.

A floating sofa frame and flying chairs captured in the mirror, tassels and pillows—these elements add up to image magic.

COLLECTIONS

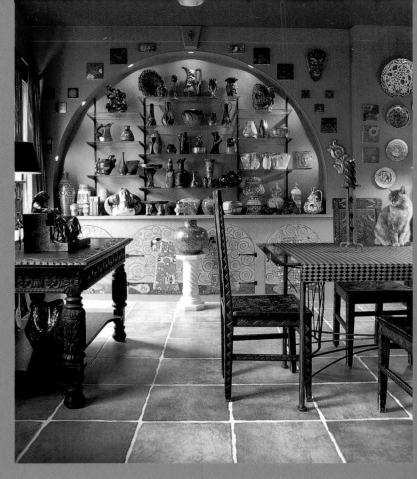

Collections present the opportunity to capture a look at the personality of the homeowner and offer a little glimpse into their lives. Snow globes and lunch boxes suggest whimsy and are fun to photograph. Antique Ironstone, on the other hand, suggests quieter tastes. Even the fixtures housing a collection can be interesting: Here, above right, collectors of fine pottery and china built a beautiful arched shelf structure that combines function and beauty.

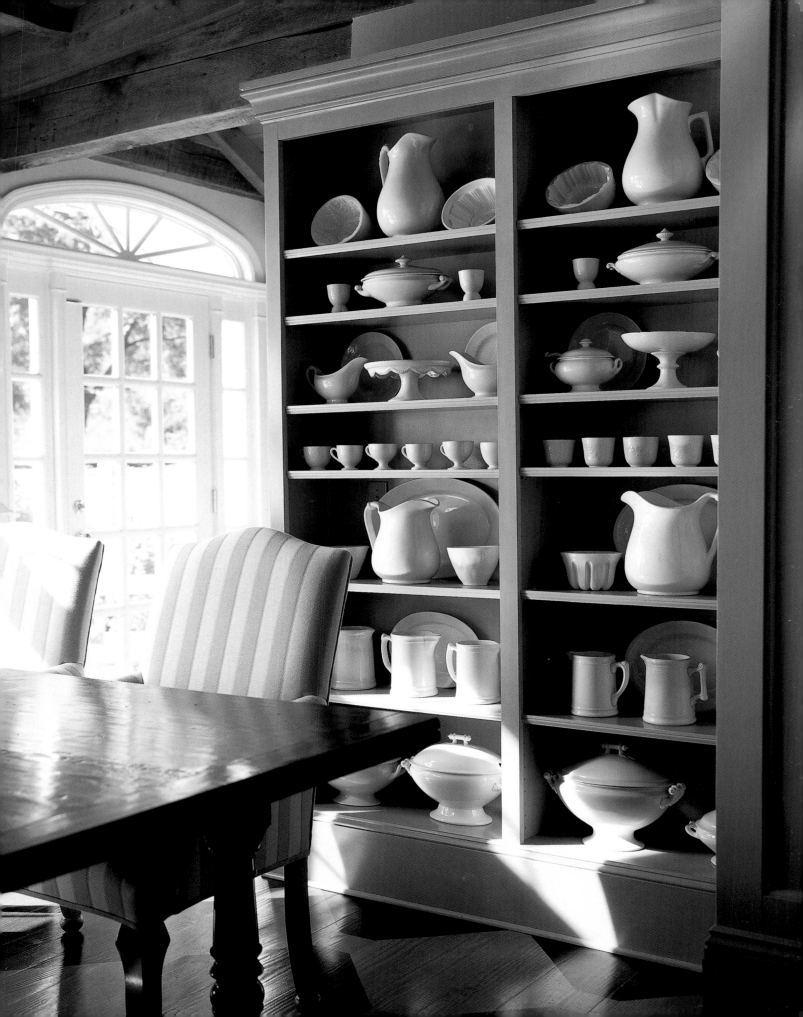

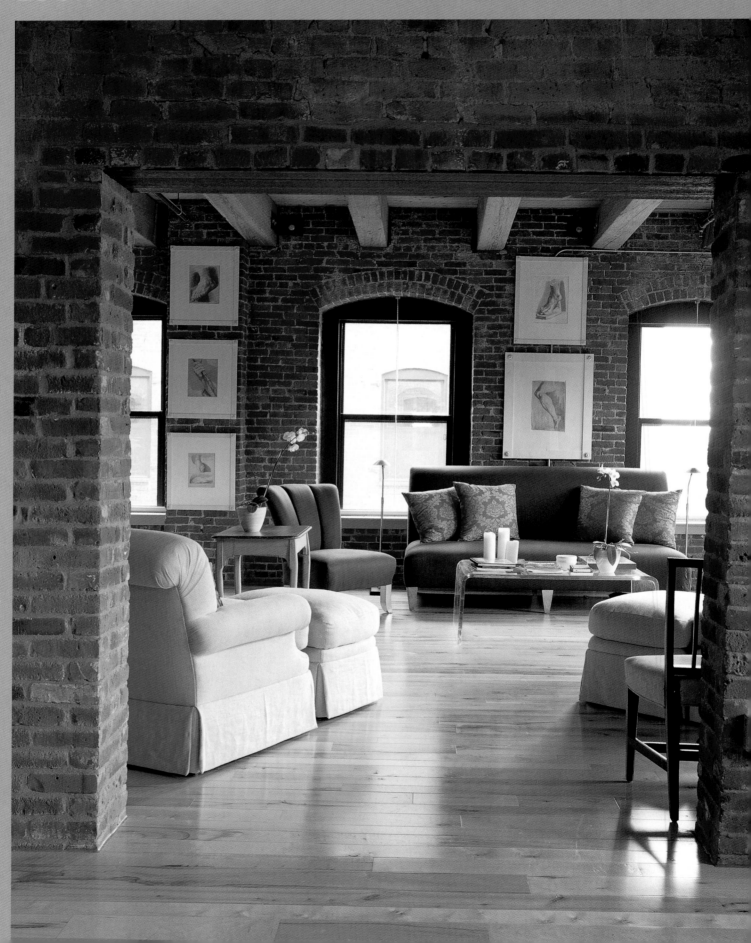

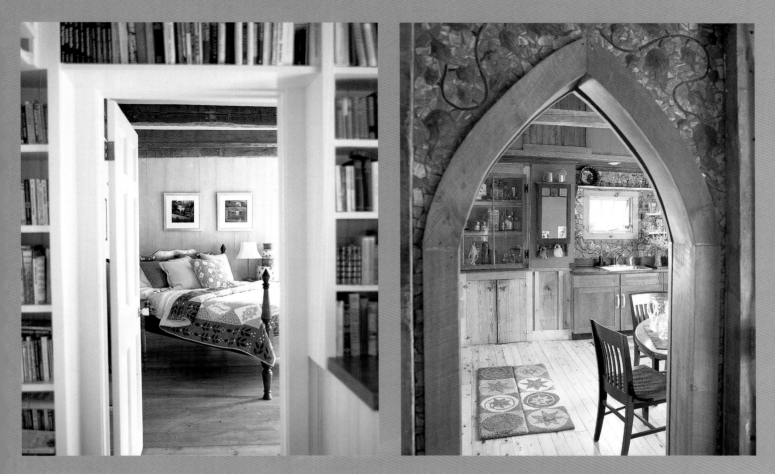

Look-throughs create a sense of mystery and discovery, because you're not just looking at something, you're "looking in."
Meanwhile, foreground elements draw the viewer's eye to what is beyond.

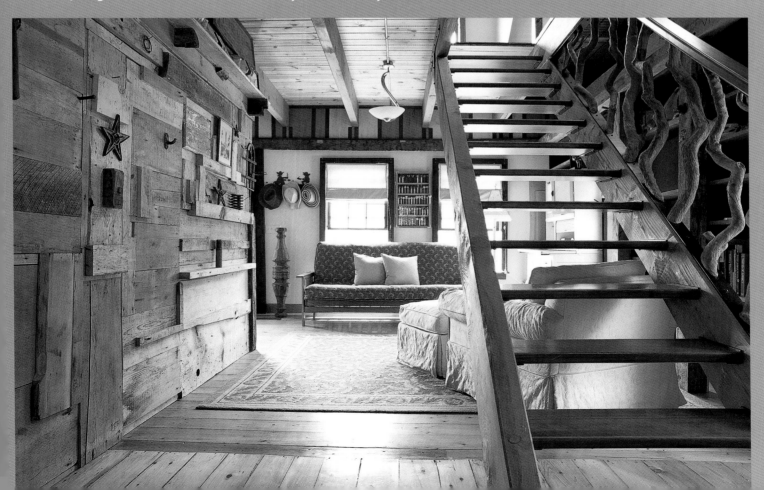

FIREPLACES

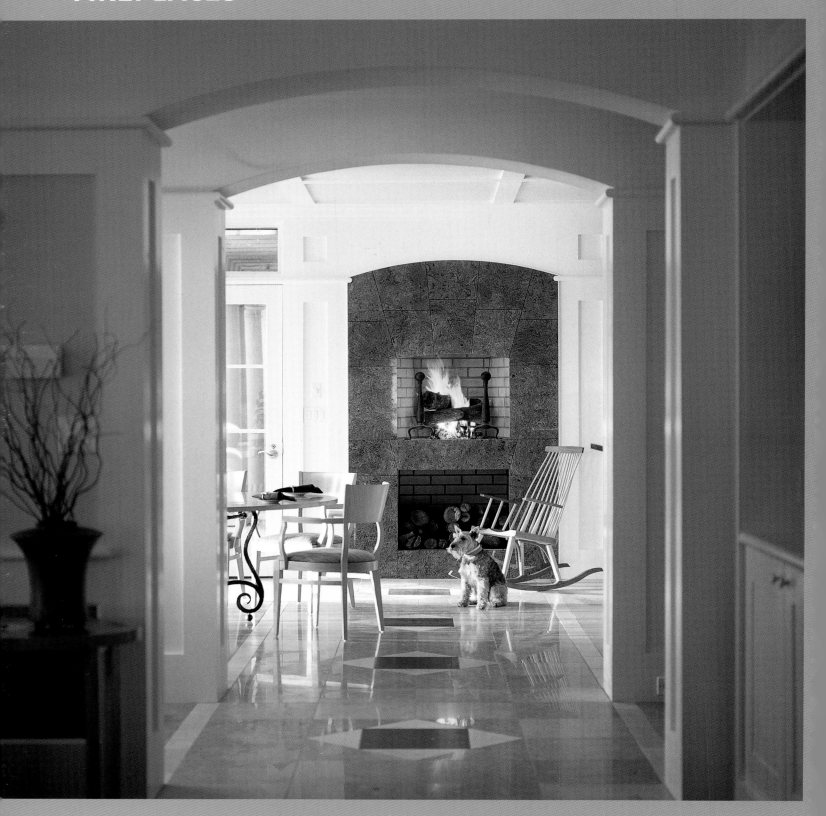

The color and sculptural beauty of a fire can add much to a shot. You can almost feel the warmth. Keep in mind, though, that editors will usually decline a fire for a summer shoot.

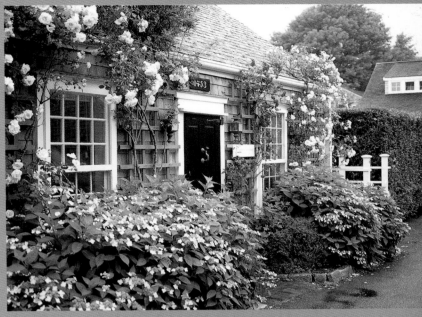

...e cottage shots would be nice enough, but the series is intriguing. The viewer looks at each photograph, comparing it with the others, ...rth and around. The effect is almost cinematic.

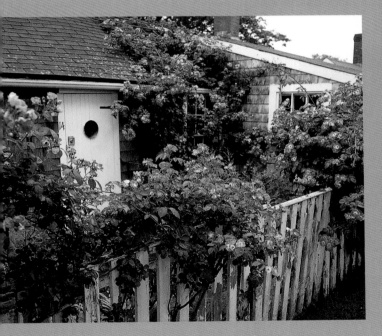

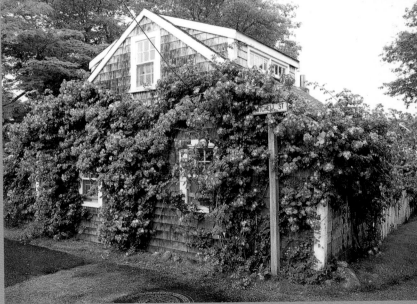

STAIRCASES

If a house has a good-looking staircase, use it—for many of us, a staircase suggests mystery and exploration, and it's hard to look at a photograph of a staircase and not feel the urge to climb it.

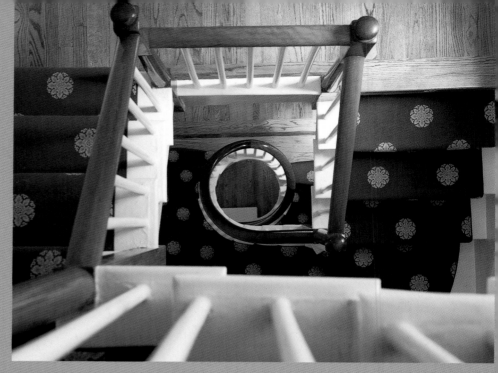

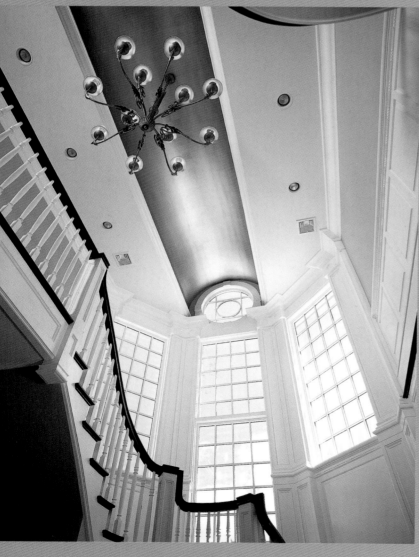

MIRRORS

It's amazing what a mirror can do in a room and even more in a photograph. You may have to shim and tilt the mirror to give you the right reflection, especially if you and your camera are dead center, but when the reflection is right, the effect can be magic. A trick I've learned over the years is to keep the mirror a bit out of focus to add to the illusion of depth.

BASICS FOR THE AMATEUR

Even if you are not going to make a profession out of interior photography, with sound principles in place, you can make really nice pictures with some consistency. All you need to do is learn a few basics and, to avoid expensive lighting equipment, how to use natural light.

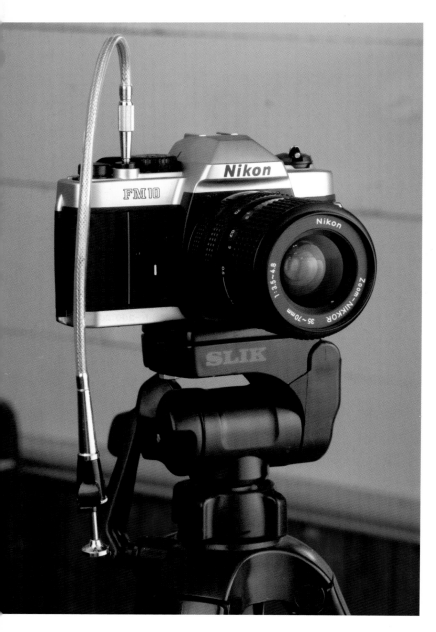

Pentax mysteriously stopped production of the K1000 a few years ago, so Nikon stepped in with the entry-level, fully manual FM10. It's great! I just wish the standard 35 to 70mm zoom was a bit wider, but you can buy a new or used 24mm lens for extra-wide shots.

The Ideal Basic Camera

You probably own a point-and-shoot camera. The camera focuses and sets the lens aperture and shutter speed automatically so you don't have to do much. It even has a handy little built-in flash to take care of those dark scenes. That camera is fine, right? Wrong! You might as well serve TV dinners for Thanksgiving. Your pictures will come out every time, and every one will be terrible. The focus and framing will be approximate and poor. The lighting with that built-in flash will be flat and harsh, eliminating all depth and texture, turning a silk purse into a sow's ear. Please, please, just throw away that point-and-shoot. For interiors (and in my opinion, everything else) you need a "think and shoot."

To make good interior photographs all you really need is a manually controlled 35mm single-lens reflex camera, a decent tripod, a little thing called a cable release, and a big thing called patience. The type of camera that I am recommending used to proliferate until the mid-1980s, when the camera industry got greedy and baited us with sexy automatic marvels. Many of them can be used manually, but are unnecessarily complicated, so I'm urging beginners to stick with the simplest manual camera for interiors.

There is only one fully manual 35mm SLR camera being manufactured today, the Nikon FM10. This is a nice camera with an interchangeable lens mount, and it's not terribly expensive. It has manual shutter speeds from 1 second to 1/2000 of a second, accepts many, mostly older manual focus, manual aperture lenses, and has a simple built-in light meter. Unfortunately, it is only packaged with a 35mm to 70mm zoom lens, which is just barely wide-angle enough for interior photography. You could buy an FM10 with its zoom lens and also buy a fixed (non-zoom) 24 or 28mm wide-angle lens, which you would attach to the camera for the widest, overall room shots. Of course, there are many automatic cameras

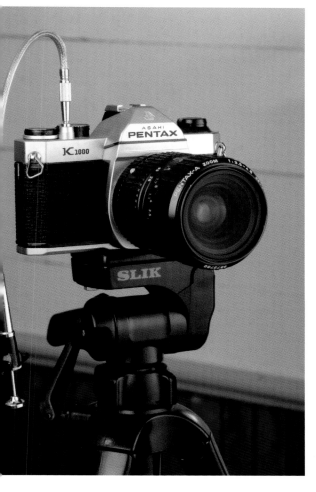

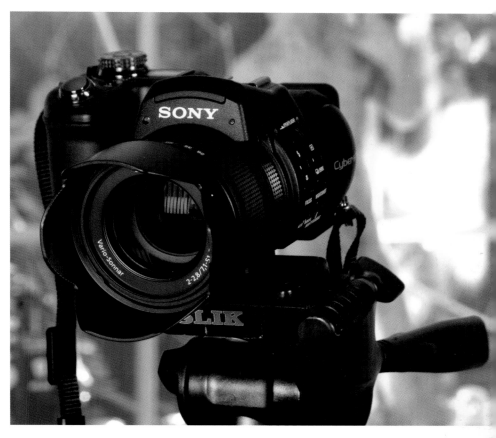

For decades, the Pentax K1000 has been recommended as the ideal student camera. It combines manual simplicity and quality, and with the 28-to-80mm zoom, it's an economical interior-shooting machine.

This incredible Sony digital camera has a sharp 28-to-200 mm zoom lens (wide- angle to telephoto), 8 megapixels (anything over 4 is good), and many manual and automatic controls. It's excellent for shooting interiors.

that can be switched to manual mode and will be perfectly effective, too, though unnecessarily complicated for interiors. The Nikon N80 is a very good camera, and it's affordable, as are the accompanying lenses, and many large camera stores stock this equipment.

I can't resist a bargain and enjoy saving a few bucks on a good used camera, particularly on eBay. Those familiar with this online auction site know the addictive power of being able to find whatever we want for the best price, and used cameras are a perfect eBay items. I amassed a dream camera collection in a single, frantically obsessive year of eBaying. You can be very frugal and buy an Nikon FM10 or a Pentax K1000, with a 24 or 28 to 70 or 80mm zoom lens, on eBay, making sure the dealer is good and the camera's condition is excellent. Any amount less than $300 for these items is very good. You might also want to go to some of the many Web sites that sell photo supplies. I recommend www.bhphotovideo.com, www.adorama.com, or www.calumetphoto.com for on-line purchases of new equipment.

Now that your manual camera is in hand, take it to a big camera store and try it on a few different tripods. Get one that goes low when the legs are collapsed and can extend at least as high as your eye level when the legs are extended. It should feel sturdy and the camera shouldn't sway or vibrate easily. Also, be sure the camera can be easily tilted 90 degrees from a horizontal to vertical position. The tilting, panning, and leveling movements should feel smooth and solid. There are many light but sturdy models on the market for less than $150. While you're there, pick up a good cable release for about $20, a few rolls of 100-speed color negative film, and a small camera bag in which you can fit everything but the tripod. Okay, you're set!

Have Fun with Natural Light

When you get to a location, put your camera bag and tripod down and start looking around. You want to feel the pictures before you handle the equipment. I usually walk around with my thumbs out at 90 degrees like a French painter, framing up possible shots. Whether this tactic helps me see the compositions or just looks cool, I'm not sure, but it seems to settle me into my visual mindset. Keep looking, walking around, getting in corners; go low, go closer, look at details, take it all in. What do you like? What do you dislike? Your job is to remember these feelings for when you start shooting. You're not just there to take pictures, you're there to please yourself and others with beautiful discoveries.

Now that you're all excited about the visual delights you're about to capture, decide where to start. Look where and how low or high to get the best feeling for the scene, and position the tripod. Mount your camera and view the shot. Try the tilt, pan, zoom, and focus. Does the scene look as you envisioned it would? Pay particular attention to furniture and accessories that partially block or "grow out of" other things. You may be able to get rid of these distracting tangents with a better camera position, or by moving or eliminating some things in the room. I think that the phrase "less is more" was invented for interior photography. You are almost always better off when you simplify and take some things out of a frame. The point is to make a clear statement, not to show a bunch of stuff. Avoid objects that compete, and keep the things that complement each other and the overall feel of the shot. Keep looking through the viewfinder and making adjustments to the camera and the scene, until the entire composition looks clear, simple, and has a good flow—in other words, until the composition feels right to you.

Now you're very close, and all that's left is lighting and shooting. Hopefully the room has some natural window light. I usually turn off the lamps and overhead lights, which would look bright yellow-orange on film if you leave them on, and I just admire the simple purity of natural light. This basic window light, even on a cloudy day, will almost always be adequate, and will often be gorgeous. You must, however, accept one inevitable fact. In your photos, the windows will often look very, very bright, also known as "blown out." This occurs because the brightness outside is much greater than the brightness inside. It will sometimes make white curtains simply disappear in a cloud of brightness. I love this effect, because of the powerful, spiritual feeling of the light blasting through the windows, and then gently washing over the room, caressing each detail. (For more about "blown-out" windows, see page 54.)

Load your 100 ISO color negative film and set the ISO dial on your camera to 100. Check your composition, focus your lens, and look at the light meter. You will now make a series of at least six exposures, one, two, three, and four or more times brighter than what the meter tells you is normal. The meter is actually just suggesting what a normal exposure might be, and in this situation, the meter is being fooled by those very bright windows. It's up to you to create good exposures; in this case, a good exposure will be lighter than what the meter is indicating. You can just turn up the brightness by lengthening the shutter speed to $\frac{1}{4}$, $\frac{1}{2}$, 1 second or more. On a bright day, your exposure might be f8 at $\frac{1}{4}$ second. On a dark day, it may be f5.6 at 1 second. Don't worry about wasting a roll of film; it's cheap compared with everything else, especially your time. The pros always shoot many different exposures of each shot (this is called bracketing), because they know things can go wrong, and they never want to go back for a reshoot.

TAKING CARE OF BUSINESS

Most photographers in the land are self-employed freelancers. The word "free" in freelancing may be misleading, because the self-employed lifestyle imposes many responsibilities, obligations, and tasks. Here are some general truths about the business of being a freelance photographer I've come across over my many years of experience.

A successful photographer is a good business person. People think artists have their heads in the clouds and don't have a clue about business. Well, that's not true. A photographer must market a product that is difficult to define or quantify, and at the same time must possess a wide range of skills to handle the many facets of a small business. As an artist, you need to stay loose and be creative, but simultaneously you must think in pragmatic terms and also be a marketer, money manager, and tax accountant, and wield all sort of other business talents.

You've got to love being a photographer. When you are not shooting, you are editing, organizing, sending out photographs, purchasing and maintaining equipment and supplies, discussing future jobs with clients and vendors, marketing and promoting your business, and always thinking, thinking, thinking about everything. In other words, you have to enjoy spending most of your waking and some of your sleeping hours nurturing and feeding a ravenous, bottomless pit of a business. If you are dedicated to being a photographer, you wouldn't have it any other way.

Treat long-term clients with the utmost care. Steady clients are not always easy to find, but these gems are the backbone of your business. And as the old adage says, "It's easier to keep an old client than to find a new one." You should find several good clients, so if something goes wrong with one, there will be others to pick up the slack. As you improve your clientele to include those who publish the work you like to do and develop a rapport with them, your business will become more about what you want to be doing.

Hire a full-time manager. I did so twenty years ago, and it was the best business decision I have ever made. I reasoned that if I could devote more time to photography, and less time to scheduling, invoicing, editing, ordering, shipping, organizing, and discussing business with clients, I could make more than enough money to employ a manager. I was right. What I hadn't expected was the added benefit of having a friend who cared about the business. This has proven valuable in innumerable cases of discussing goals, ideas, and dreams. I also employ a group of young photographers as freelance assistants. They work sporadically for me, and many of them assist a handful of other photographers as well. Some photographers will employ full-time assistants, but I have found the variety and change of scenery with freelancers to be beneficial for all parties.

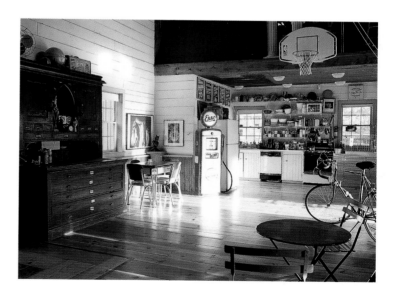

I suppose a photo of my favorite place in the world, a remodeled nineteenth-century carriage house that I call my studio, says a lot about me. Though I am on location for most of my work, I do get to enjoy this space from time to time.

GLOSSARY

DIFFUSER A translucent surface that glows when lit from behind and converts harsh, direct light into soft, diffuse light.

DIGITAL BACK An attachment that allows film camera bodies to be used for digital photography.

FIREWIRE A type of connection and cord that links a digital camera to a computer for shooting and downloading.

GEAR HEAD A type of tripod head that has gears and is controlled by turning knobs; it is very precise for interior work.

GOBO A black card used to shield a strong backlight from hitting the lens, which would cause flare.

MEMORY CARD An in-camera digital storage card.

MONOLIGHT A self-contained flash unit.

POLARIZER A useful filter that minimizes and sometimes eliminates glare.

POLAROID BACK A camera attachment that enables any camera to shoot Polaroids.

REFLECTOR Any surface that when hit with light, reflects that light back. In photography, white and silver surfaces are most commonly used to return or bounce the light onto the subject.

REFLEX CAMERA A camera that allows the photographer to view the subject directly through the lens.

SCRIM A screen that is used to reduce the amount of light without altering the quality of the light.

SILK A sheer, translucent surface that slightly diffuses transmitted light.

SKYLIGHT Blue light from the sky found in shady areas on a clear day.

UMBRELLA A lightweight, collapsible parabolic light reflector, ingeniously derived from the standard rain-shielding device.

VIEW CAMERA A type of camera that has highly adjustable lens and film planes, manual settings, and direct, ground-glass viewing.

DESIGN CREDITS

I'd like to express thanks to these talented interior designers and artists who have allowed me to photograph their work. Their rooms appear in this book and serve as examples of beautiful and inspiring living spaces.

Susan Sargent	Milton Schwartz
Charles Spada	Polly Peters
Frank Roop	John DeBastiani
Harry Zeltzer	Laura Glen
Weena and Spook	Jon Andersen
Judy Schultze	Sandy Koehane
Gayle Mandle	Chub Whitten
Peter Wheeler	Siemasko-Verbridge
Gregor Cann	Architects
Robin Pellesier	M.J. Berries Design
David Tonnesen	Jean Clapp
Anne Fitzgerald	Sandra Fairbanks
Molly Moran	Jamie Braun
Mark Christofi	Ken Kelleher
Elizabeth Speert	Chuck Ross
Cheryl and Jeffrey Katz	Lindsay Boutros-Ghali
Tacey Luong	James MacNeely
Kevin McLaughlin	Stephen Chung
Charles Riley	Michael Carter
Astrid Vigeland	J.R. Burrows
James Day	Eleanor Samuels
Benn Theodore	

INDEX

Page numbers in italics refer to photographs

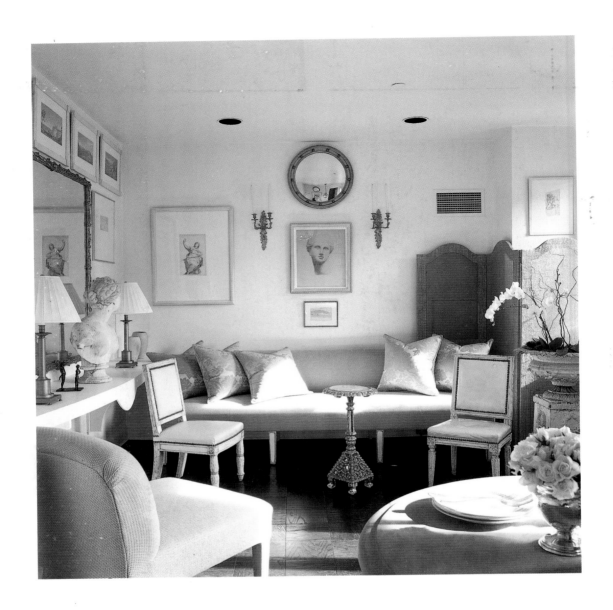